COLORADO 24/7

DK

CONNECTICUT 24/7

DK

DELAWARE 24/7

DK

FLORIDA 24/7

DK

GEORGIA 24/7

DK

KANSAS 24/7

DK

KENTUCKY 24/7

DK

LOUISIANA 24/7

MAINE 24/7

DK

MARYLAND 24/7

MONTANA 24/7

DK

NEBRASKA 24/7

DK

NEVADA 24/7

DK

NEW JERSEY 24/7

DK

NEW HAMPSHIRE 24/7

OKLAHOMA 24/7

DK

OREGON 24/7

DK

PENNSYLVANIA 24/7

DK

RHODE ISLAND 24/7

DK

SOUTH CAROLINA 24/7

DK

VIRGINIA 24/7

DK

WASHINGTON 24/7

VIRGINIA 24/7

DK

WISCONSIN 24/7

DK

WYOMING 24/7

Put any picture you want on any s... Go to www.america24-7.com/customcover

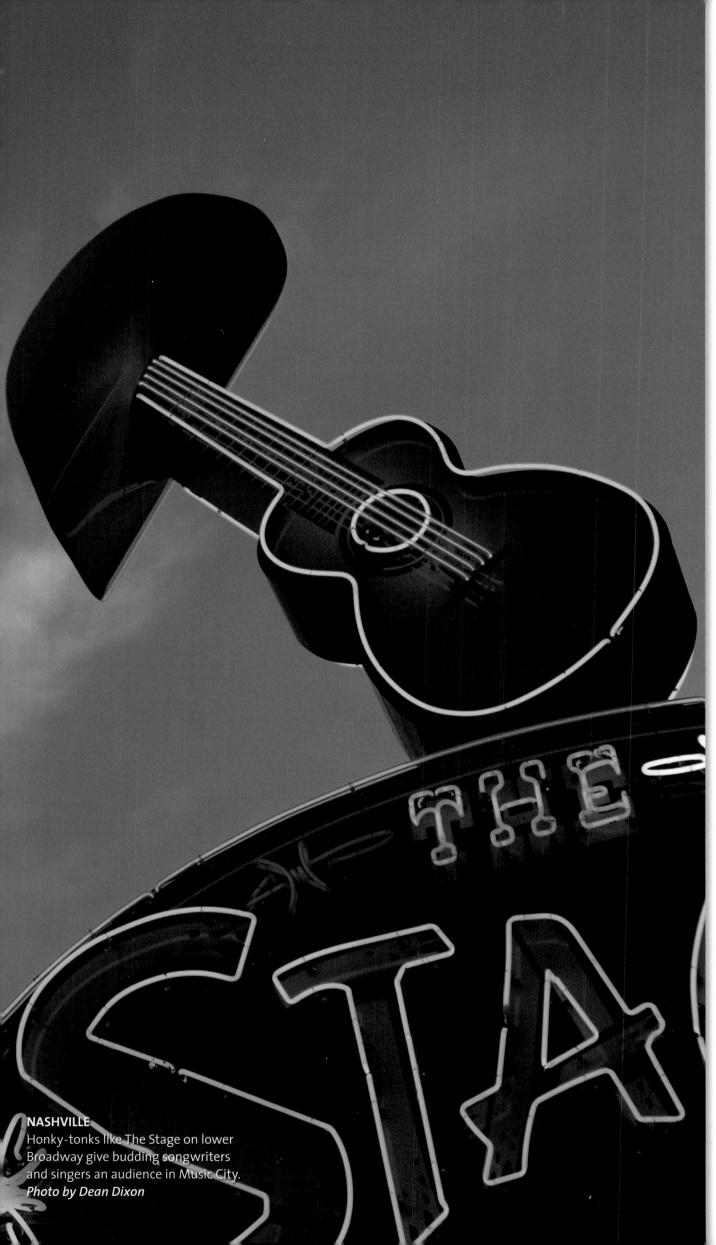

NASHVILLE
Honky-tonks like The Stage on lower Broadway give budding songwriters and singers an audience in Music City.
Photo by Dean Dixon

Tennessee 24/7 is the sequel to *The New York Times* bestseller *America 24/7* shot by tens of thousands of digital photographers across America over the course of a single week. We would like to thank the following sponsors, the wonderful people of Tennessee, and the talented photojournalists who made this book possible.

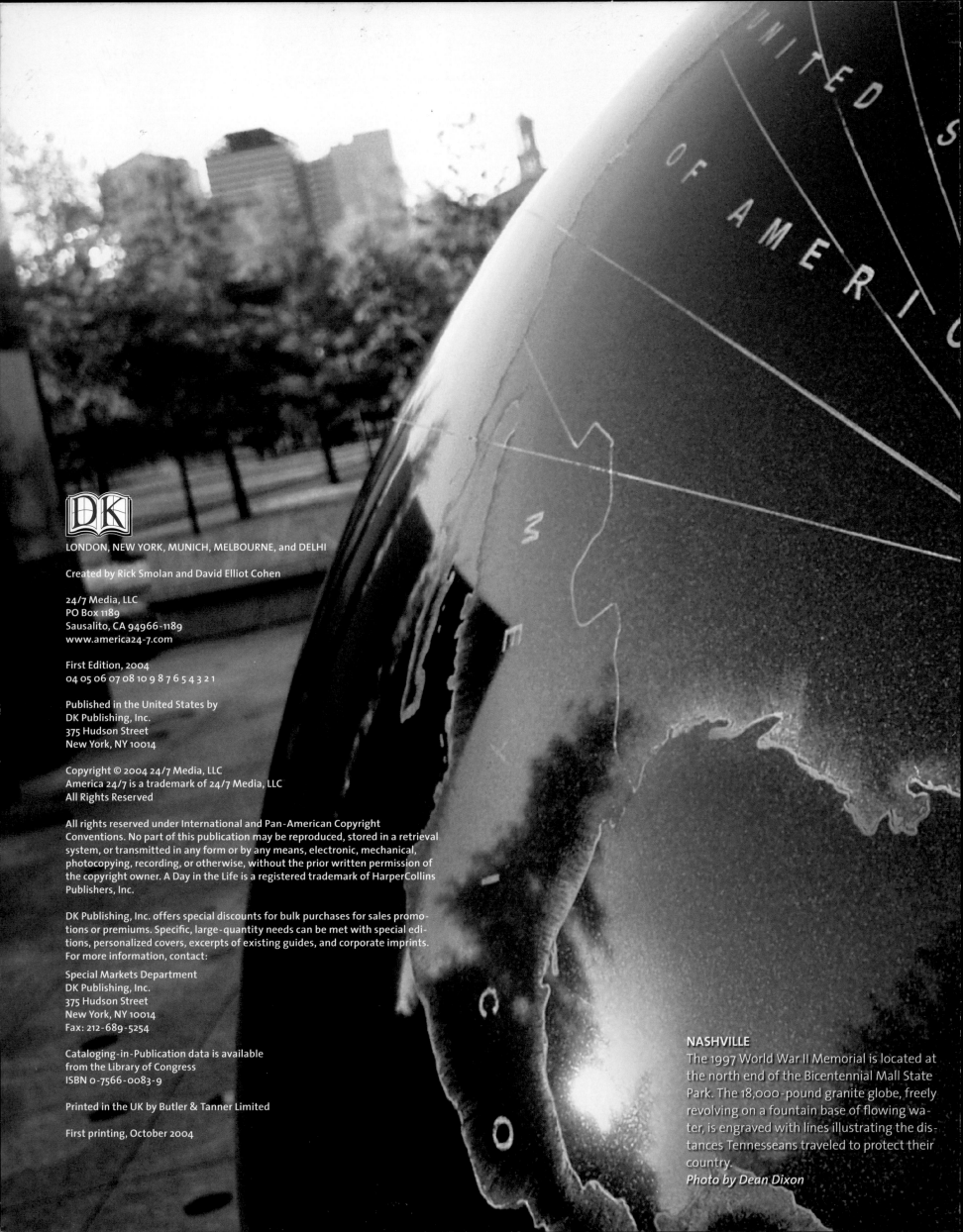

DK

LONDON, NEW YORK, MUNICH, MELBOURNE, and DELHI

Created by Rick Smolan and David Elliot Cohen

24/7 Media, LLC
PO Box 1189
Sausalito, CA 94966-1189
www.america24-7.com

First Edition, 2004
04 05 06 07 08 10 9 8 7 6 5 4 3 2 1

Published in the United States by
DK Publishing, Inc.
375 Hudson Street
New York, NY 10014

DK Publishing, Inc. offers special discounts for bulk purchases for sales promo-
tions or premiums. Specific, large-quantity needs can be met with special edi-
tions, personalized covers, excerpts of existing guides, and corporate imprints.
For more information, contact:

Special Markets Department
DK Publishing, Inc.
375 Hudson Street
New York, NY 10014
Fax: 212-689-5254

Cataloging-in-Publication data is available
from the Library of Congress
ISBN 0-7566-0083-9

Printed in the UK by Butler & Tanner Limited

First printing, October 2004

NASHVILLE
The 1997 World War II Memorial is located at
the north end of the Bicentennial Mall State
Park. The 18,000-pound granite globe, freely
revolving on a fountain base of flowing wa-
ter, is engraved with lines illustrating the dis-
tances Tennesseans traveled to protect their
country.
Photo by Dean Dixon

TENNESSEE 24/7

24 Hours. 7 Days.
Extraordinary Images of
One Week in Tennessee.

Created by Rick Smolan and David Elliot Cohen

DK Publishing

About the America 24/7 Project

A hundred years hence, historians may pose questions such as: What was America like at the beginning of the third millennium? How did life change after 9/11 and the ensuing war on terrorism? How was America affected by its corporate scandals and the high-tech boom and bust? Could Americans still express themselves freely?

To address these questions, we created *America 24/7*, the largest collaborative photography event in history. We invited Americans to tell their stories with digital pictures. We asked them to shoot a visual memoir of their lives, families, and communities.

During one week in May 2003, more than 25,000 professionals and amateurs shot more than a million pictures. These images, sent to us via the Internet, compose a panoramic yet highly intimate view of Americans in celebration and sadness; in action and contemplation; at work, home, and school. The best of these photographs, more than 6,000, are collected in 51 volumes that make up the *America 24/7* series: the landmark national volume *America 24/7*, published to critical acclaim in 2003, and the 50 state books published in 2004.

Our decision to make *America 24/7* an all-digital project was prompted by the fact that in 2003 digital camera sales overtook film camera sales. This techno-logical evolution allowed us to extend the project to a huge pool of photographers. We were thrilled by the response to our challenge and moved by the insight offered into American life. Sometimes, the amateurs outshot the pros—even the Pulitzer Prize winners.

The exuberant democracy of images visible throughout these books is a revela-tion. The message that emerges is that now, more than ever, America is a supersized idea. A dreamspace, where individuals and families from around the world are free to govern themselves, worship, read, and speak as they wish. Within its wide margins, the polyglot American nation manages to encompass an inexplicably complex yet workable whole. The pictures in this book are dedicated to that idea.

—*Rick Smolan and David Elliot Cohen*

American nightlight: More than a quarter of a billion people trace a nation with incandescence in this composite satellite photograph.
Photo by Craig Mayhew & Robert Simmon, NASA Goddard Flight Center/Visions of Tomorrow

Songs of Tennessee

By Larry Daughtrey

It's a soft spring day at a log cabin on a Tennessee ridge. In a hollow down the way, a turkey gobbles, hopeful. Out back, a dainty whitetail doe licks the salt block, storing nutrients for the spotted miracle that will soon emerge from her swollen belly.

A satellite dish hangs off the cabin's eaves jarring the pastoral peace with images all too modern.

An hour away is Nashville, Tennessee's capital city. More than a million people cluster within the 30-mile radius of its international airport. On Music Row, multinational corporations spin out the latest country music twang, a faded echo of sturdy tunes that migrated into the hills with the people of Scotland and Ireland.

Cosmopolitan Nashville remains vaguely embarrassed to be branded as Music City, USA. No Nashvillian would approach a country legend like George Jones in the market for an autograph. The city is, by private contribution, building a dazzling symphony hall that will dwarf the touristy home of the Grand Ole Opry, a radio staple for more than 75 years. The city prefers to think of itself instead as the home of great universities (Vanderbilt and Fisk); imposing medical complexes; finance, insurance and publishing empires; the NFL Titans.

Flat, depleted cotton fields pave the way to Memphis, perched on a bluff above the churning Mississippi, 200 miles to the west. It is a city still edgy with a racial mix that's half black, half white. But it is coming to terms with a culture that blends blues and barbecue with FedEx and AutoZone.

Six hundred miles to the east, foothills rise into the misty peaks of the

OOLTEWAH

Ooltewah means owl's nest or resting place in Cherokee. It is said that Hernando de Soto and his Spanish conquistadors camped in the Ooltewah Gap on their expedition into North America. The explorers "found" the Mississippi River at a spot south of Memphis in 1541.

Photo by Chad McClure

Great Smoky Mountains National Park. Tucked into the hills is a secretive complex called Oak Ridge, which produced the components of America's first nuclear bomb and every one since. A few nearby congregations still handle poisonous snakes in their worship.

Newer poisons also lurk in the hills. Makeshift, clandestine methamphetamine laboratories have replaced copper stills. Redneck crack. The new moonshine. A scourge for a young generation of rural Tennesseans.

Tennessee is of the south, but isn't. It was the last state to leave the union and the first back. Civil War wounds have not lingered as they have in other states, with angry, racially tinged debates over the Confederate flag. A vibrant, combative political system has emerged instead. The last half century has produced a bipartisan parade of presidential candidates—Estes Kefauver, Howard Baker, Al Gore, Lamar Alexander, and maybe Bill Frist in 2008.

The governor is a Harvard-educated New York native, Phil Bredesen. He drove a Volkswagen van to Nashville and invented a multimillion dollar health care business at his kitchen table. The legislature supports the nearest thing to universal health care in America, and no Tennessee child is uninsured. It also made it legal for us to collect and eat road kill.

Down the gravel road from the log cabin is a village named Temperance Hall. On Friday nights, construction workers and aging farmers who can't read a musical note gather to fiddle the ancient songs abandoned by Music Row. No smoking, drinking or cursing, please.

For more than 40 years, LARRY DAUGHTREY *has been a reporter and columnist for* The Tennessean *in Nashville. Though not born in a log cabin, he lives in one near Lancaster.*

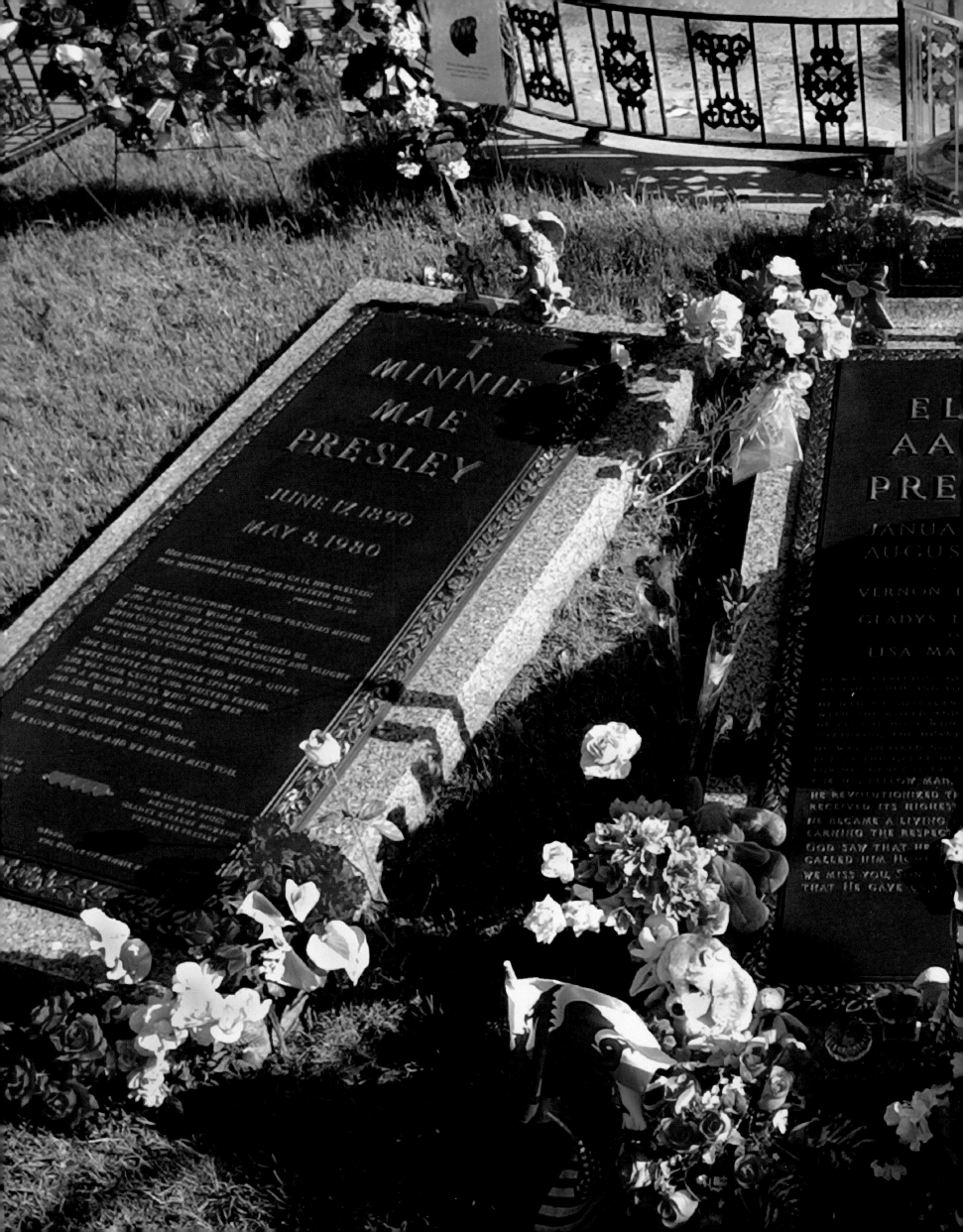

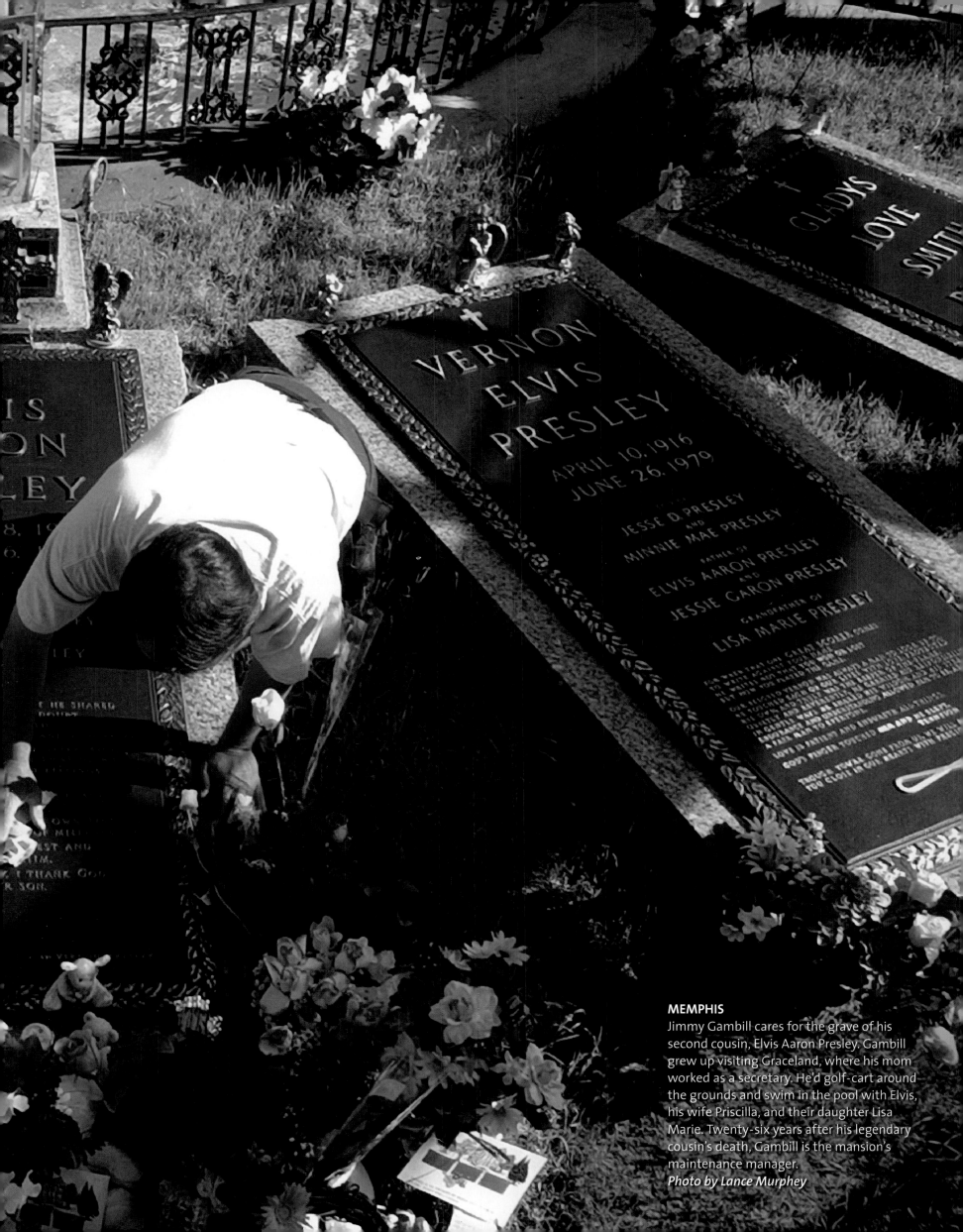

MEMPHIS
Jimmy Gambill cares for the grave of his second cousin, Elvis Aaron Presley. Gambill grew up visiting Graceland, where his mom worked as a secretary. He'd golf-cart around the grounds and swim in the pool with Elvis, his wife Priscilla, and their daughter Lisa Marie. Twenty-six years after his legendary cousin's death, Gambill is the mansion's maintenance manager.
Photo by Lance Murphey

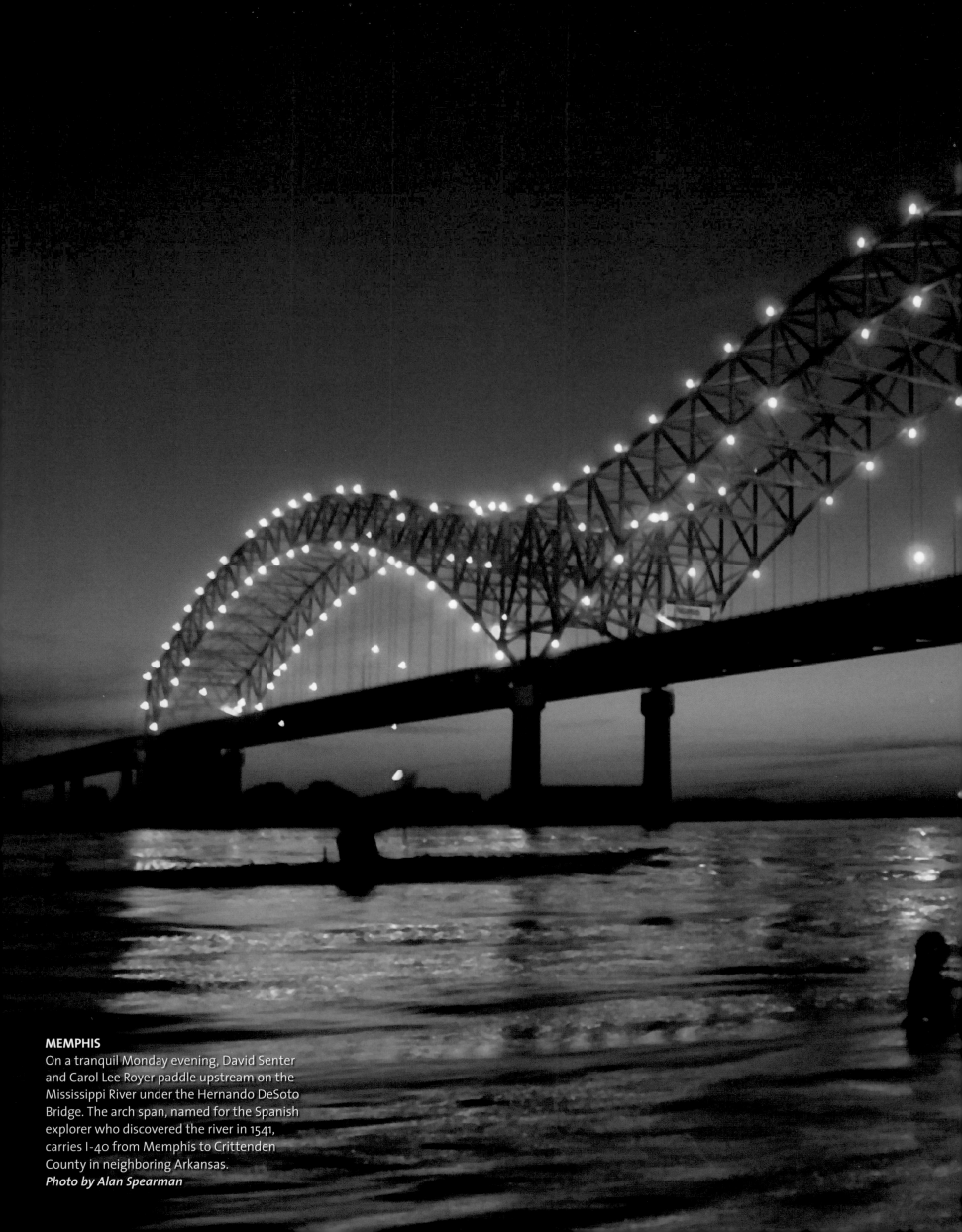

MEMPHIS

On a tranquil Monday evening, David Senter and Carol Lee Royer paddle upstream on the Mississippi River under the Hernando DeSoto Bridge. The arch span, named for the Spanish explorer who discovered the river in 1541, carries I-40 from Memphis to Crittenden County in neighboring Arkansas.
Photo by Alan Spearman

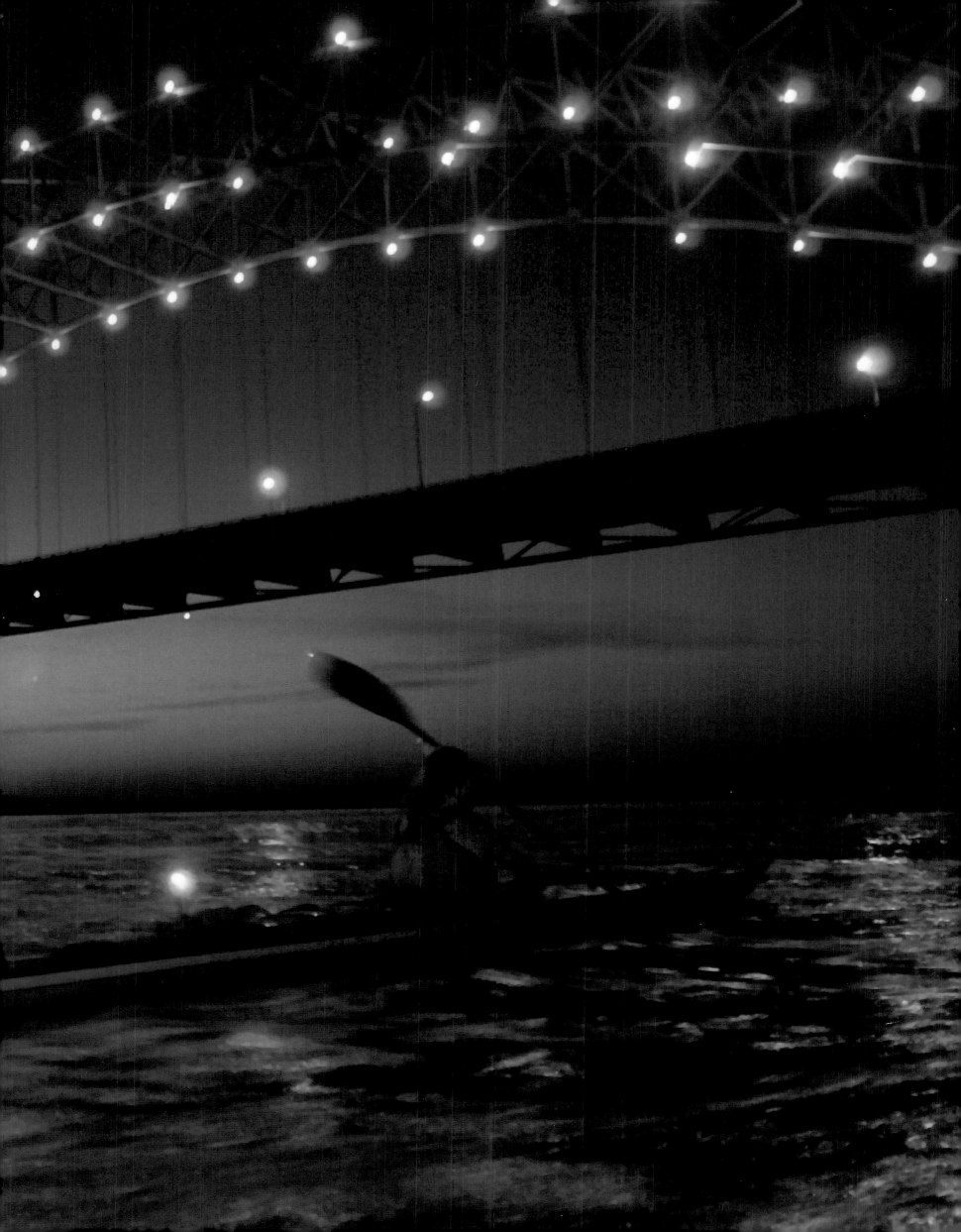

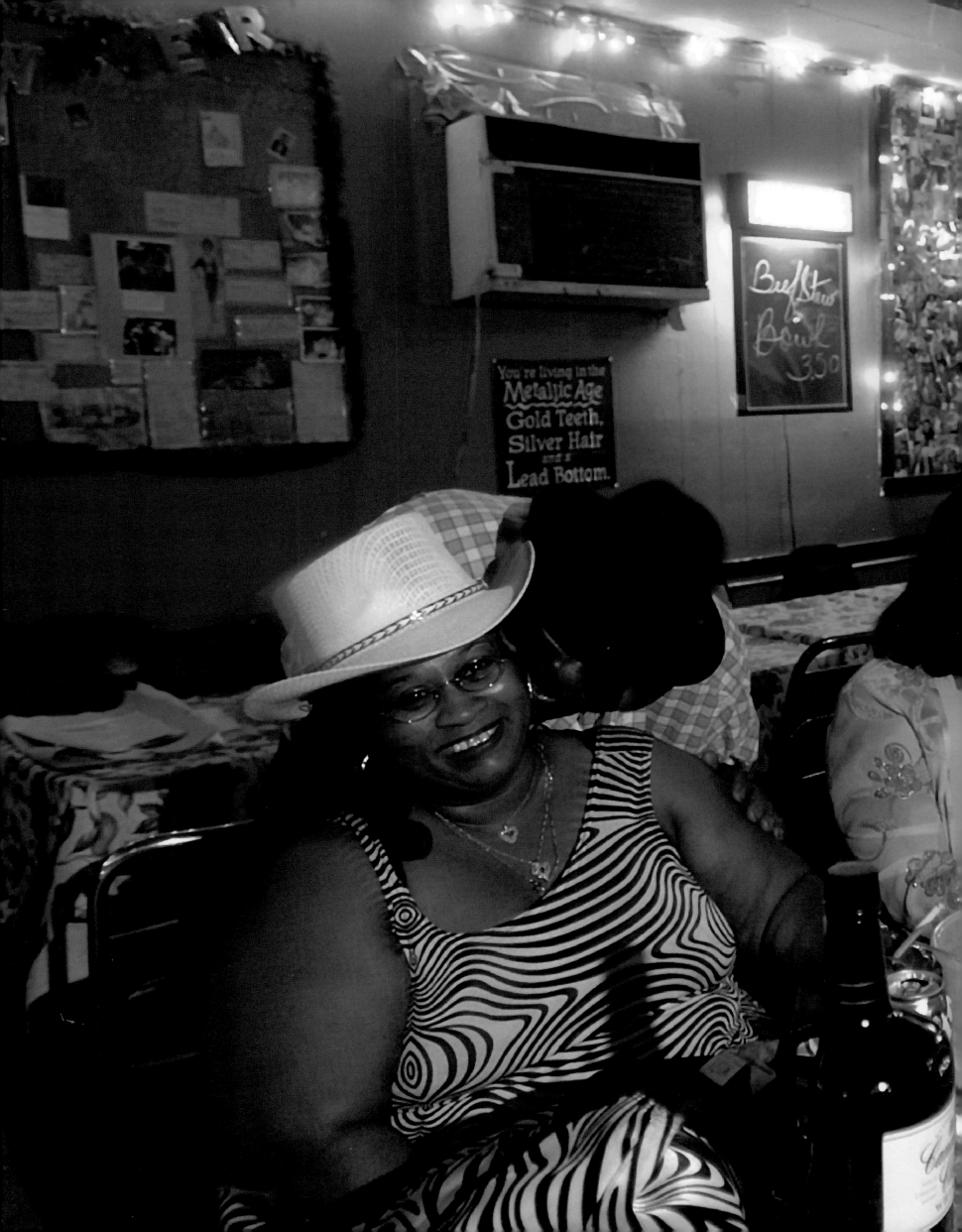

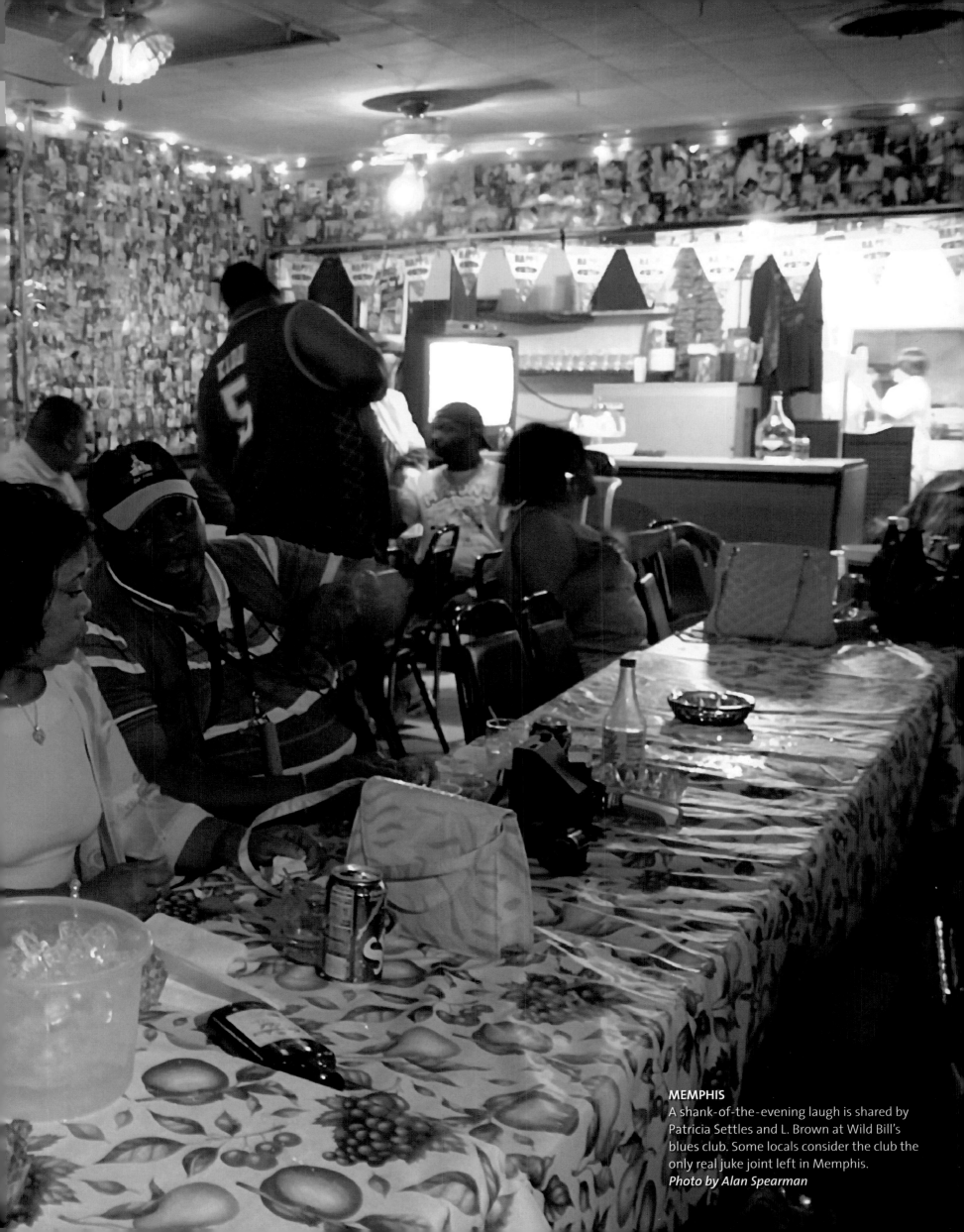

MEMPHIS
A shank-of-the-evening laugh is shared by
Patricia Settles and L. Brown at Wild Bill's
blues club. Some locals consider the club the
only real juke joint left in Memphis.
Photo by Alan Spearman

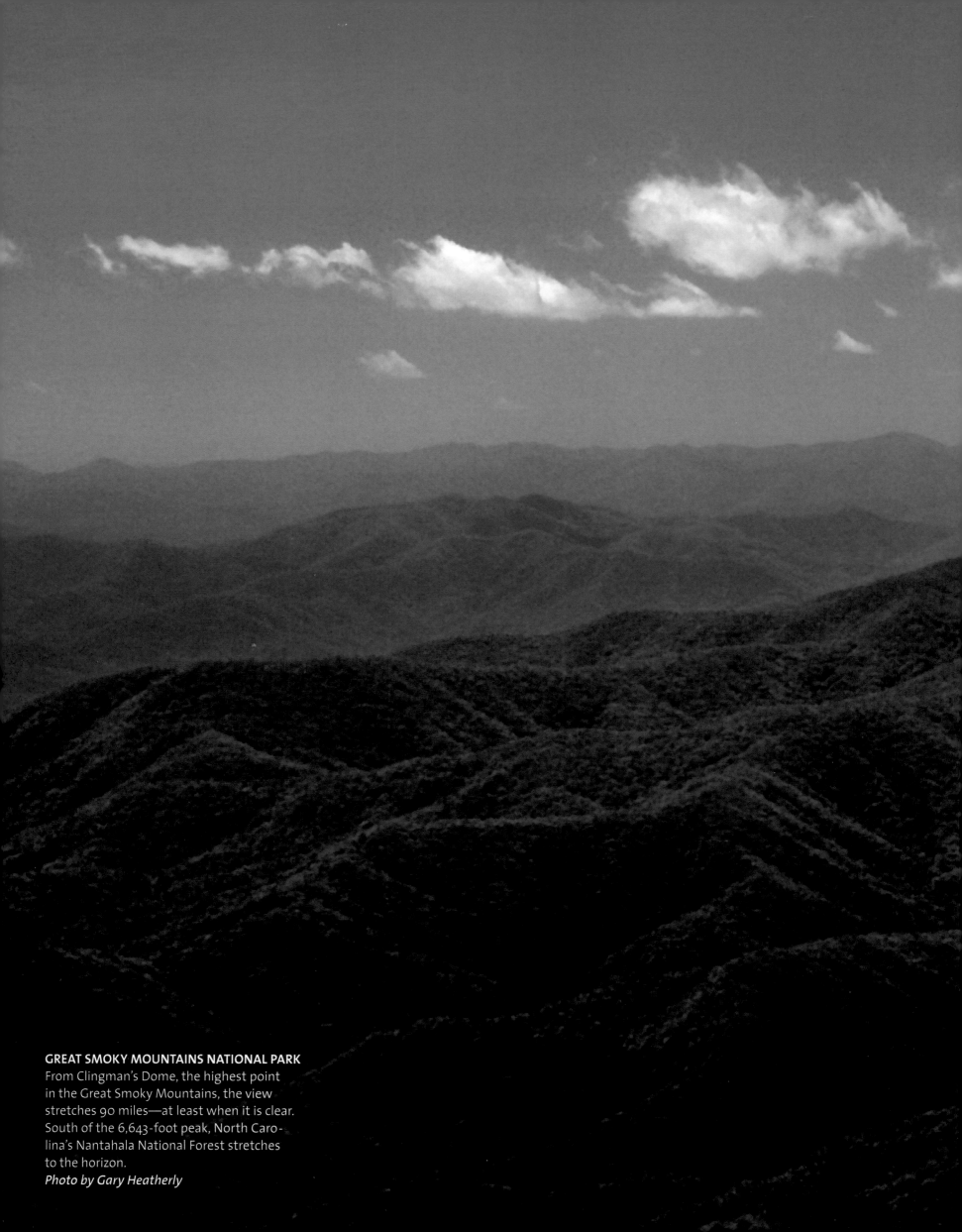

GREAT SMOKY MOUNTAINS NATIONAL PARK
From Clingman's Dome, the highest point
in the Great Smoky Mountains, the view
stretches 90 miles—at least when it is clear.
South of the 6,643-foot peak, North Caro-
lina's Nantahala National Forest stretches
to the horizon.
Photo by Gary Heatherly

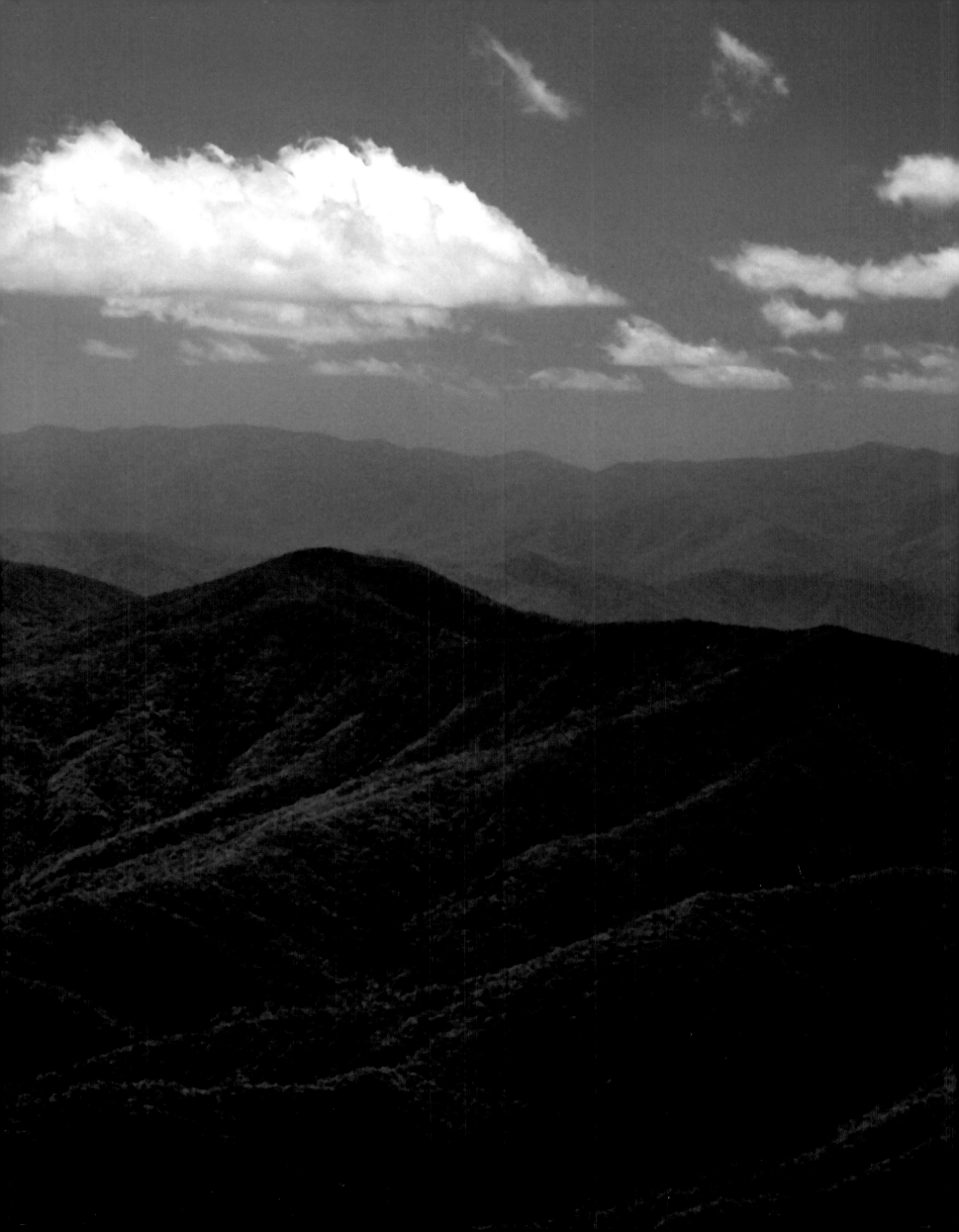

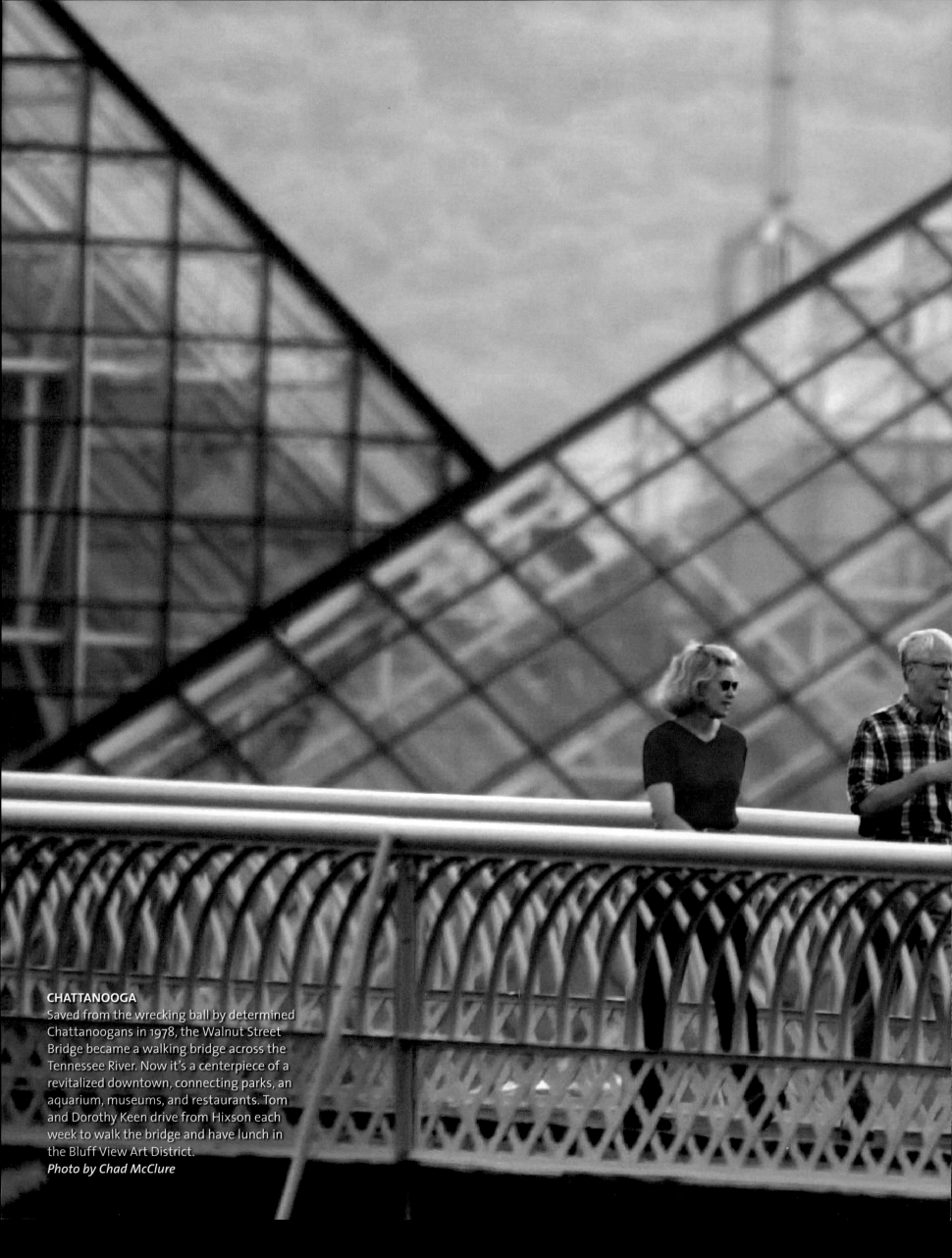

CHATTANOOGA

Saved from the wrecking ball by determined
Chattanoogans in 1978, the Walnut Street
Bridge became a walking bridge across the
Tennessee River. Now it's a centerpiece of a
revitalized downtown, connecting parks, an
aquarium, museums, and restaurants. Tom
and Dorothy Keen drive from Hixson each
week to walk the bridge and have lunch in
the Bluff View Art District.
Photo by Chad McClure

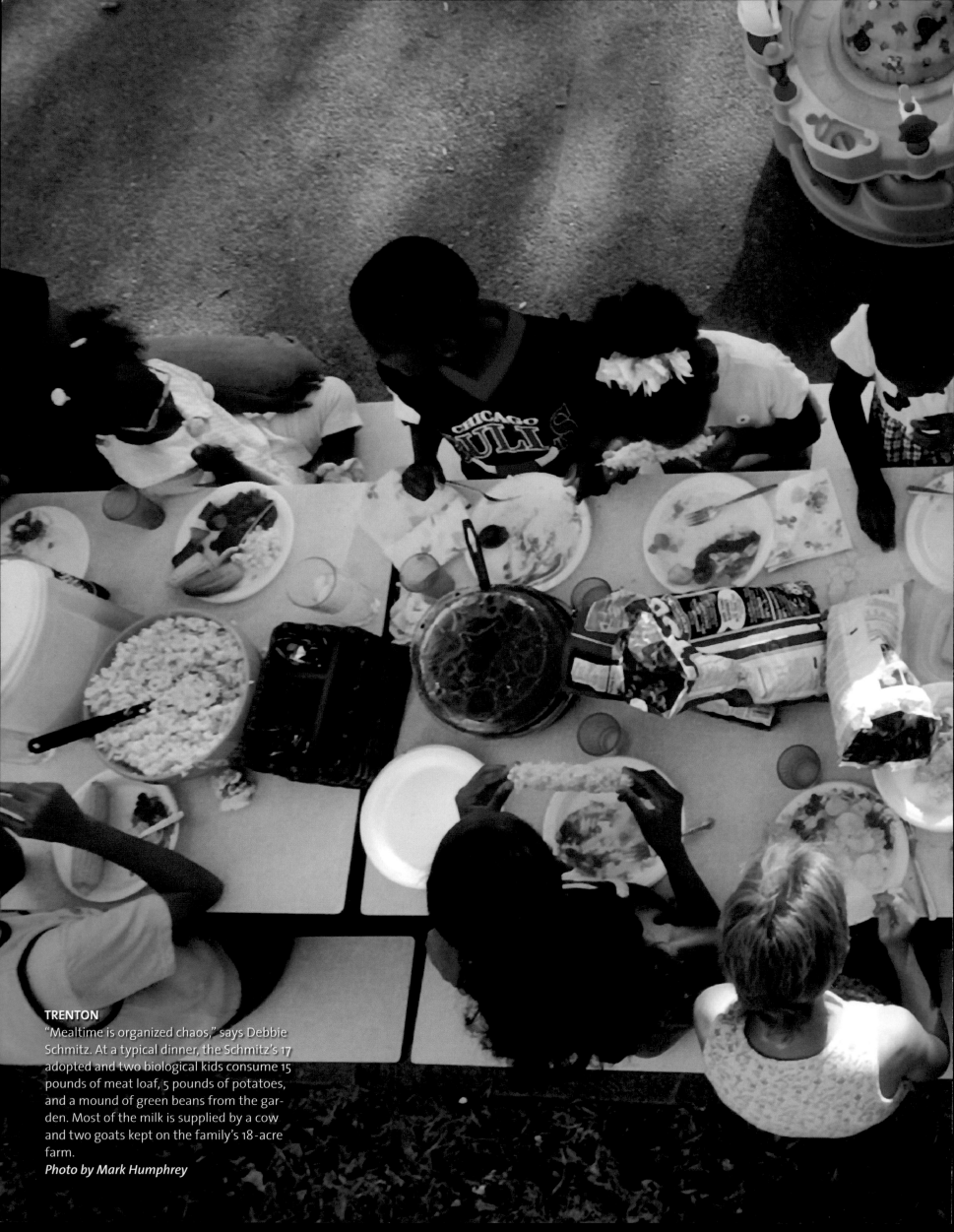

TRENTON

"Mealtime is organized chaos," says Debbie Schmitz. At a typical dinner, the Schmitz's 17 adopted and two biological kids consume 15 pounds of meat loaf, 5 pounds of potatoes, and a mound of green beans from the garden. Most of the milk is supplied by a cow and two goats kept on the family's 18-acre farm.
Photo by Mark Humphrey

Hearth & Home

TRENTON

Debbie Schmitz attends to adopted son Matteo, 3, born with a list of health problems including Moebius syndrome and limb deformities. Debbie and husband Tom began adopting kids with cognitive, physical, or emotional problems eleven years ago. "Most families want to adopt a white child who is healthy—all other kids fall by the wayside," says Debbie.

Photos by Mark Humphrey

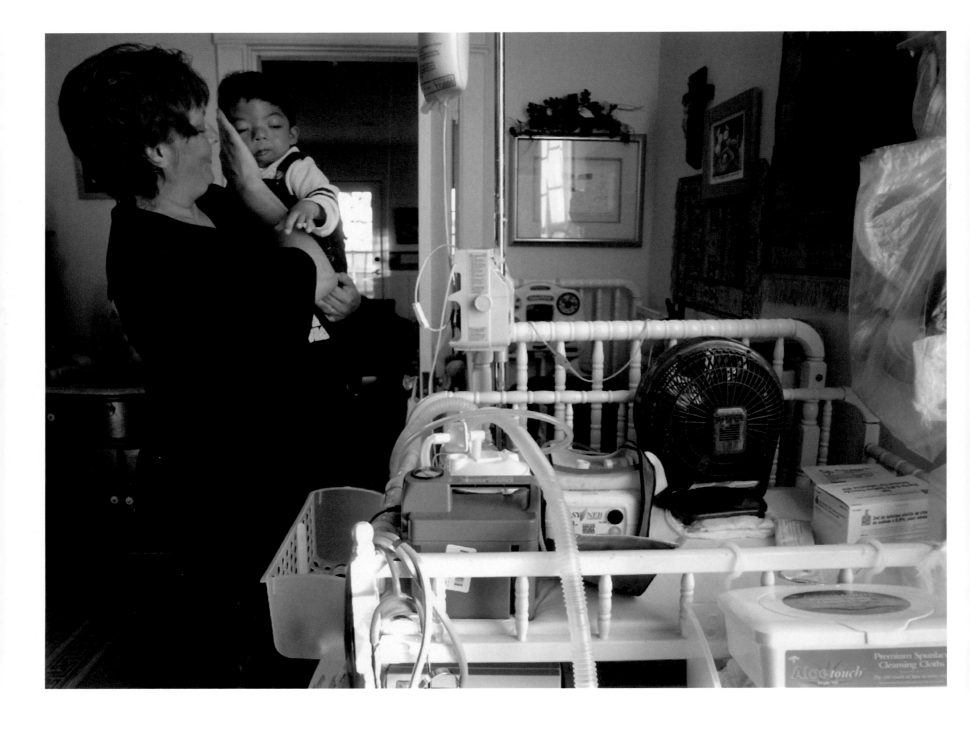

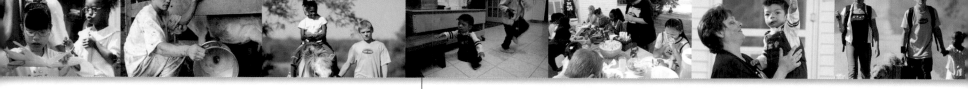

TRENTON

Five-year-old Marrissa dances around her brother Matteo in the kitchen of the Schmitz's large, 100-year-old farmhouse. Marissa, born with Down's syndrome, is gregarious, capable, and full of energy. "We treat all the kids like they are normal," says mom Debbie. "Marrissa thinks she can do anything."

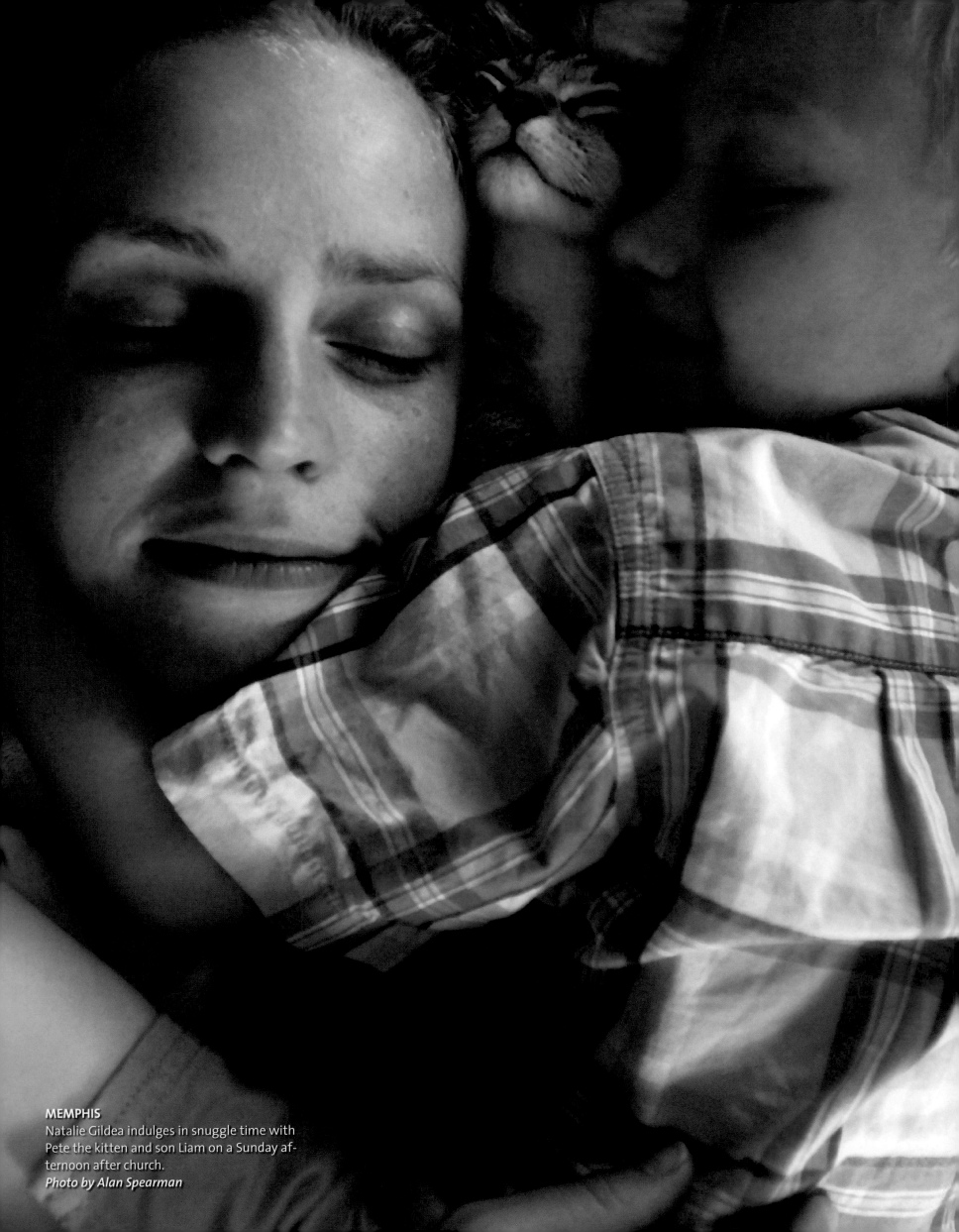

MEMPHIS
Natalie Gildea indulges in snuggle time with Pete the kitten and son Liam on a Sunday afternoon after church.
Photo by Alan Spearman

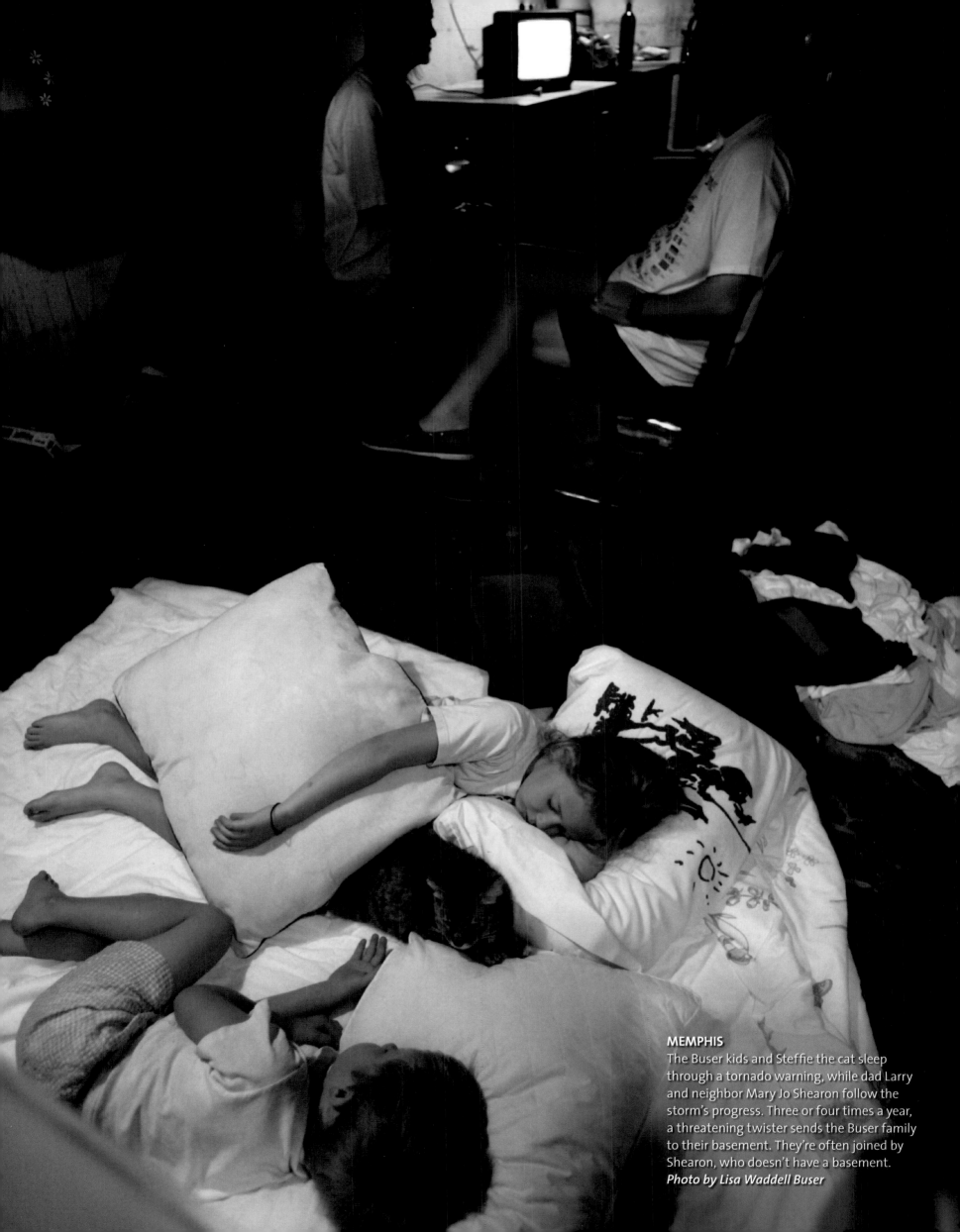

MEMPHIS
The Buser kids and Steffie the cat sleep through a tornado warning, while dad Larry and neighbor Mary Jo Shearon follow the storm's progress. Three or four times a year, a threatening twister sends the Buser family to their basement. They're often joined by Shearon, who doesn't have a basement.
Photo by Lisa Waddell Buser

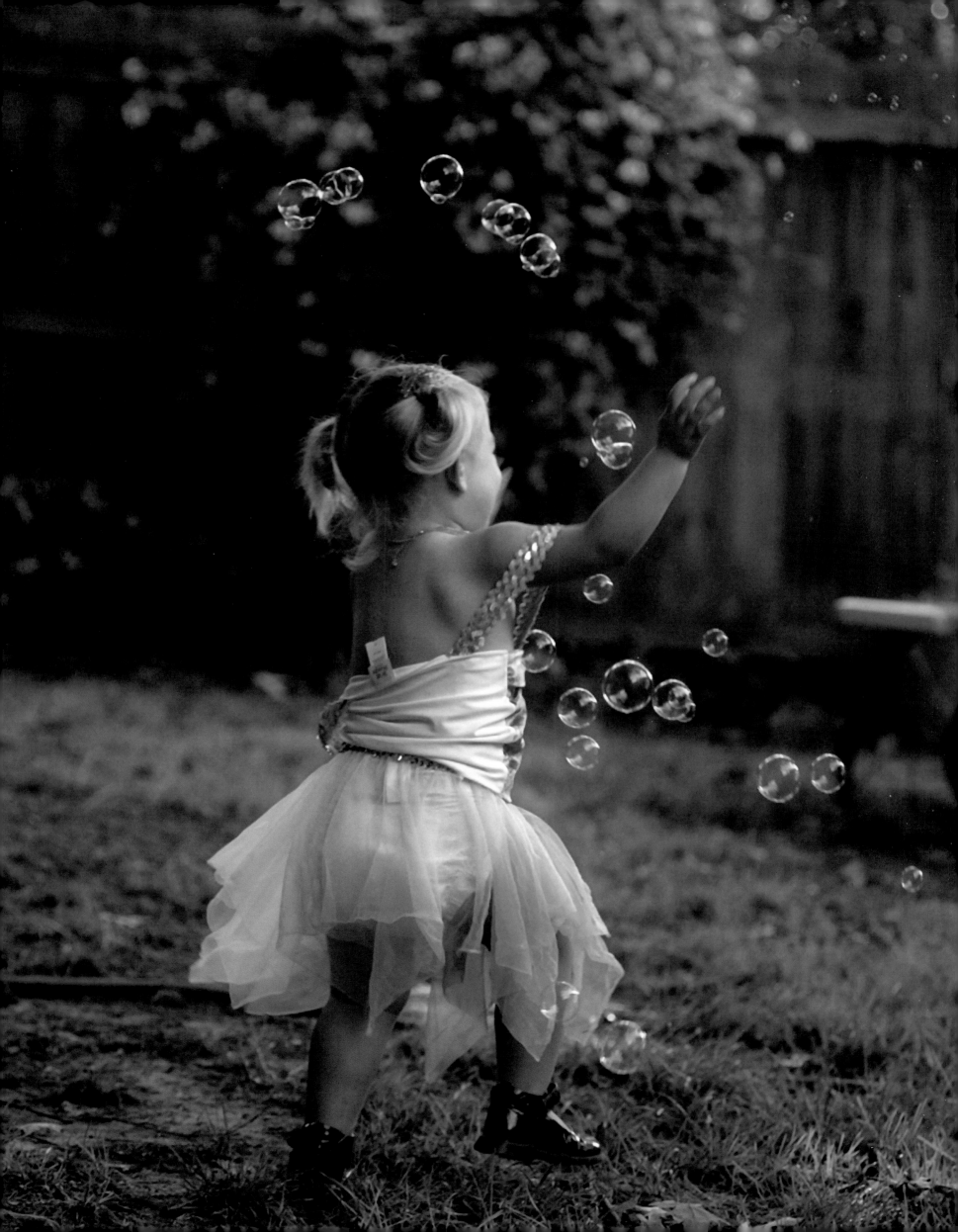

CORDOVA

Queen of her universe, aka the backyard, Elli Rose Focht dashes through a cascade of bubbles.
Photos by Karen Pulfer Focht

CORDOVA

A persistent, little 2-year-old alarm clock, Elli Rose rustles her sister Jessica out of bed for school.

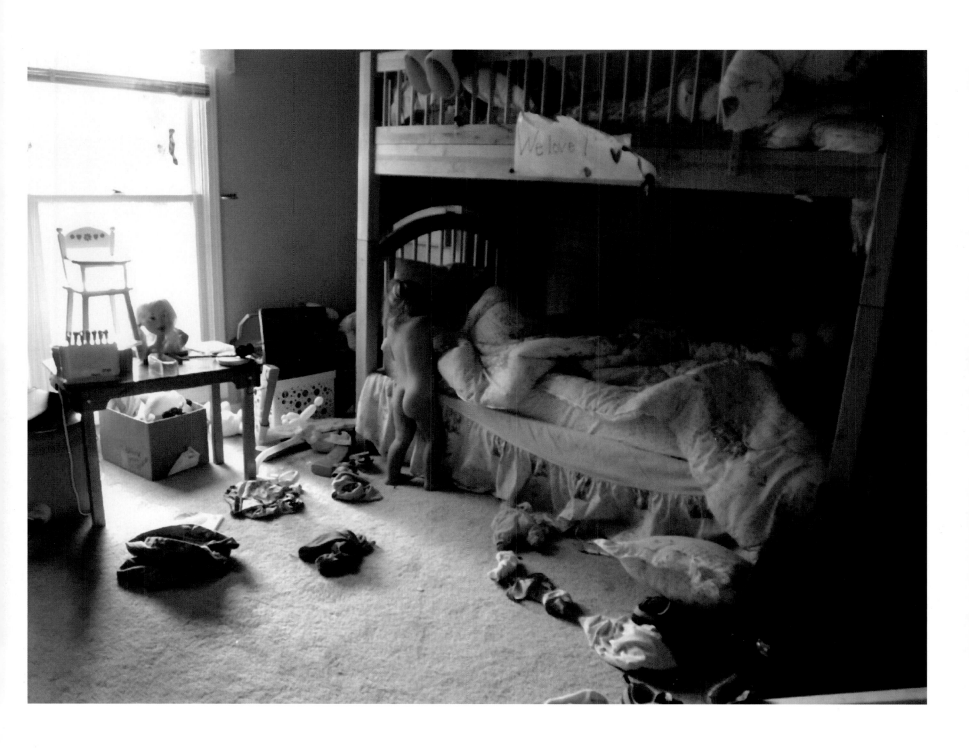

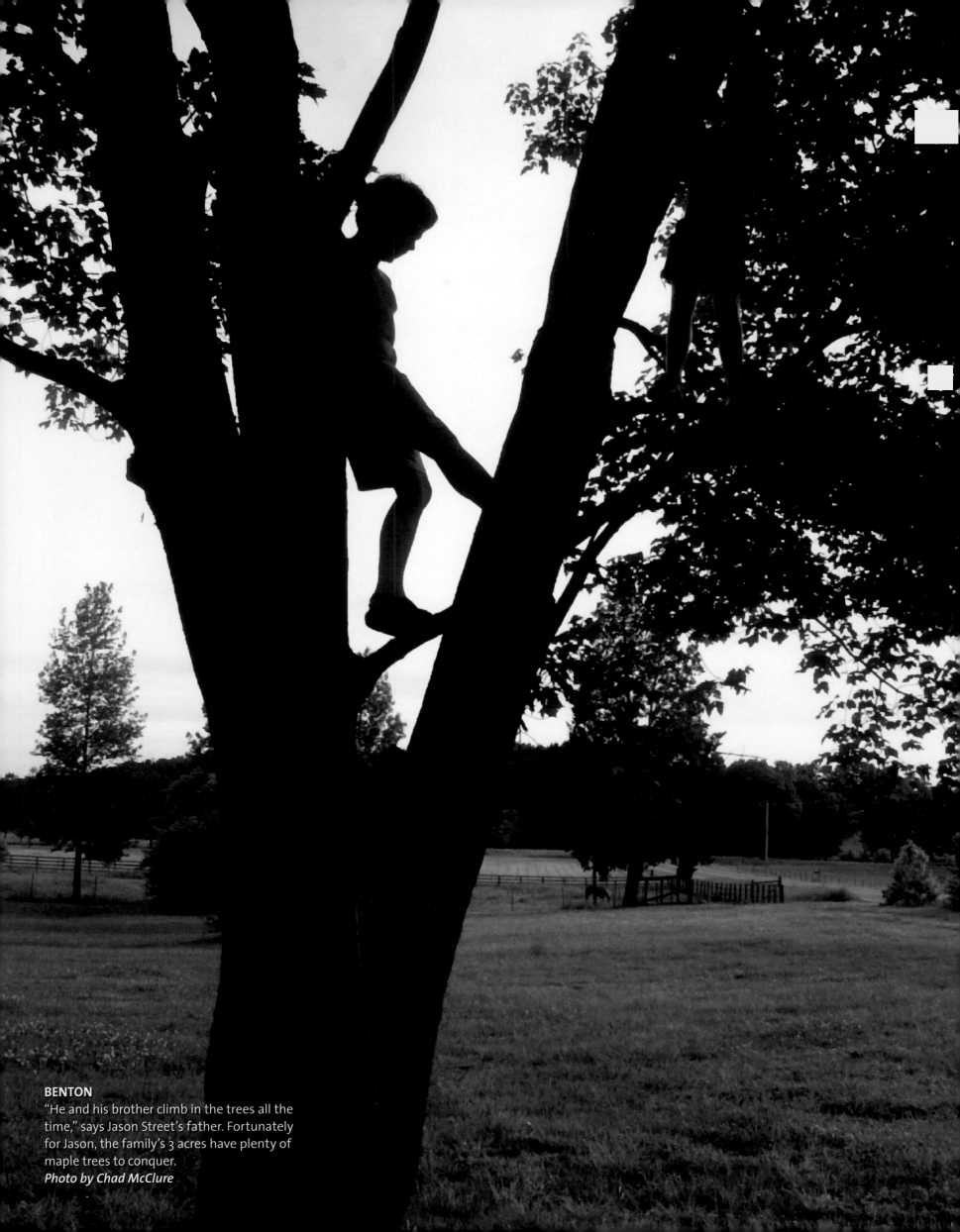

BENTON
"He and his brother climb in the trees all the time," says Jason Street's father. Fortunately for Jason, the family's 3 acres have plenty of maple trees to conquer.
Photo by Chad McClure

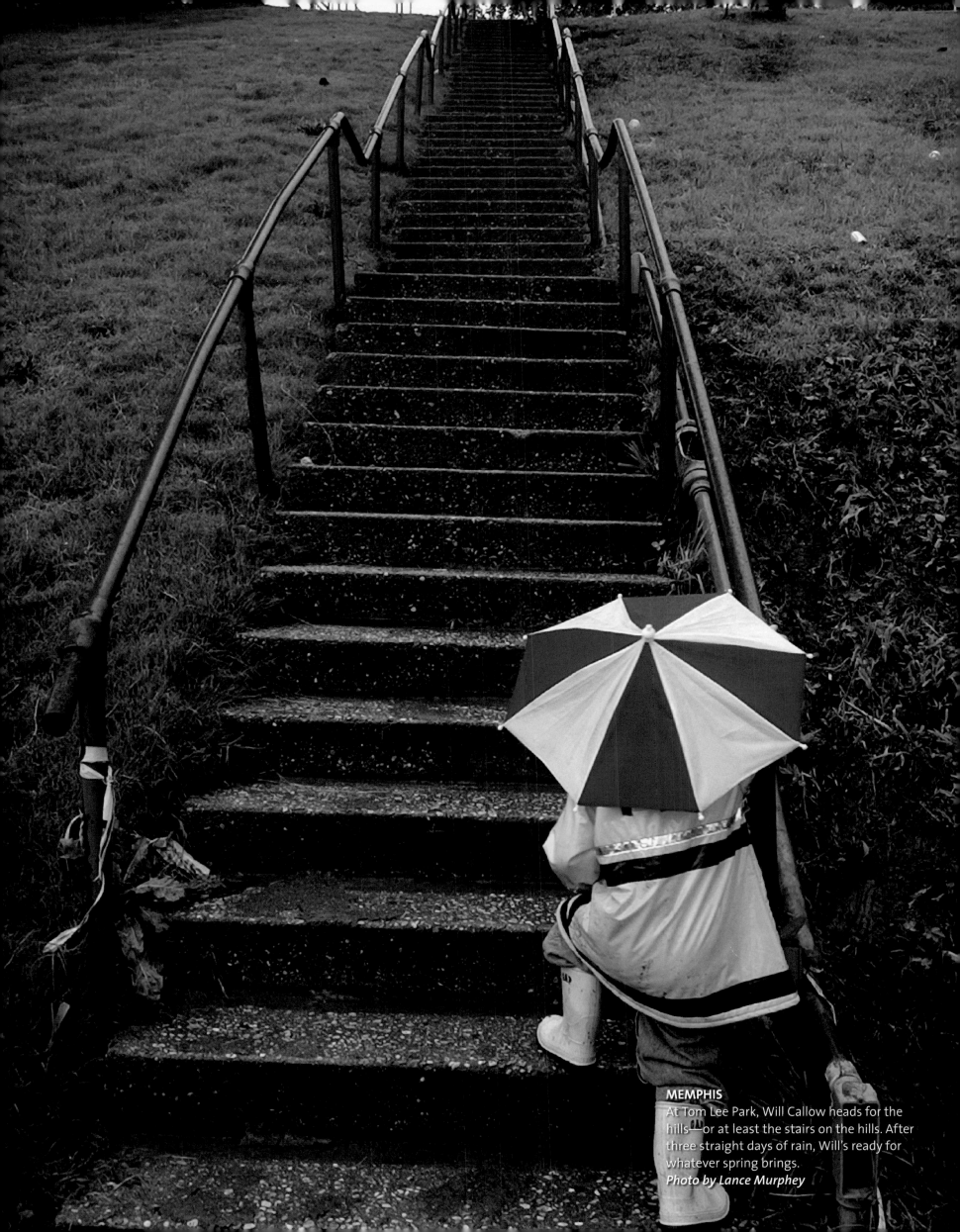

MEMPHIS
At Tom Lee Park, Will Callow heads for the hills—or at least the stairs on the hills. After three straight days of rain, Will's ready for whatever spring brings.
Photo by Lance Murphey

GREENEVILLE

The moment before the main event can make a flower girl jittery. Jessica Leigh Freshour peeks out to see how many people will watch her lead Debra Weems and her bridesmaids to the altar.
Photo by John E. May

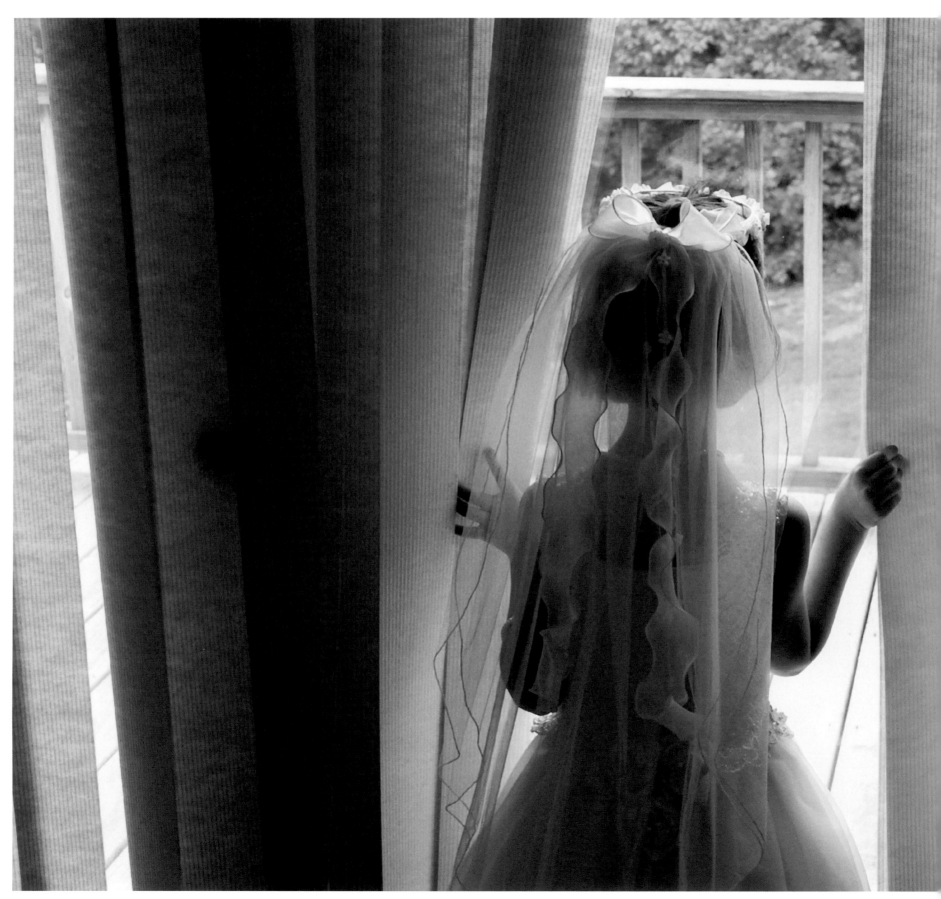

NASHVILLE
Fourteen-year-old Jenny Humphrey relies on her sister Kate, 17, for makeup and hair pointers before her first middle school dance. "I'm pleased the girls are becoming allies," their father Mark says, "and that Jenny turned to her older sister for help rather than mom and dad."
Photo by Mark Humphrey

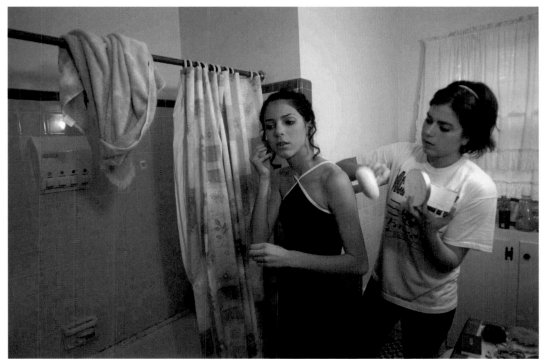

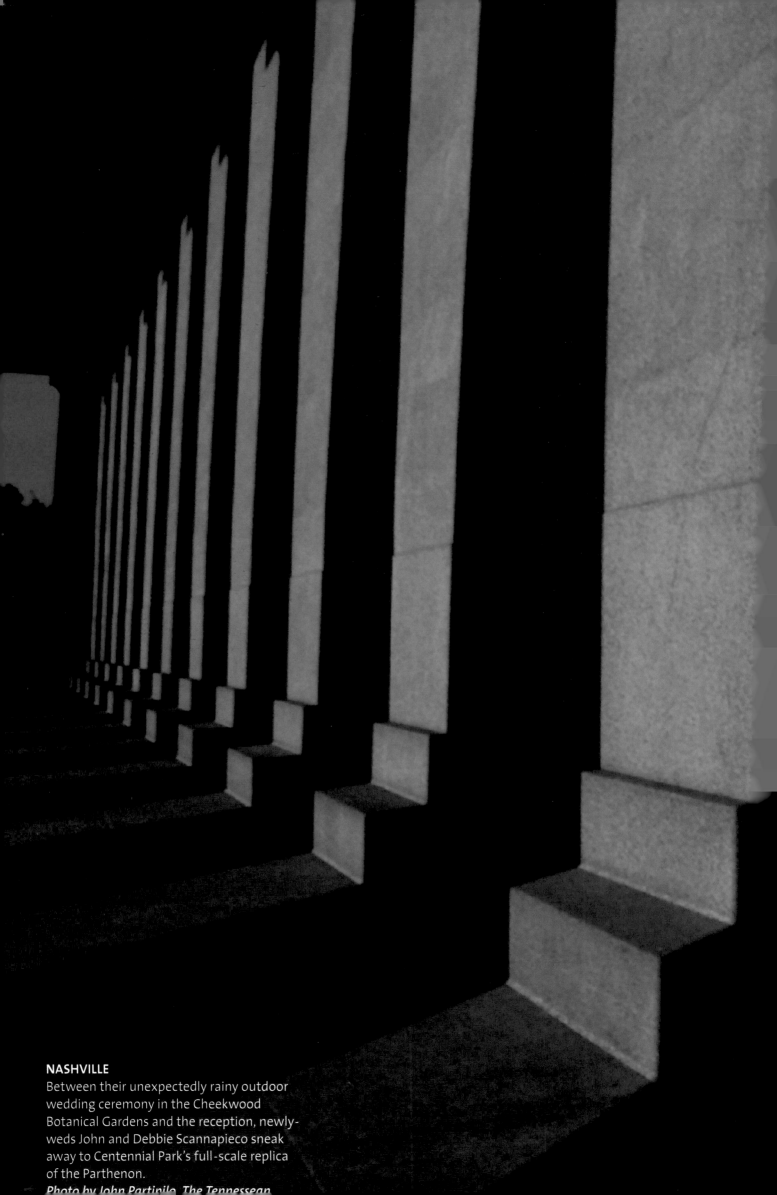

NASHVILLE
Between their unexpectedly rainy outdoor wedding ceremony in the Cheekwood Botanical Gardens and the reception, newly-weds John and Debbie Scannapieco sneak away to Centennial Park's full-scale replica of the Parthenon.

Photo by John Partipilo, The Tennessean

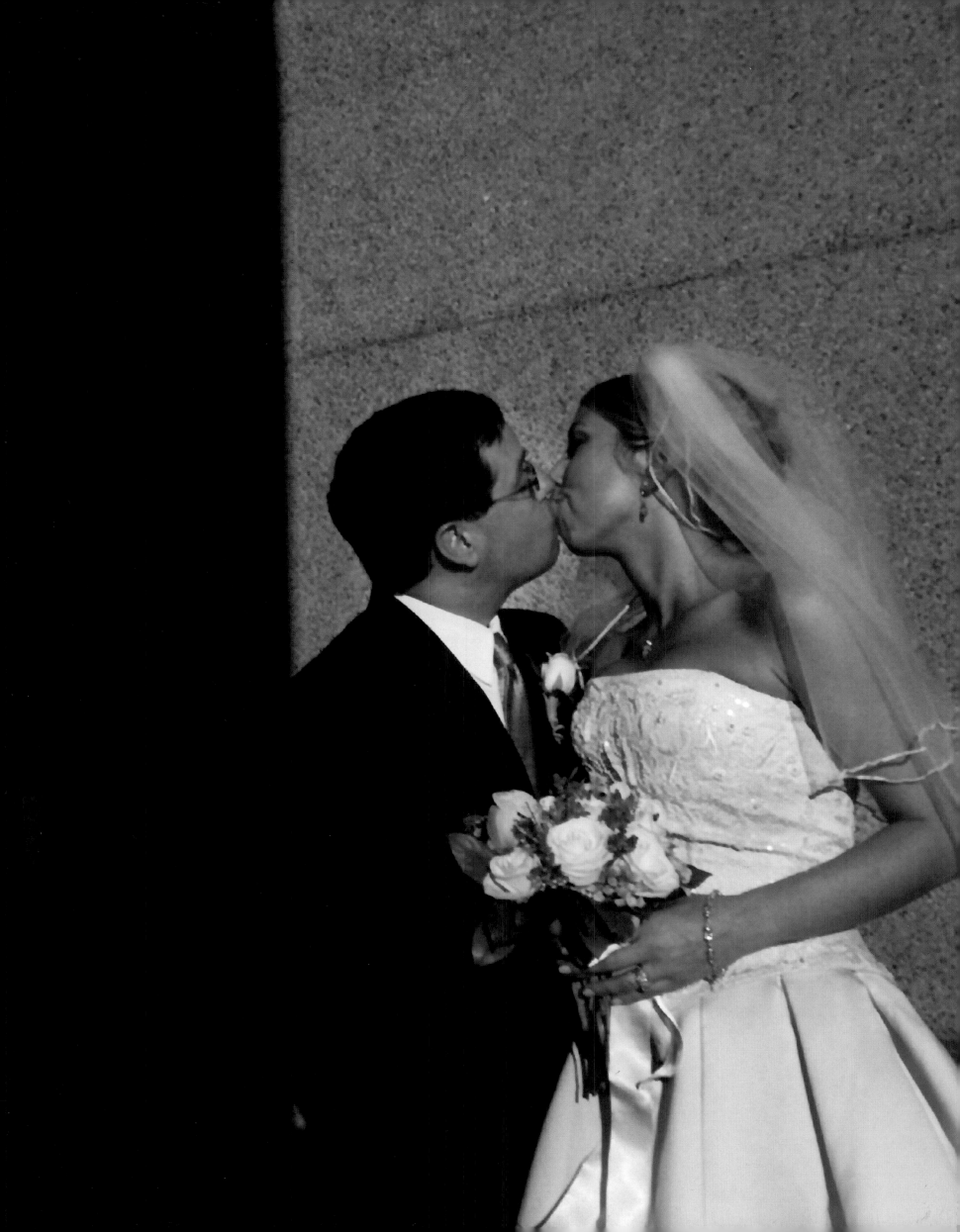

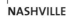

NASHVILLE

In 1988, years before they met and fell in love, Nehayet Abdulkadar and Gohdar Abdulkadir fled Saddam Hussein's Iraq. They spent more than two years in Turkish refugee camps and arrived in America in 1991. Like many Kurds, they made a new home in Nashville, site of America's largest Kurdish population (approximately 8,000).
Photos by John Partipilo, The Tennessean

NASHVILLE
Sitting beside his bride, Gohdar Abdulkadir savors the live, Kurdish music and dancing at his wedding celebration in Nashville's Edwin Warner Park.

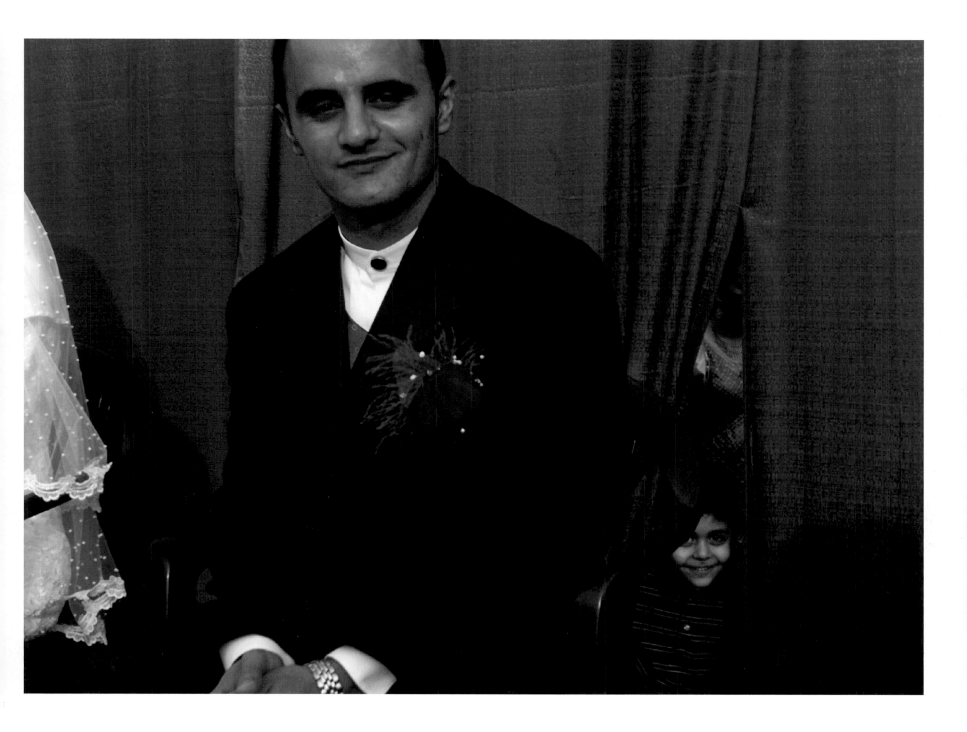

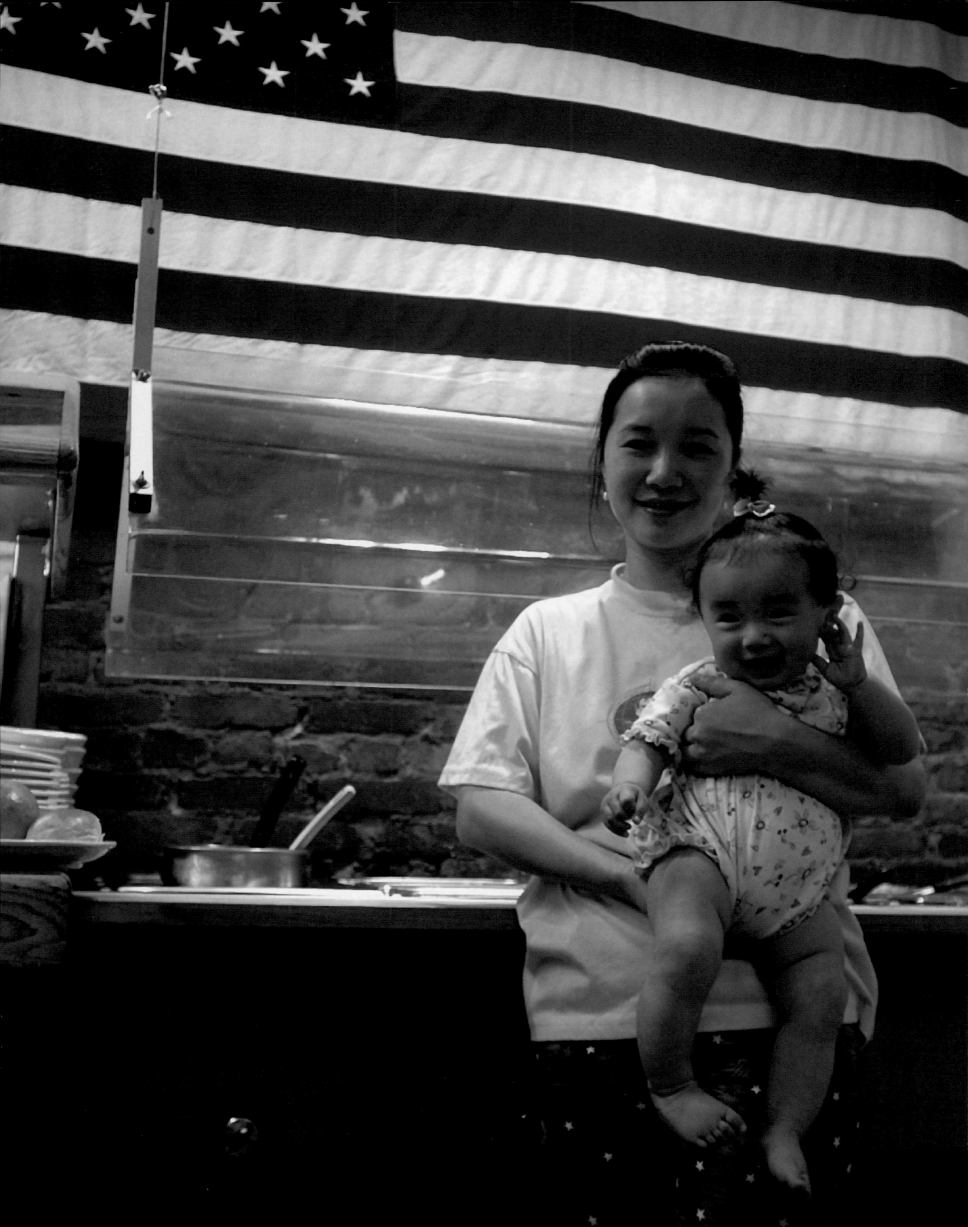

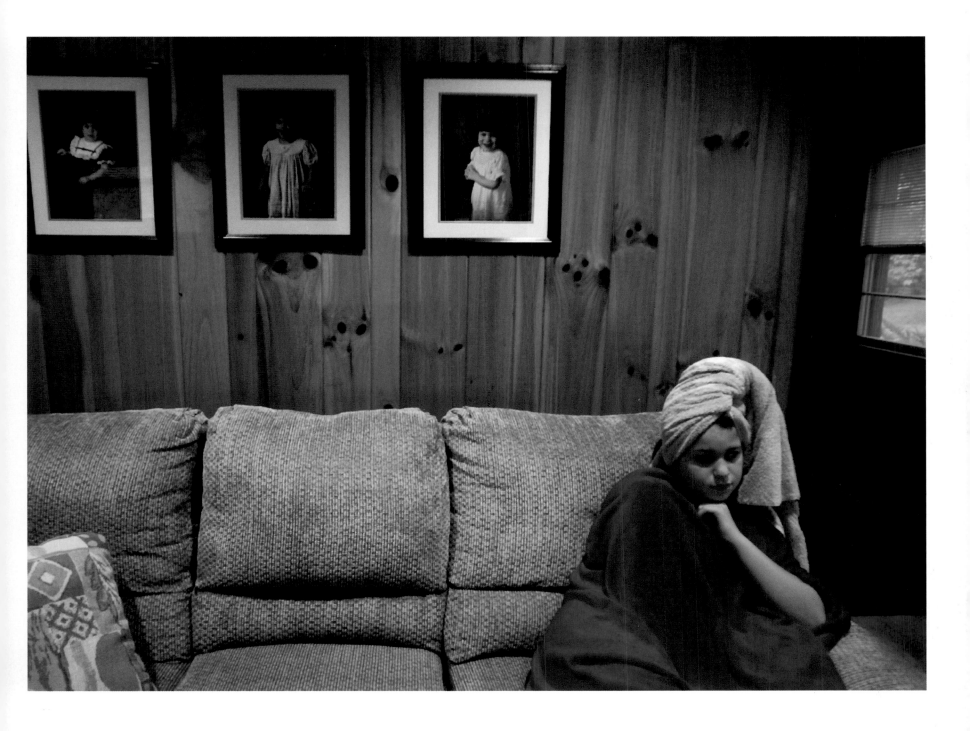

COLLIERVILLE

In 1993, Mississippi native Andy Chow opened the Café Grille, an "American home cooking" steak house. He and wife Helen, who is from Kaiping, China, were pen pals for five years before they met. She came to Tennessee in September 1996, and they married two months later. Helen and daughter Caitlin welcome customers to their restaurant on Collierville Square.

Photo by Alan Spearman

NASHVILLE

Ellen Humphrey likes routine. Up at 5:45 a.m., the 11-year-old allows enough time for a little TV and a relaxed breakfast before getting dressed and leaving for school. "She doesn't like to be rushed," says her dad Mark.

Photo by Mark Humphrey

CLARKSVILLE

When 8-year-old A.J. Prescott was born, the doctors said he would only live a couple years—he had a cleft pallet and small chest, compounded by dwarfism. But A.J., who now attends second grade at Moore Elementary School, proved them wrong.

Photos by John Russell, Maximum Exposure

CLARKSVILLE

Second-grade teacher Tammy McDowell reviews a math assignment with A.J. The school's worked hard to make A.J. feel independent. They've lowered his coat rack, built a special desk designed to grow with him, and added a stall with a small commode in the boys' bathroom.

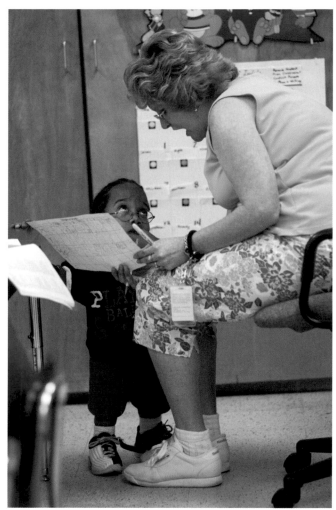

CLARKSVILLE

A... ptiches in on a batch of pancakes with his mom Ancrea Galbreath. He mixes the batter and pours; she flips. "There's very little he can't do," she says. "What he lacks in height, he makes up for in ego."

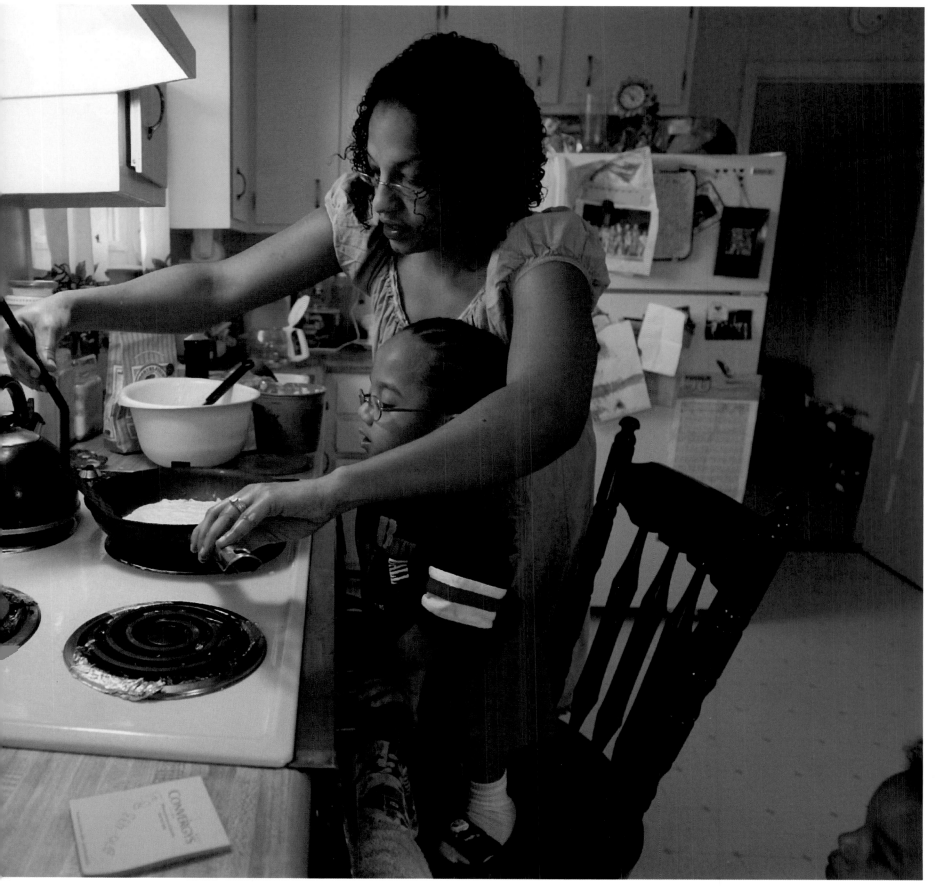

SEQUATCHIE VALLEY

A walk to his neighbor's land from his own 32 acres on the Sequatchie River reminds artist Andrew Saftel why his work increasingly reflects his environmental concerns. "Tennessee is so beautiful," he says. "But we've got all the issues— clear-cut logging with no regulations, industrial water pollution, the Oak Ridge nuclear plant."
Photos by Gary Heatherly

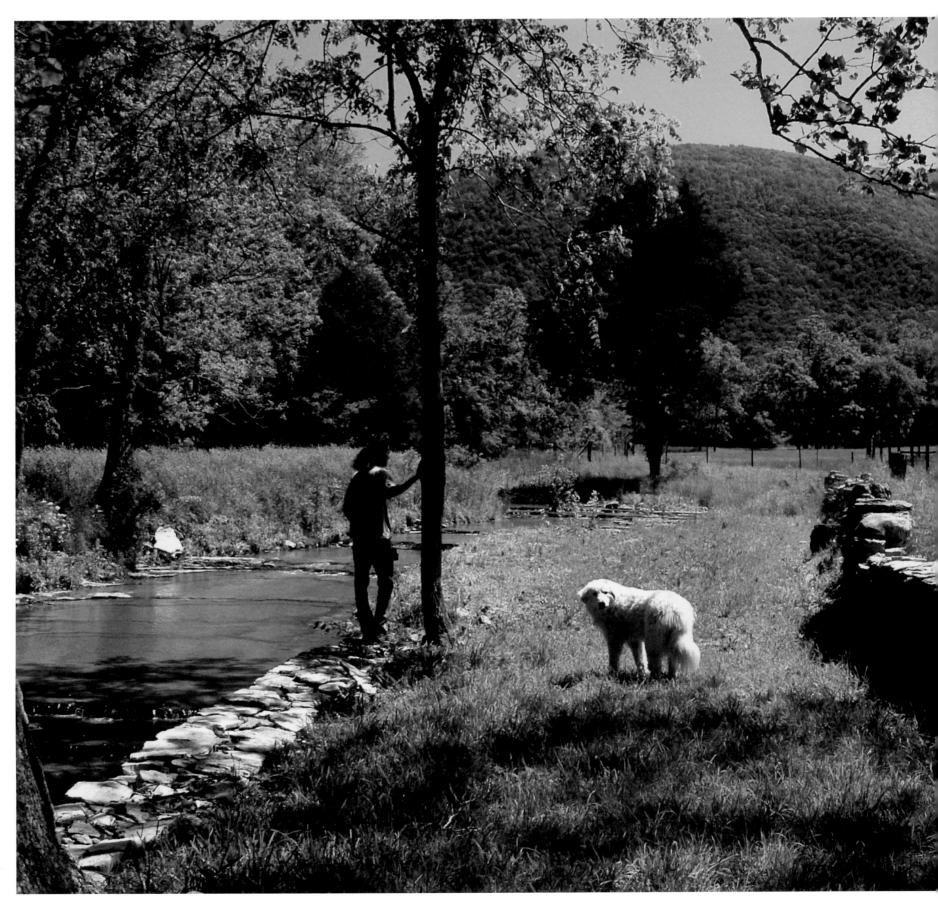

In his studio, Saftel works on a multimedia piece titled *A Place to Live*, which is destined for a Florida gallery. He pencils in these words adjacent to his drawing of an owl: "Homeless great horned owl needs a place to live in the woods."

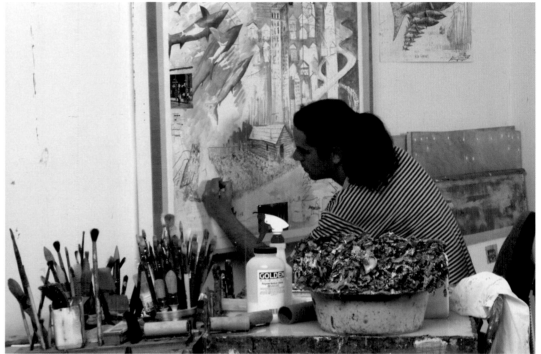

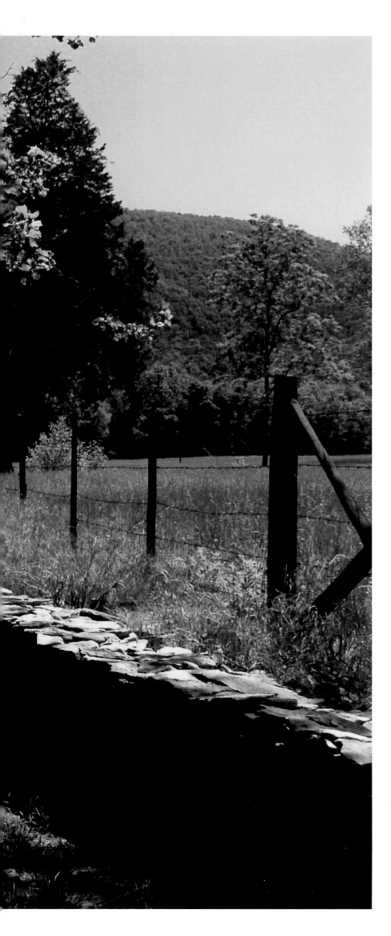

MILLERSVILLE

Jesse Corn (taking photo), his first cousin April Brown, and her son Drew all live on Grandpa Jack Corn's 200-acre farm. Corn set aside his land as a wildflower preserve ten years ago. Thanks to efforts like his, the once-endangered Tennessee coneflower has rebounded.
Photos by Jack Corn

MILLERSVILLE

Eleven-year-old Jesse Corn has been driving for a year. He cruises around his grandpa's farm in a pickup and also has gotten pretty good at bush-hoggin' a field (cutting down the brush). "All the farm kids drive," says Grandpa Jack. "You put 'em in an open field. They go slow and don't hit anything. They learn pretty quick that way."

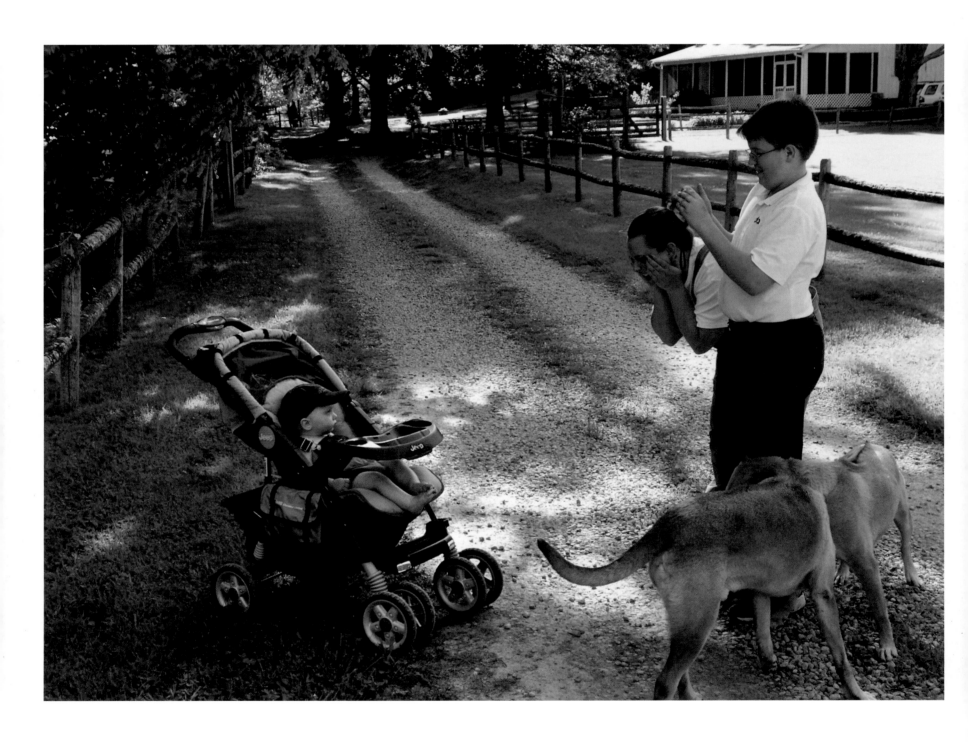

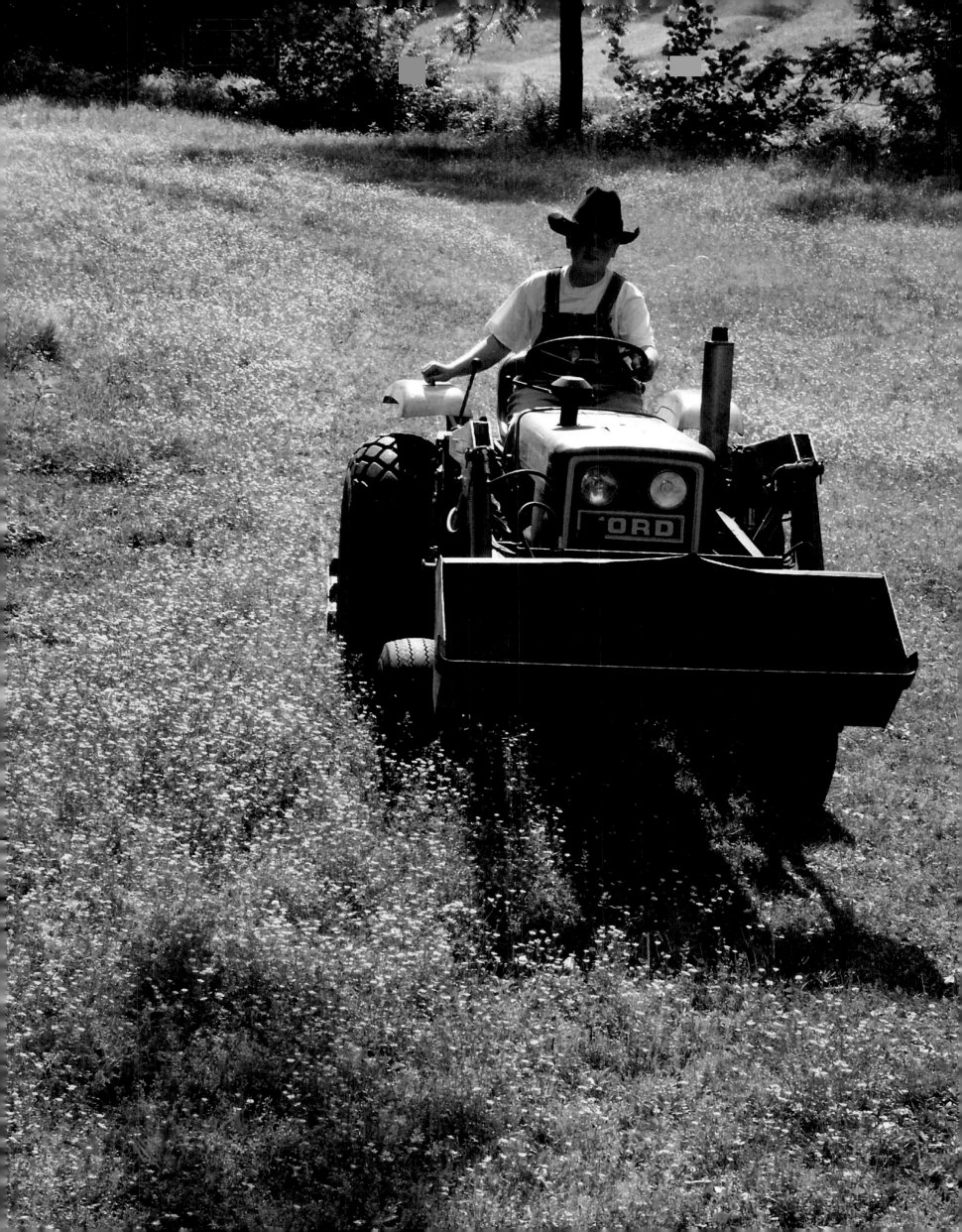

MEMPHIS
Marlon Johnson is glad mom's hair is starting to
grow back after a recent leukemia treatment.
April Johnson, 21, who has been fighting cancer
since she was 14, is staying with her family at
Target House in a free two-bedroom apartment
run by St. Jude Hospital.
Photo by Karen Pulfer Focht

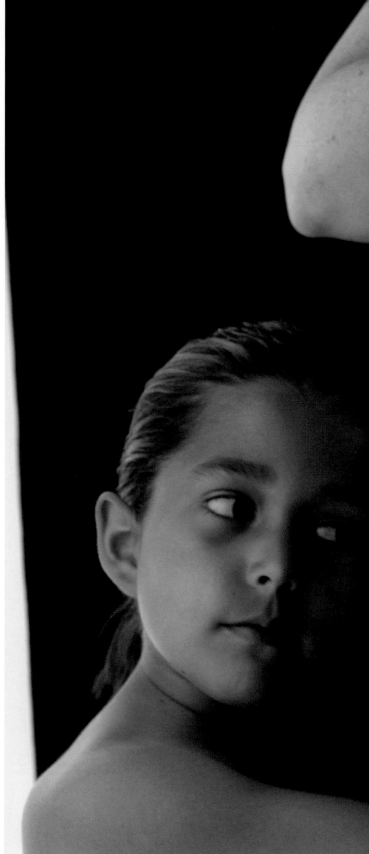

NASHVILLE
Family portrait. Autrianna Mae Contreras won-
ders: What does a new sister sound like?
Photo by Dean Dixon

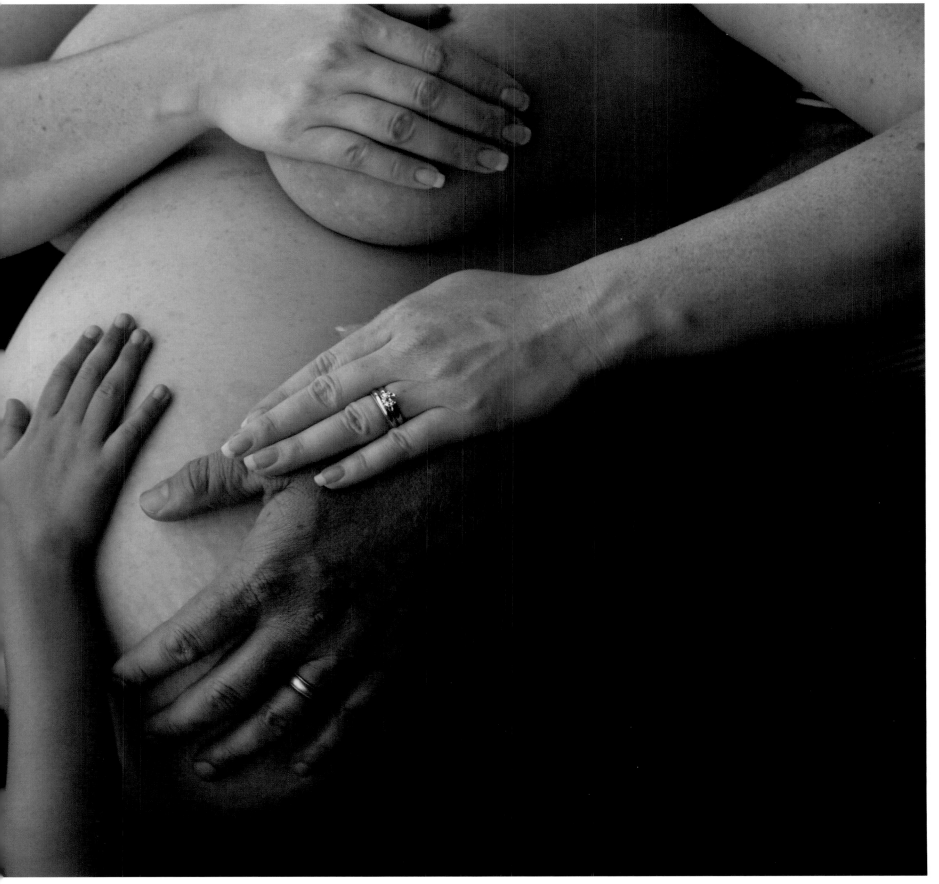

The year 2003 marked a turning point in the history of photography: it was the first year that digital cameras outsold film cameras. To celebrate this unprecedented sea change, the *America 24/7* project invited amateur photographers—along with students and professionals—to shoot and, via the Internet, submit digital images. Think of it as audience participation. Their visions of community are interspersed with the professional frames throughout this book. On the following four pages, however, we present a gallery produced exclusively by amateur photographers.

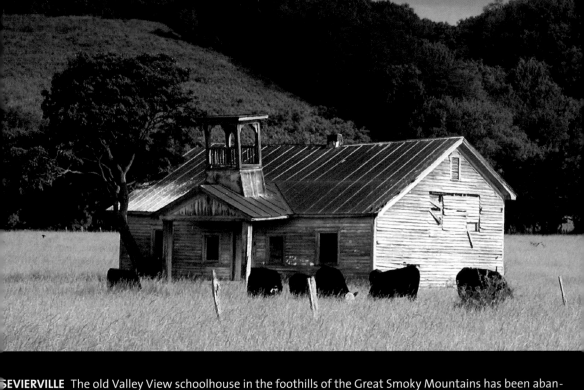

SEVIERVILLE The old Valley View schoolhouse in the foothills of the Great Smoky Mountains has been abandoned for more than 50 years. The remaining "students" enjoy the school's free lunch program.
Photo by Richard Vance

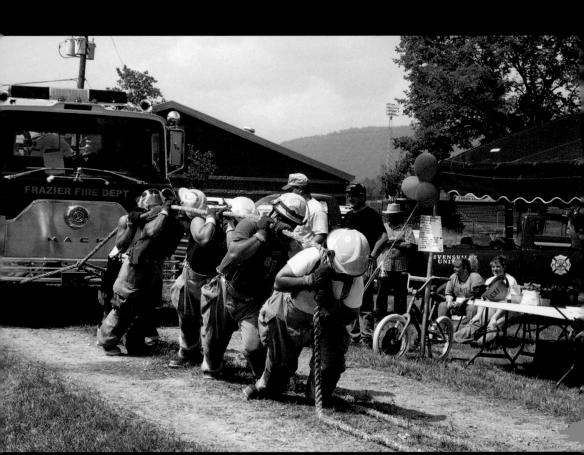

EVENSVILLE Where's the fire? Frazier volunteer firefighters lean into a pumper pull during the Rhea County firefighter jamboree. The guys dragged the 12-ton fire truck for 10 feet. *Photo by Margie Hodge*

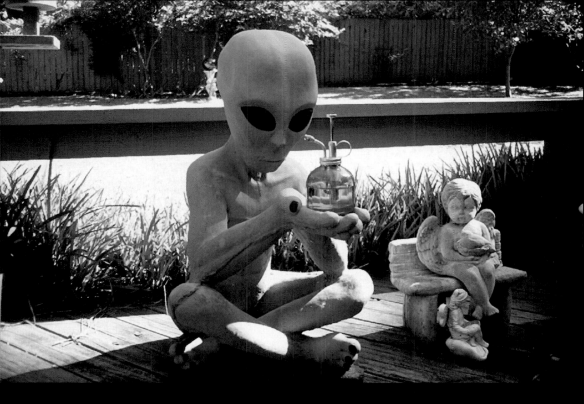

MEMPHIS A backyard in White Station poses the question: If plants had guardian spirits, would they be human, angelic, or alien? *Photo by Dave Hymel*

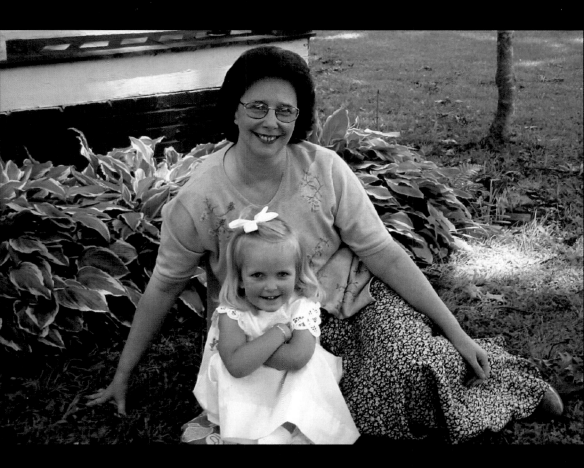

BEMIS The home beauty shop Susan Maynard inherited makes her feel connected to the folks who were her mom's customers. It also gives her the flexibility to spend an afternoon in the shade of an old pin oak with granddaughter Chloe. *Photo by Ray Maynard*

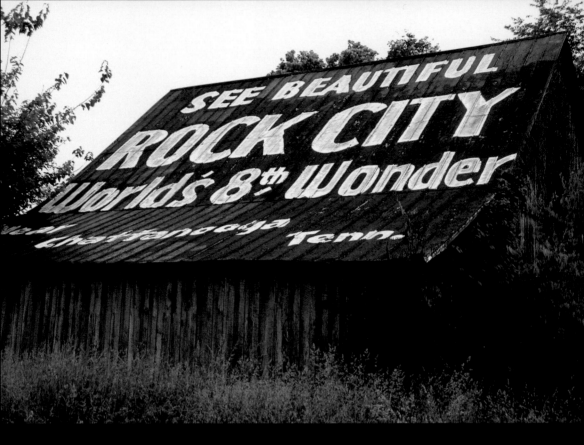

CLARKSVILLE Between 1935 and 1970, Clark Byers and his crew painted 900 signs on barn roofs to lure visitors to Rock City's caves, waterfalls, and rock formations atop Lookout Mountain. *Photo by David Tallon*

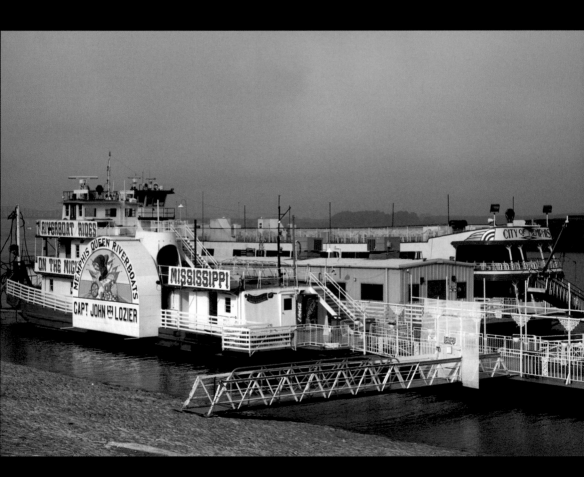

MEMPHIS Rained out: At the Memphis in May International Festival, the *City of Memphis* party boat offers cruises around Memphis Harbor. *Photo by Rickey Newell*

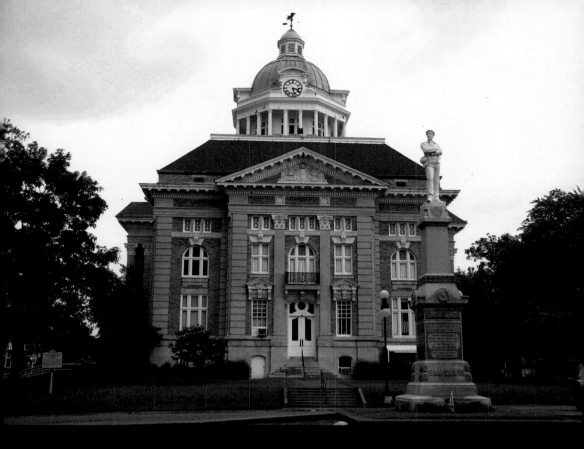

PULASKI The Giles County Courthouse was built for $97,600 in 1909. Citizens were so upset at the cost that they voted the commissioners out of office. These days, residents are proud of the building.
Photo by Gina Collins

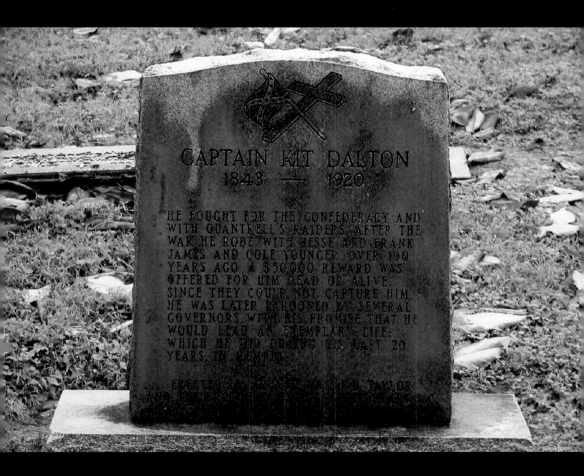

CAPTAIN KIT DALTON
1843 — 1920

HE FOUGHT FOR THE CONFEDERACY AND
WITH QUANTRELL'S RAIDERS. AFTER THE
WAR HE RODE WITH JESSE AND FRANK
JAMES AND COLE YOUNGER. OVER 100
YEARS AGO A $50,000 REWARD WAS
OFFERED FOR HIM DEAD OR ALIVE.
SINCE THEY COULD NOT CAPTURE HIM,
HE WAS LATER PARDONED BY SEVERAL
GOVERNORS WITH HIS PROMISE THAT HE
WOULD LEAD AN EXEMPLARY LIFE;
WHICH HE DID DURING HIS LAST 20
YEARS IN MEMPHIS.

MEMPHIS At Elmwood Cemetery, Kit Dalton—Jesse James gang member, Confederate raider, and Cuban army

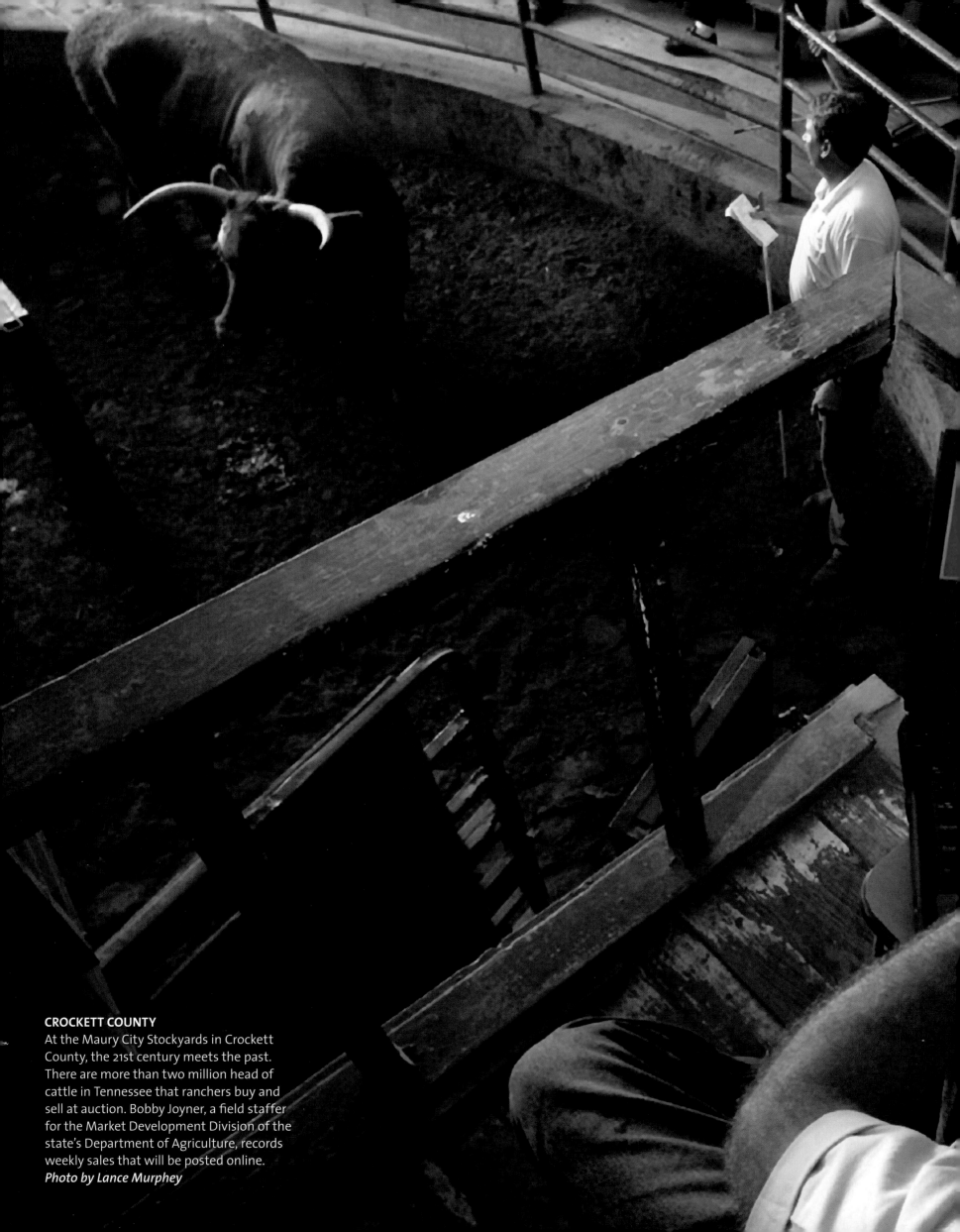

CROCKETT COUNTY

At the Maury City Stockyards in Crockett County, the 21st century meets the past. There are more than two million head of cattle in Tennessee that ranchers buy and sell at auction. Bobby Joyner, a field staffer for the Market Development Division of the state's Department of Agriculture, records weekly sales that will be posted online.
Photo by Lance Murphey

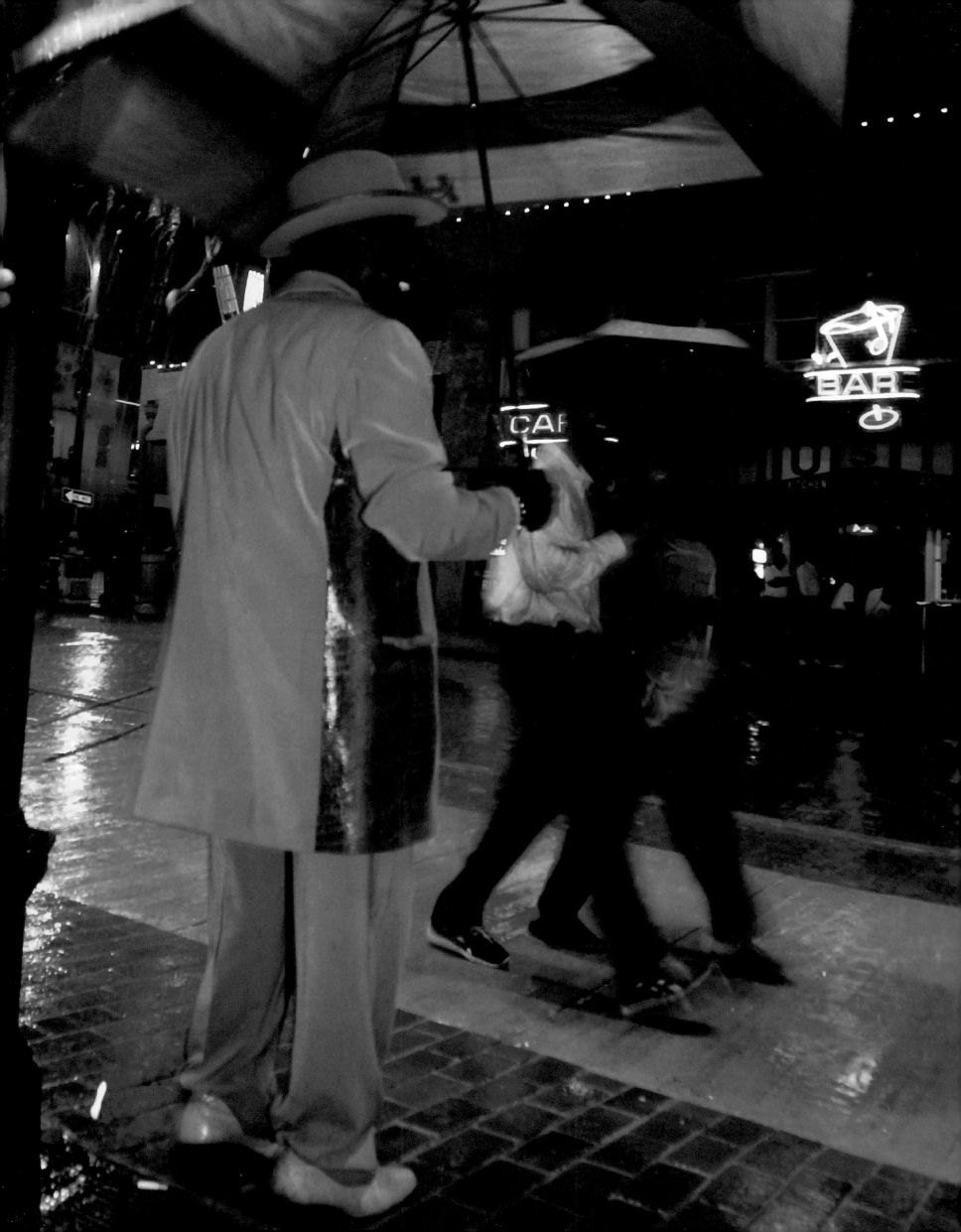

MEMPHIS

Outside B.B. King's Blues Club on Beale Street, barker Charles Paige tries to snag customers who rush by on a stormy night. Paige is the self-proclaimed "ambassador of blues" on the historic street, which is, at once, the home of the blues and the birthplace of rock 'n' roll.

Photo by Karen Pulfer Focht

GERMANTOWN

Plumber Terry Crowell checks in with his partner as they take a measurement to cut a piece of pipe. They are working on the Germantown United Methodist Church, roughing in the underground piping for a new addition.

Photo by Bruce Meisterman

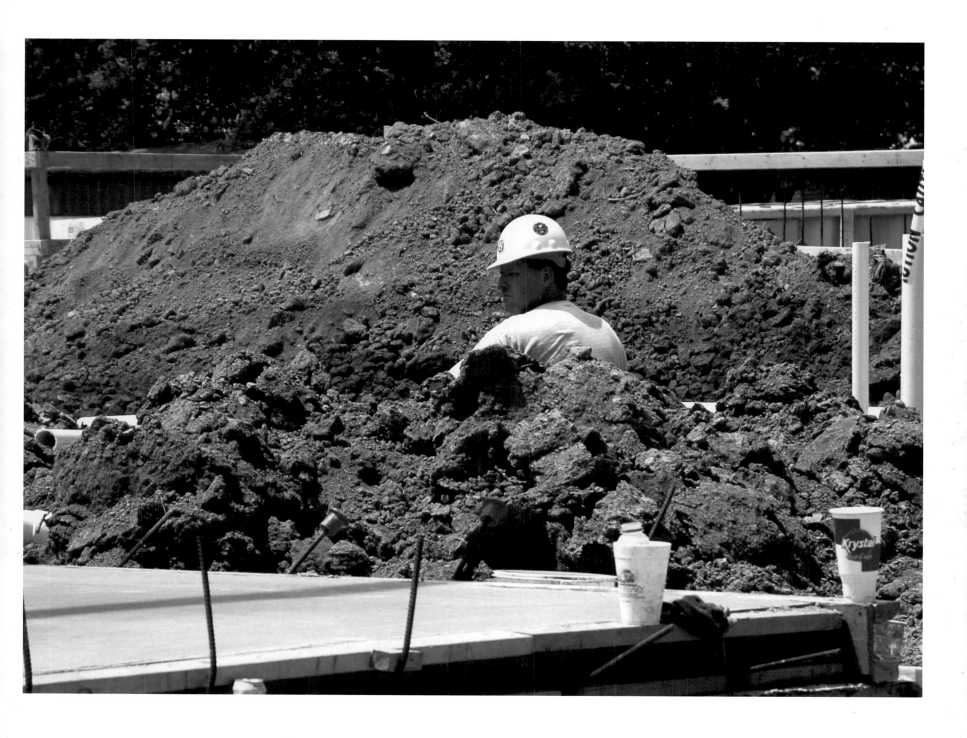

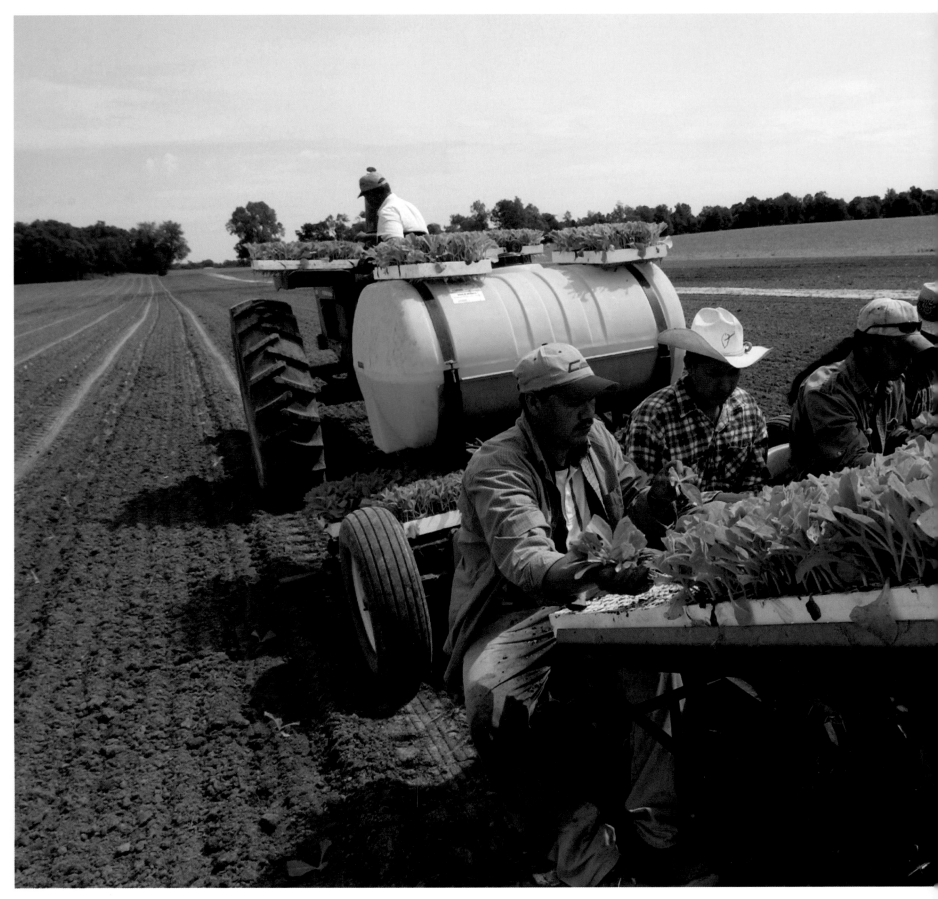

SPRINGFIELD
Banie Robertson tows his workers as they plant tobacco seedlings, a process called "setting." A fourth-generation tobacco farmer, Robertson works 50 acres north of Nashville. Like many small growers, he struggles to keep his business viable, buffeted by increased regulation, overseas competition, and falling profits.
Photo by Rusty Russell

CROSS PLAINS

Rusty Graves raises tobacco seedlings in the protective environment of his green house. The fragile young plants are difficult to grow in the field and very susceptible to blue mold, a fungus that thrives in cool, wet weather. Graves plants half of the seedlings on his 6 acres and sells the other half to tobacco farmers.
Photo by Jack Corn

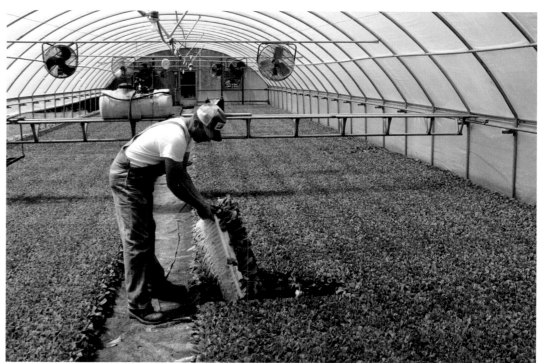

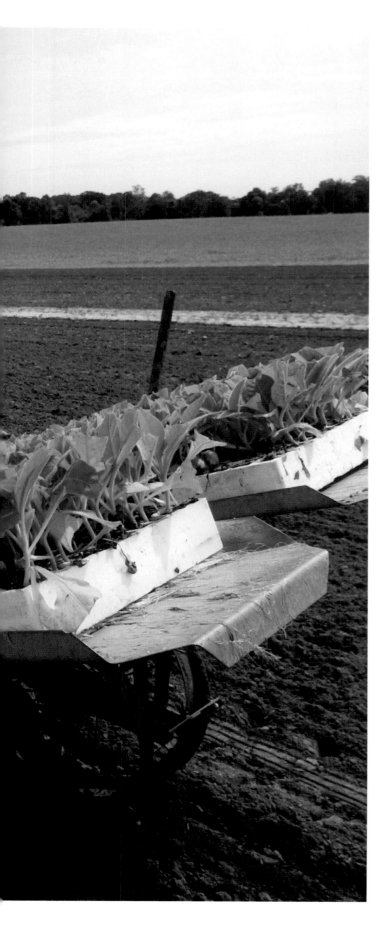

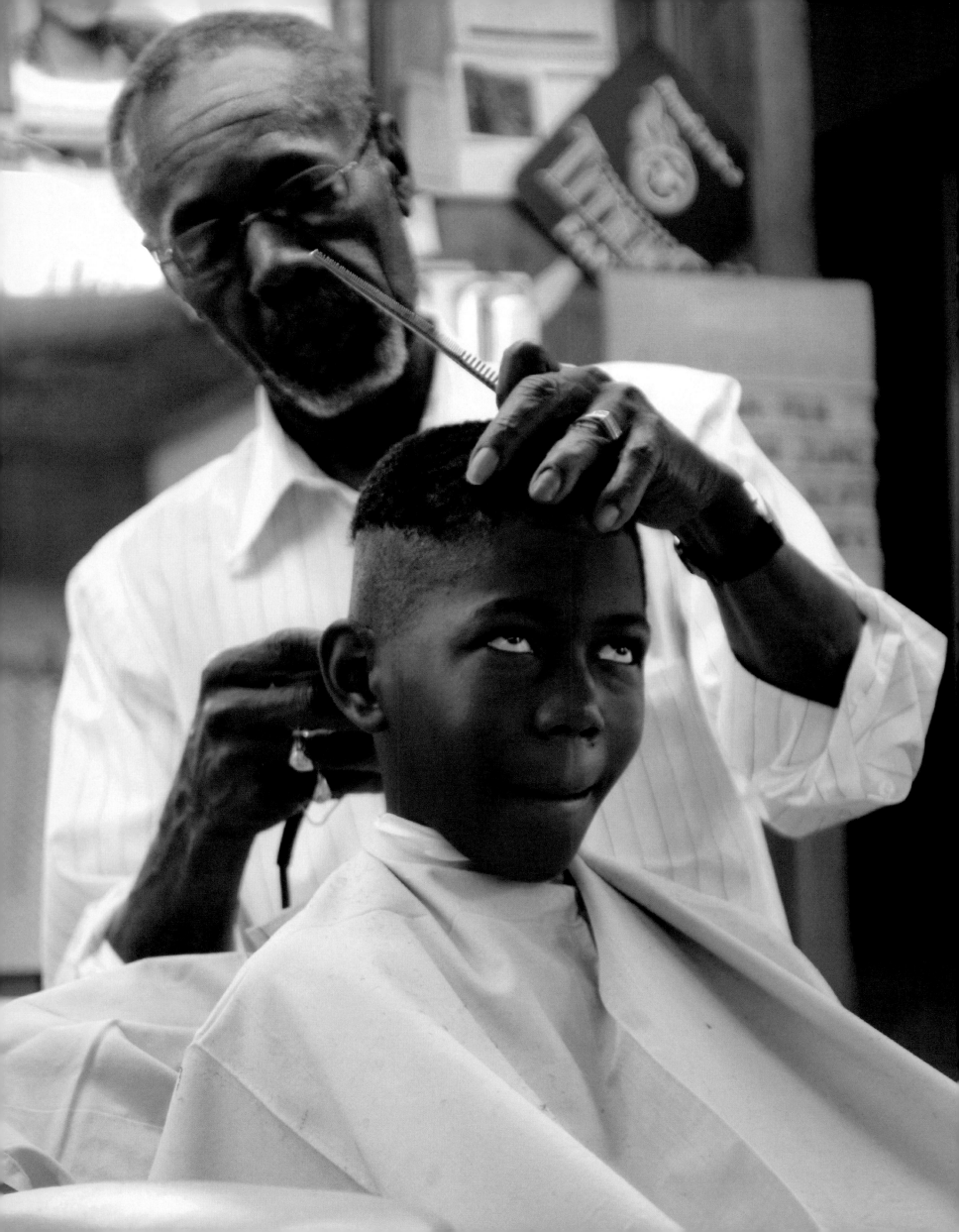

NASHVILLE

Branford Shaw gets a razor cut from Vernon Winfrey, who likes to give more than a haircut. "I try to share some inspiring words, especially with the young folks," says Winfrey. Despite the monumental success of his daughter, Oprah, the barber is still at it, because, he says, "My work is rewarding."

Photos by Dean Dixon

NASHVILLE

Saturday mornings are busy at Winfrey's Barber Shop, even with three chairs. Operating the same shop for 40 years, Winfrey has seen the styles change—college cuts in the 60s, afros in the 70s. "Afros weren't so good for barbers," he says. "Customers only came in twice a year to clip the split ends."

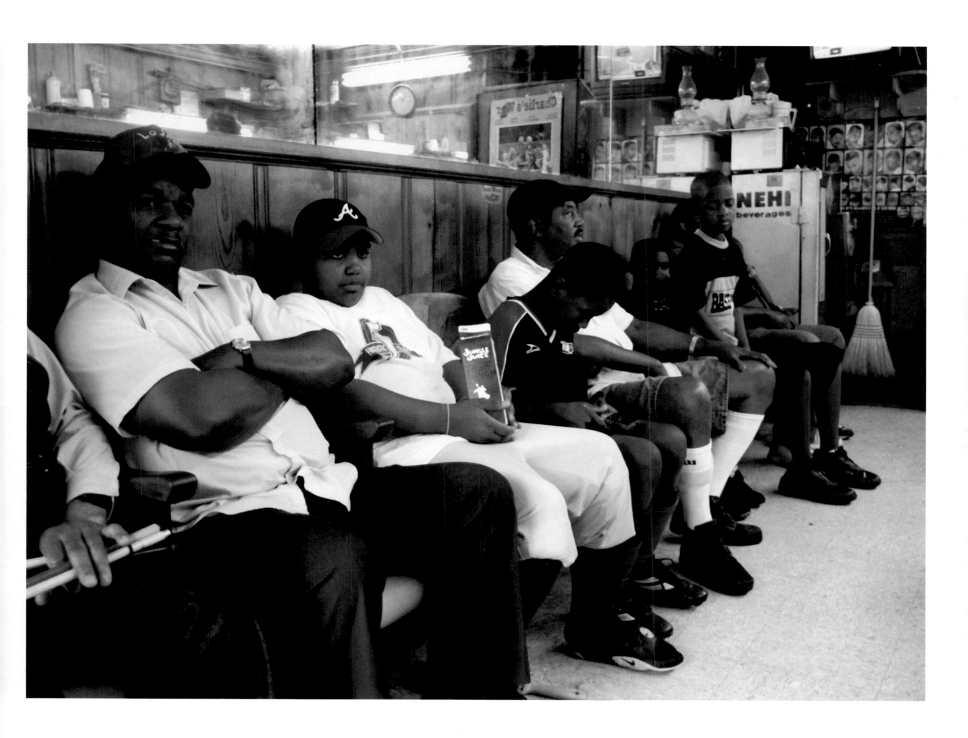

SELMER

Broom corn is a variety of sorghum, grown for its sturdy stalks. It is similar to corn but without ears.

Photos by Karen Pulfer Focht

SELMER

A new broom sweeps clean: Some folks assign magical properties to brooms, claiming a well-made brush can sweep away negativity. But most of the brooms made by Jack Martin of Hockaday Handmade Brooms—aside from the Harry Potter model—are just used to sweep floors, sidewalks, and hearths.

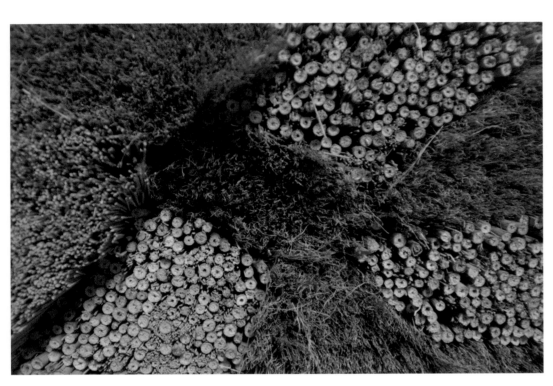

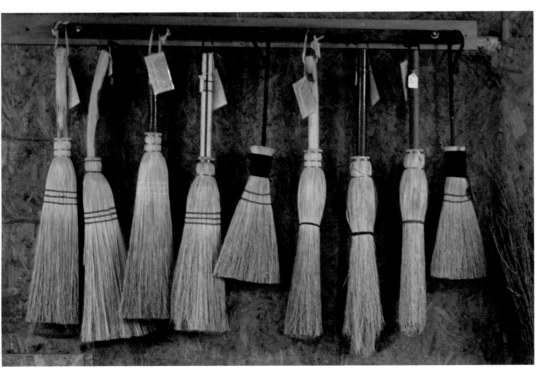

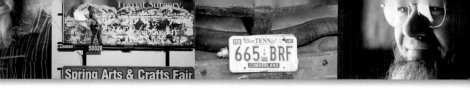

SELMER

Jack Martin makes corn brooms on a "kicker table," a broom-wrapping contraption built by his great-grandfather. "It takes me five months and 45 minutes to make every broom," he says. "That's five months to grow and harvest the broomcorn, and 45 minutes to put the broom on the handle." Martin is teaching his grandkids how to build a good broom.

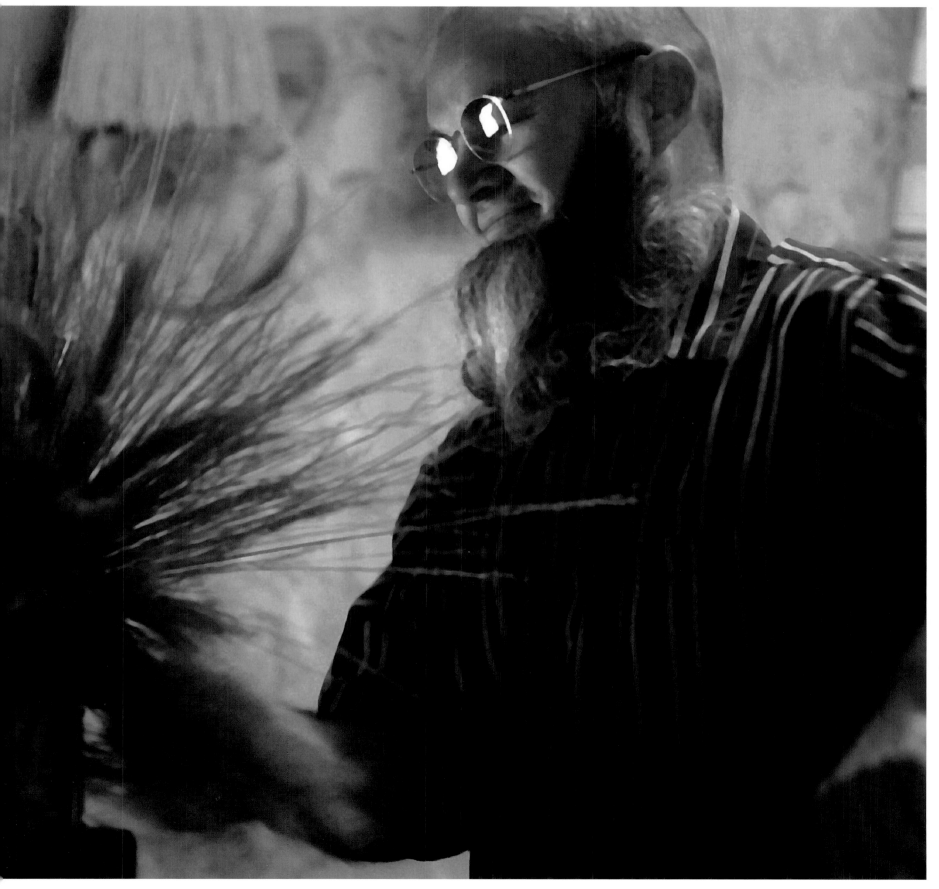

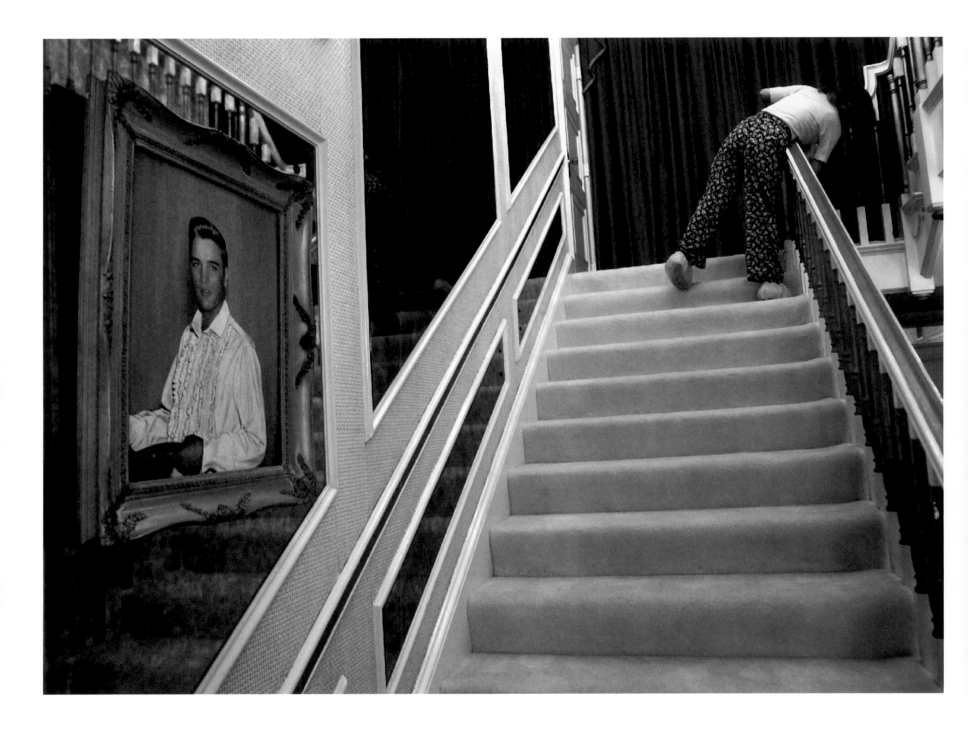

COLLIERVILLE

Peter Hellwig emigrated from Germany in 1957 to work on a cotton farm. "Europe is too small," he says. "I wanted to go someplace where I had a chance to get my own place." In 1963, he bought the small farm where he now raises 40 head of Piedmontese cattle for their low-cholesterol meat and a few dairy cows for raw milk.
Photo by A.J. Wolfe

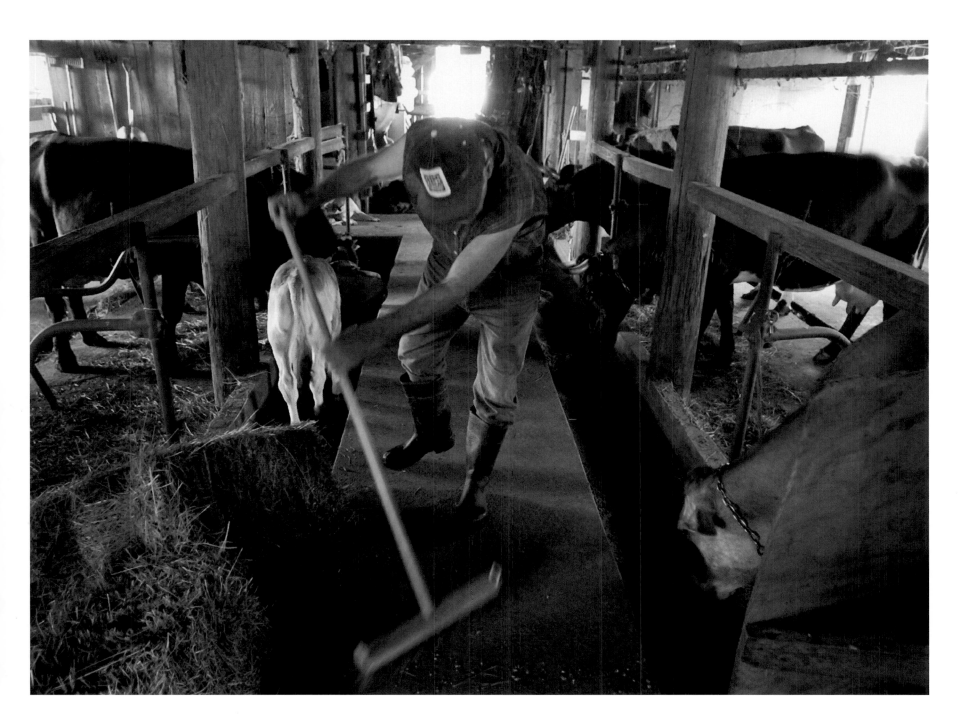

CHATTANOOGA
Before her annual checkup at the Chattanooga
Zoo, Sasha, an aggressive 15-year-old jaguar, is
tranquilized. Once she is asleep, zoo veterinarian
Dr. Charles Myers performs many of the same
procedures he would on a house cat: vaccinating,
taking blood, and cleaning her teeth.
Photo by Billy Weeks

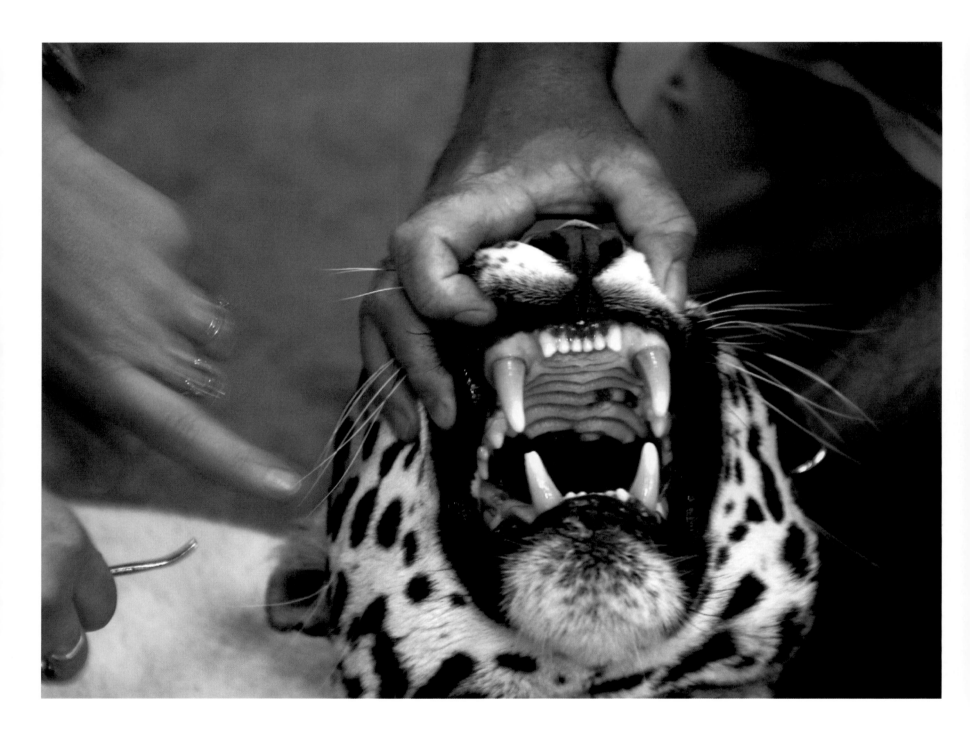

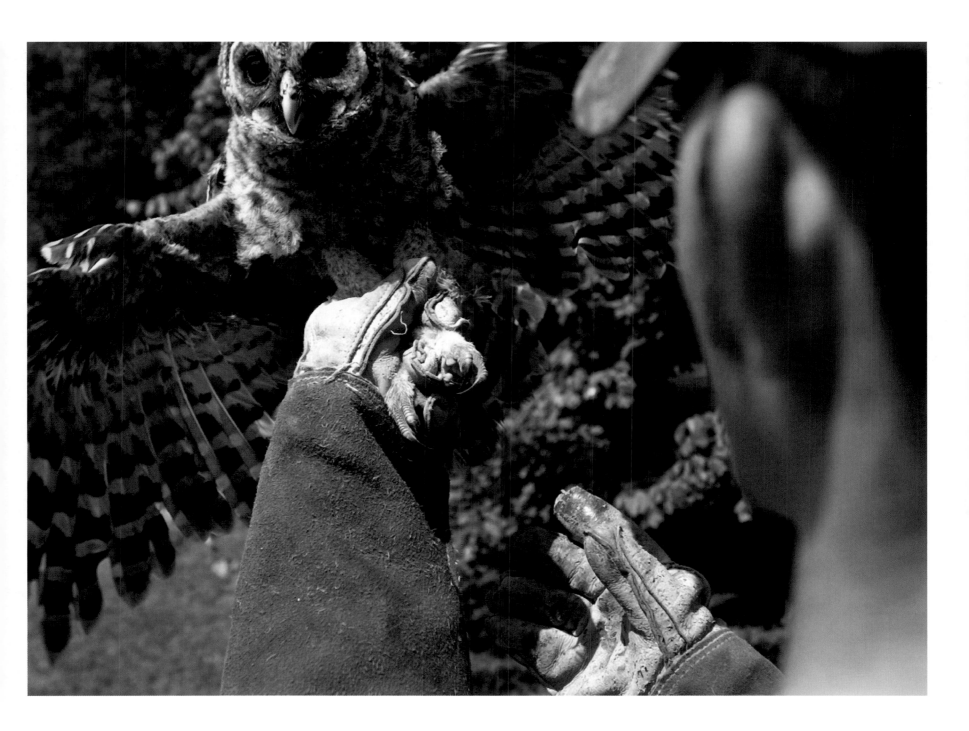

TIPTONVILLE

Naturalist John Bass handles a young barred owl at the Reelfoot Lake State Park. The owlet fell out of its nest and is being raised by Bass and his park colleagues. The park, popular with campers, hunters, and canoeists, shelters thousands of birds and waterfowl including ducks, herons, and, in the winter, approximately 200 bald eagles.
Photo by Lance Murphey

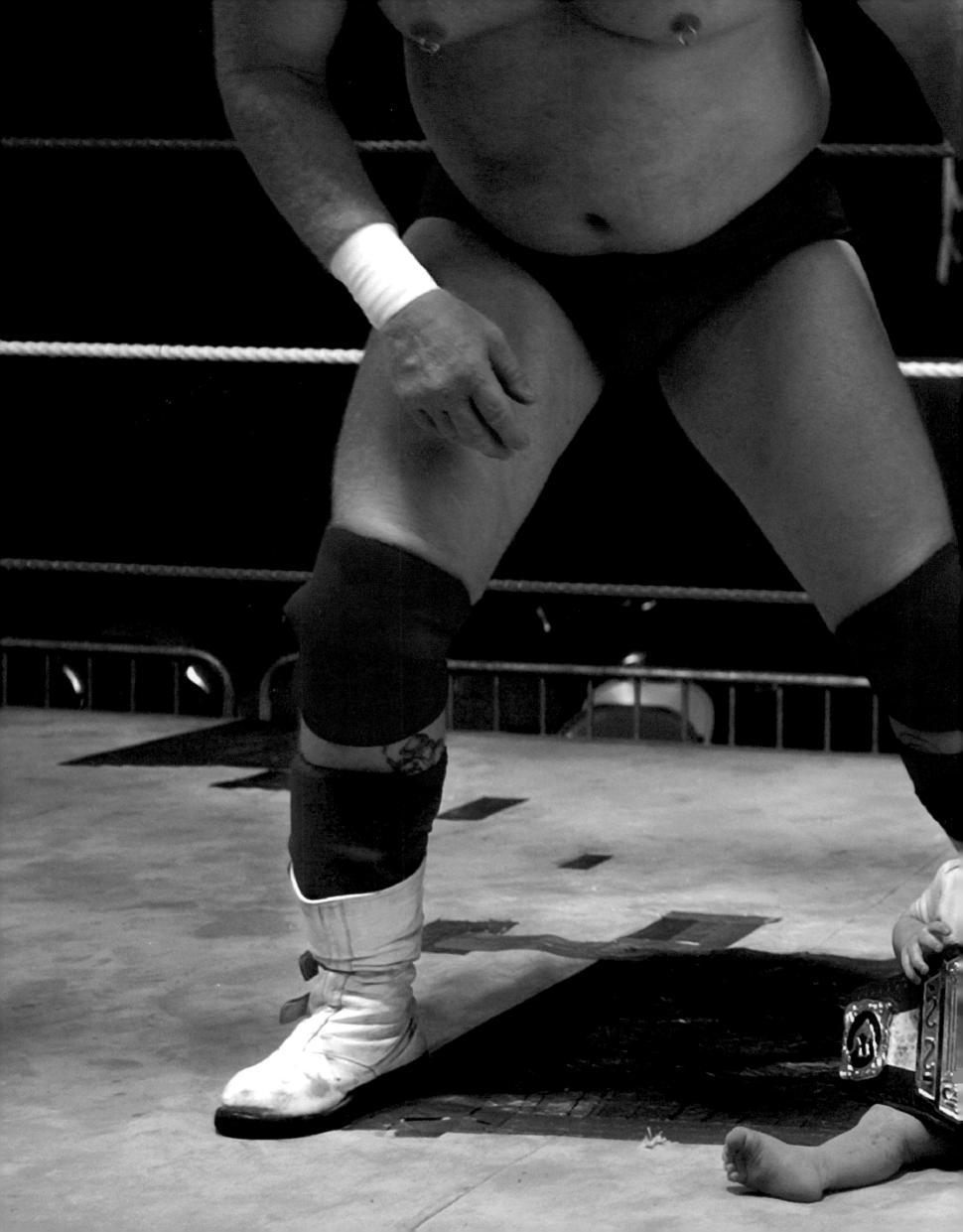

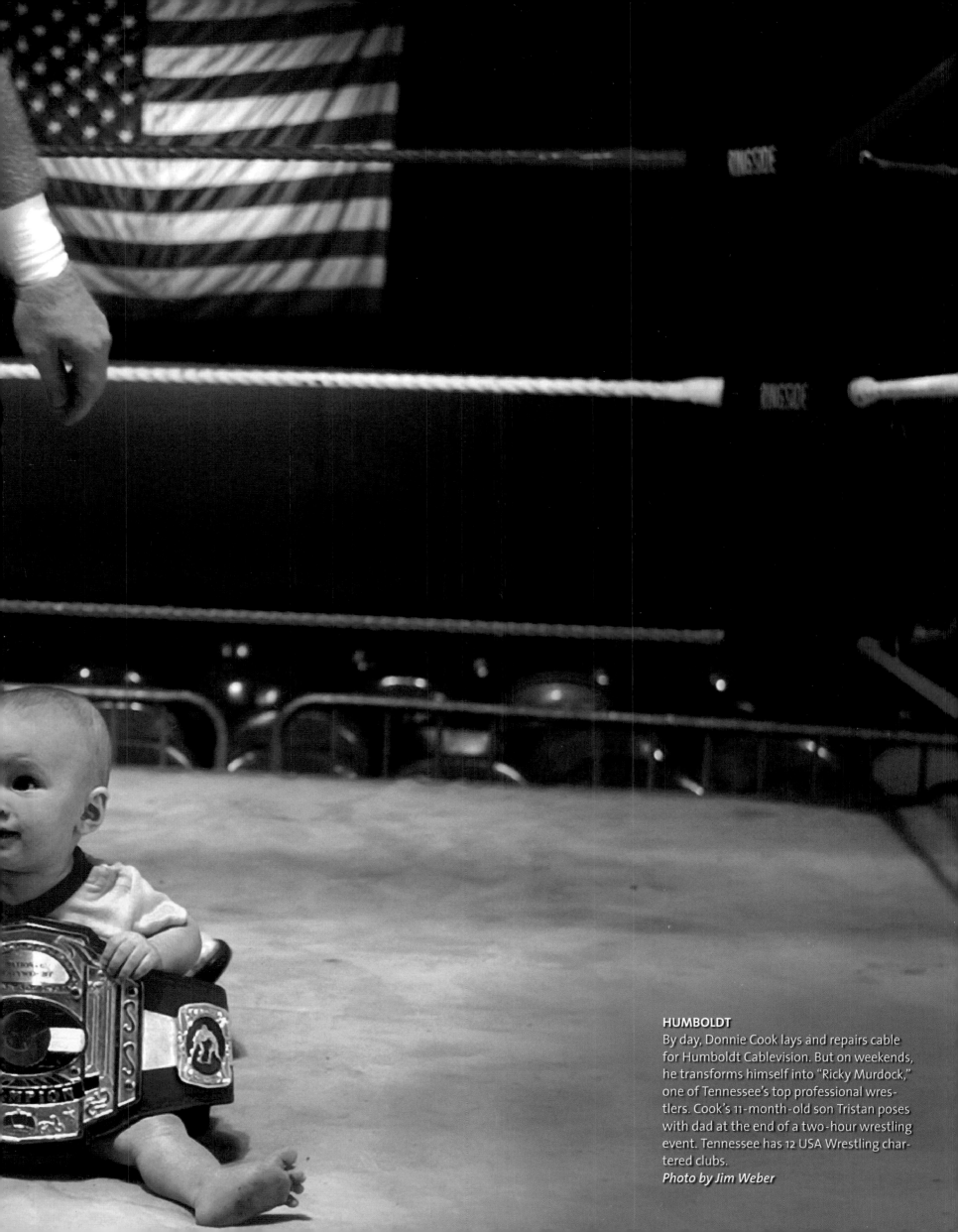

HUMBOLDT

By day, Donnie Cook lays and repairs cable for Humboldt Cablevision. But on weekends, he transforms himself into "Ricky Murdock," one of Tennessee's top professional wrestlers. Cook's 11-month-old son Tristan poses with dad at the end of a two-hour wrestling event. Tennessee has 12 USA Wrestling chartered clubs.
Photo by Jim Weber

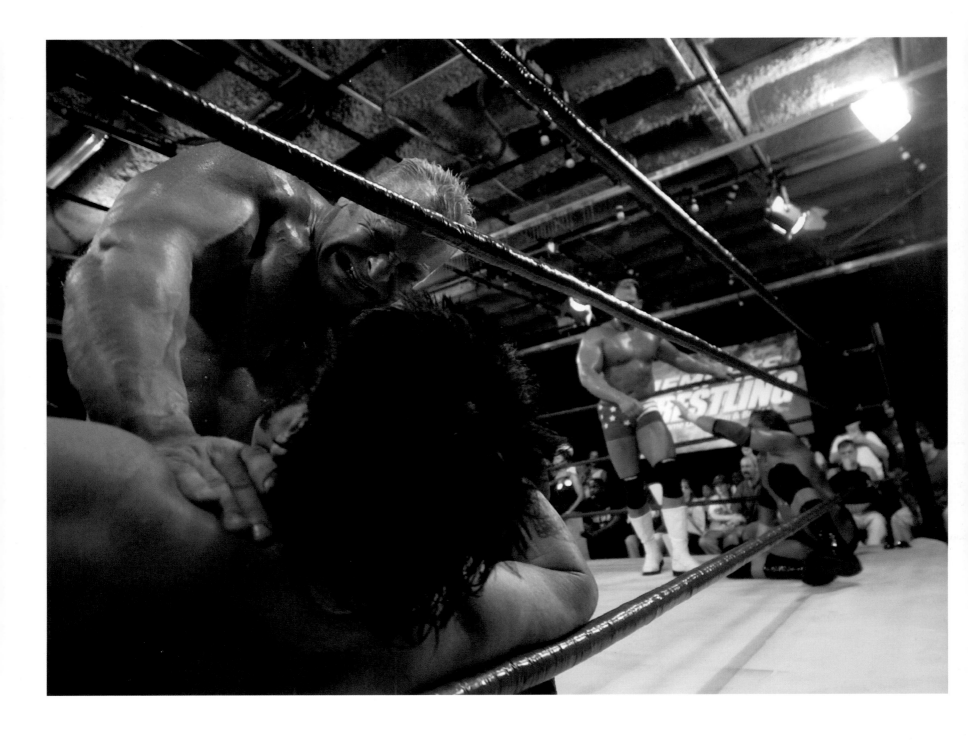

MEMPHIS
Pro wrestling has been a Memphis television staple for 50 years. British wrestler Ian Harrison, part of the tag team Shock and Awe, pins Bill Dundee on Channel 30's in-studio live show, *Memphis Wrestling.*
Photos by Jim Weber

HUMBOLDT

The arena heats up as wrestling fans get into it with David Luciano, aka "Ryan Righteous." Wearing his accountant costume, Luciano urges the antagonistic crowd to clean up its act. "I tell 'em not to swear," he says. "I'm a substitute teacher, so I say they shouldn't let their 8-year-olds flip me off."

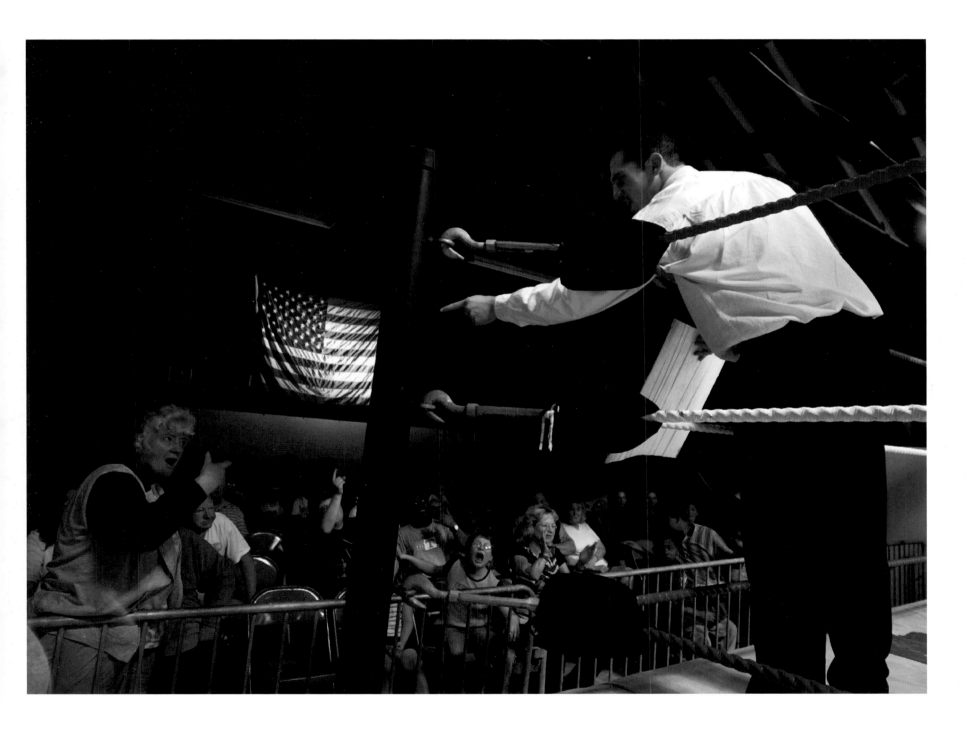

MEMPHIS
On April 17, 1973, FedEx began operations with 14 small planes flying out of Memphis International Airport. The company now has a worldwide fleet of 643 aircraft.
Photo by Rickey Newell

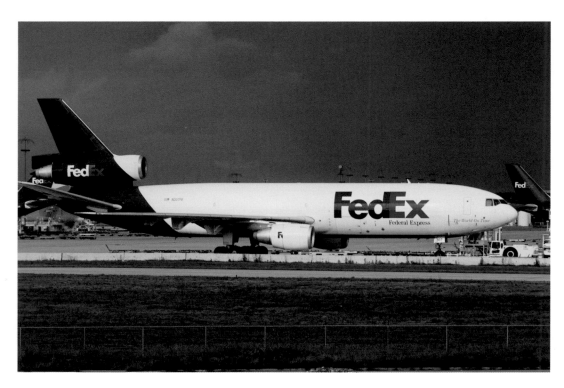

ALAMO

ABB technician Joseph Bartor readies a bushing test with a one million volt cascade transformer. Bushings are insulated protective linings used in electrical conductors. ABB, the second largest employer in Crockett County after Pictsweet Foods vegetable packing, manufactures transformers for power and petrochemical companies.
Photo by Lance Murphey

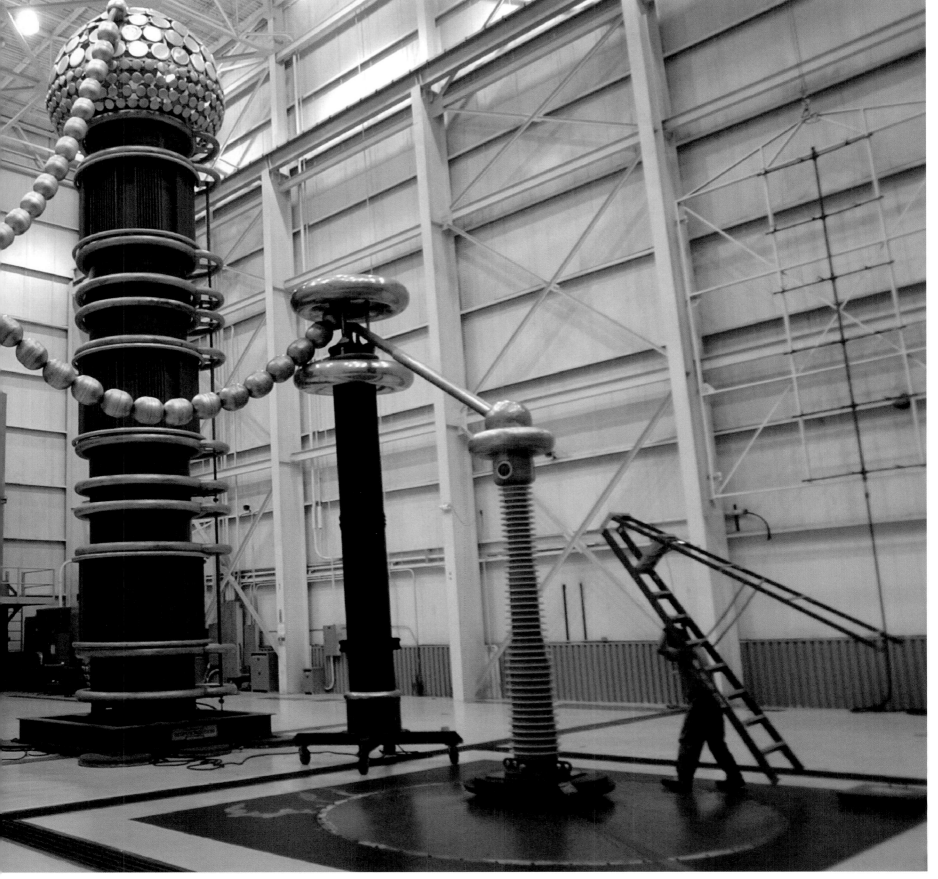

LYNCHBURG

Jack Daniel first distributed his smooth whiskey in earthenware jugs with cork stoppers. When round glass containers came in vogue in 1890, Daniel decided to distinguish his whiskey with a square glass bottle. That branding has stood the test of time. A bottle from 75 years ago, like the one in the middle, could be on a store shelf today.
Photos by Morris Abernathy

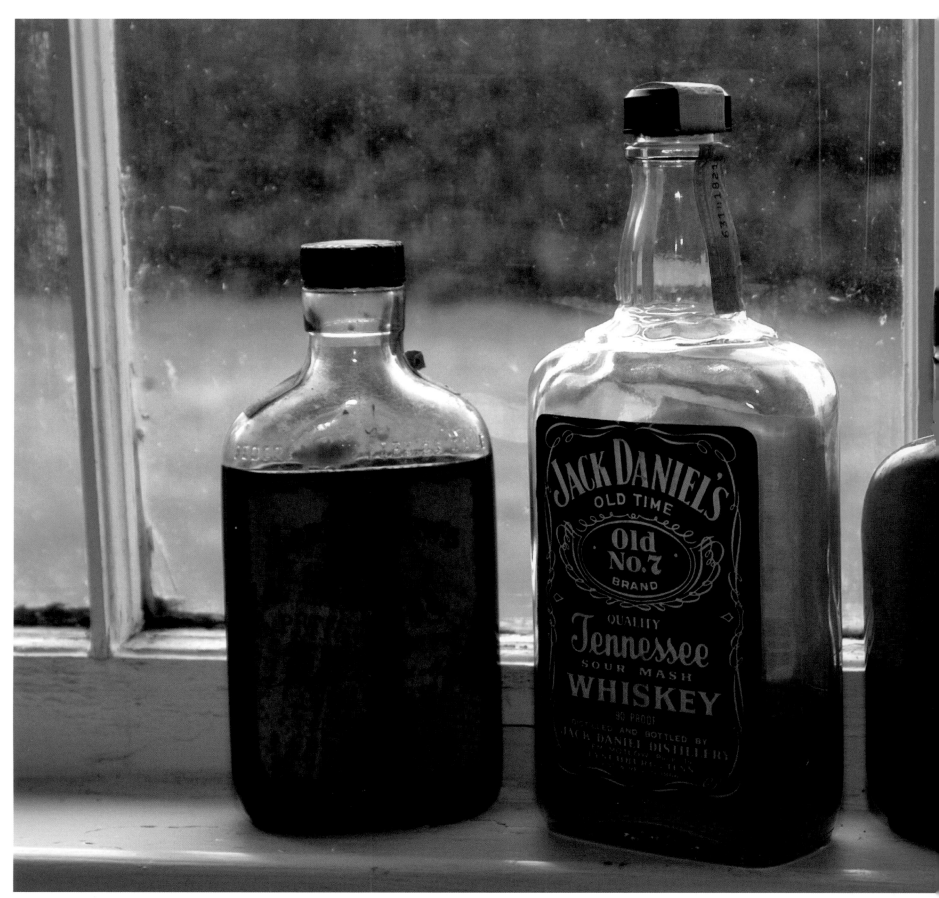

LYNCHBURG

Clint Bailey monitors the distillery's mash cooking process on 12 screens. Each system controls a different aspect, from temperature to alcohol levels. The computer equipment was installed in the late 1980s and sets off alarms if something goes awry. Bailey trained for 18 months to learn how to operate the system.

LYNCHBURG

Jack Daniel's whiskey is placed in white oak barrels to age for about four years. During that time, the barrels expand and contract, forcing the whiskey in and out of the wood and giving the alcohol its dark-amber color. The whiskey warehouse stores 20,000 barrels in various stages of aging. Little known fact: A full barrel can be purchased for $9,000.

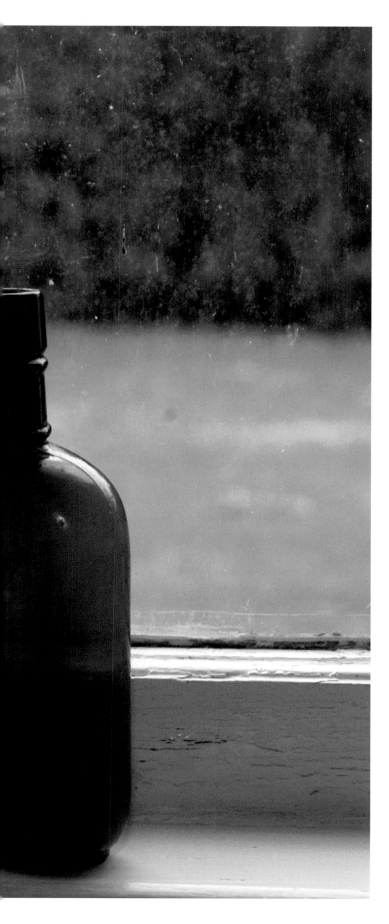

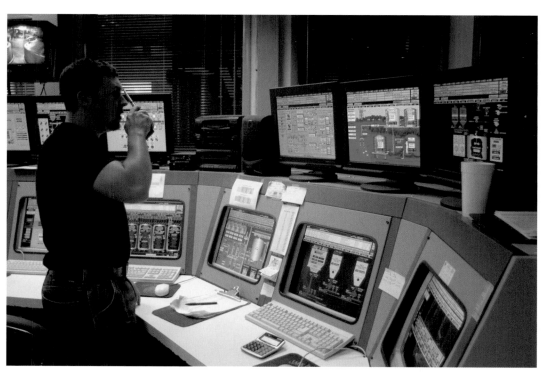

MEMPHIS

Robert "Hollywood" Raiford puts on a spectacle at his disco lounge on Vance Avenue. With smoke, mirrors, and costume changes, the 63-year-old disc jockey keeps the party going into the wee hours of the morning. All are welcome, or, as the sign on the outside of the club reads: Absolutely No Discrimination.

Photos by Alan Spearman

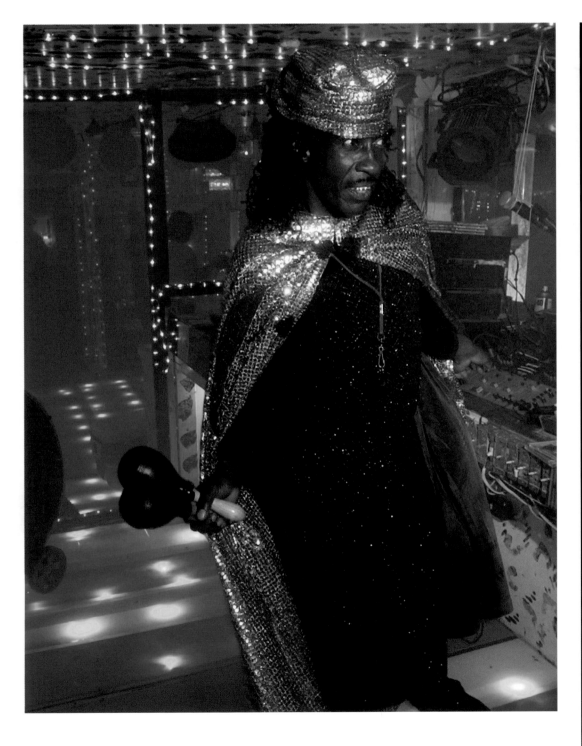

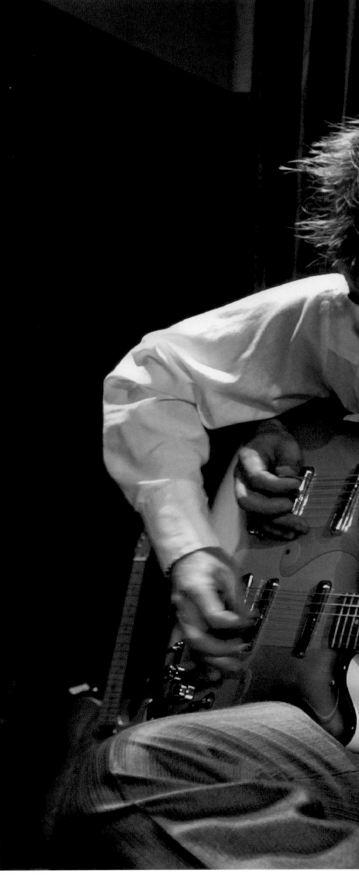

MEMPHIS

At Elvis Presley's Memphis, a nightclub on Beale Street, The Dempseys rock out. Brad Birkedahl, "Slick" Joe Fick, and Ron Perrone, Jr. have played together since their high school days in Tacoma, Washington. In 1997, they became the club's house band. They call themselves "the hardest working band in Memphis."

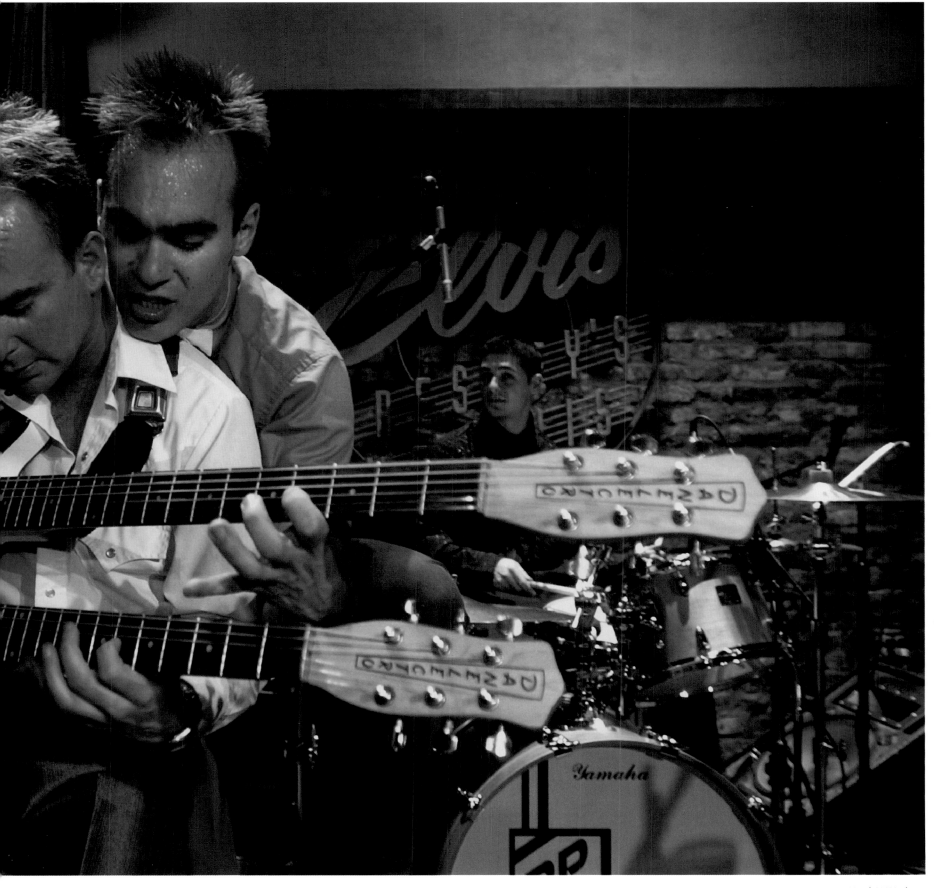

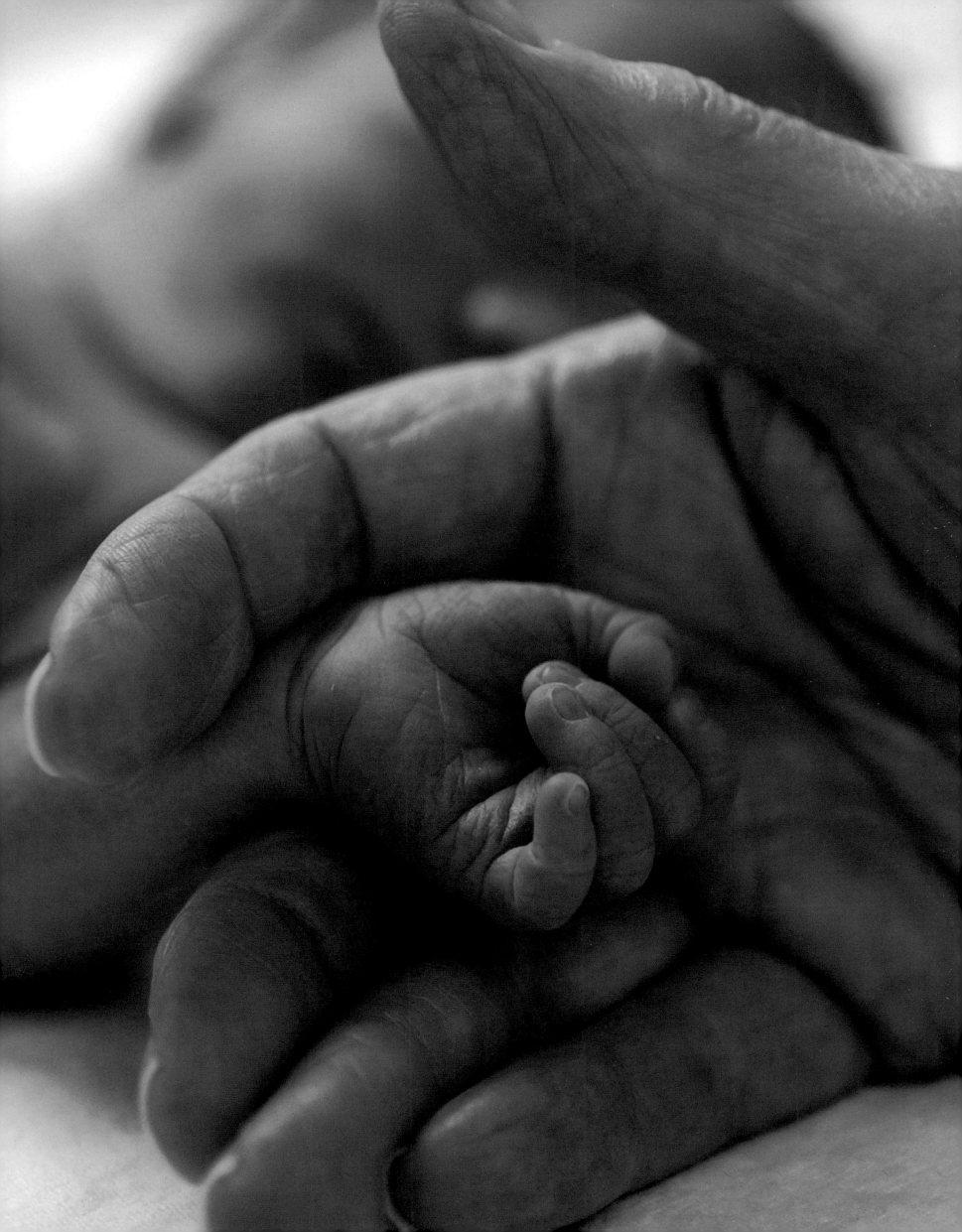

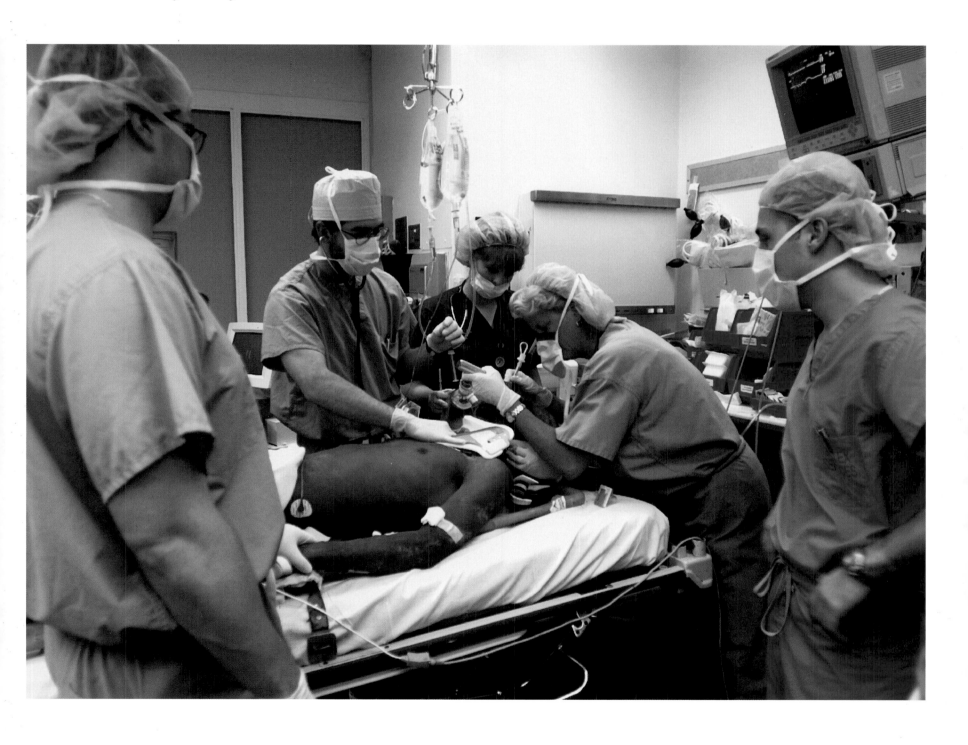

MEMPHIS

Dr. Sheldon Korones, who founded the neonatal unit at the Regional Medical Center in 1968, examines an identical twin baby born prematurely on Tuesday, May 13. The doctor has seen more than 45,000 babies come through the unit and has saved some weighing as little as a pound.
Photo by Karen Pulfer Focht

MEMPHIS

At the Elvis Presley Memorial Trauma Center, doctors and nurses work to save a man who suffered a severe head injury in a fight. Helicopters bring patients from a 150-mile radius to the 24-hour, Level One facility, which is funded in part by donations from Elvis fans.
Photo by Alan Spearman

CHATTANOOGA

Ditto Townsend works in the melting department of Eureka Foundry, a family business started in 1902. The 80-employee jobbing foundry casts iron machine parts for a variety of industries. "Great-grandfather Pat Delany started the business. My two brothers and I are the fourth generation," says owner Fred Hessler.
Photos by Billy Weeks

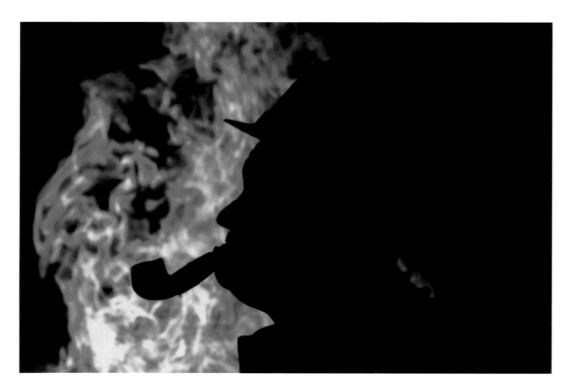

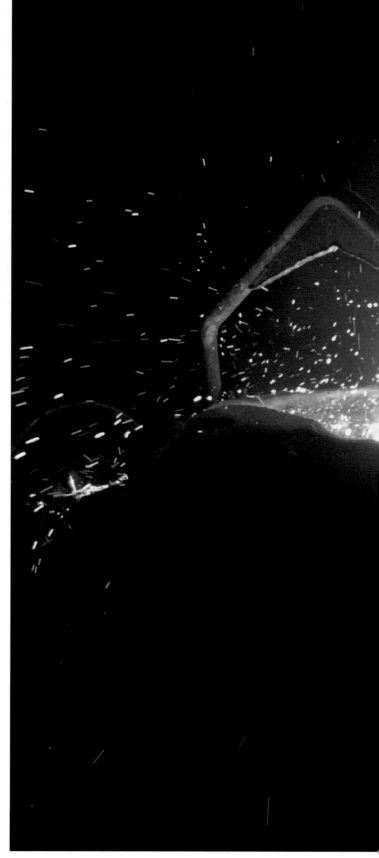

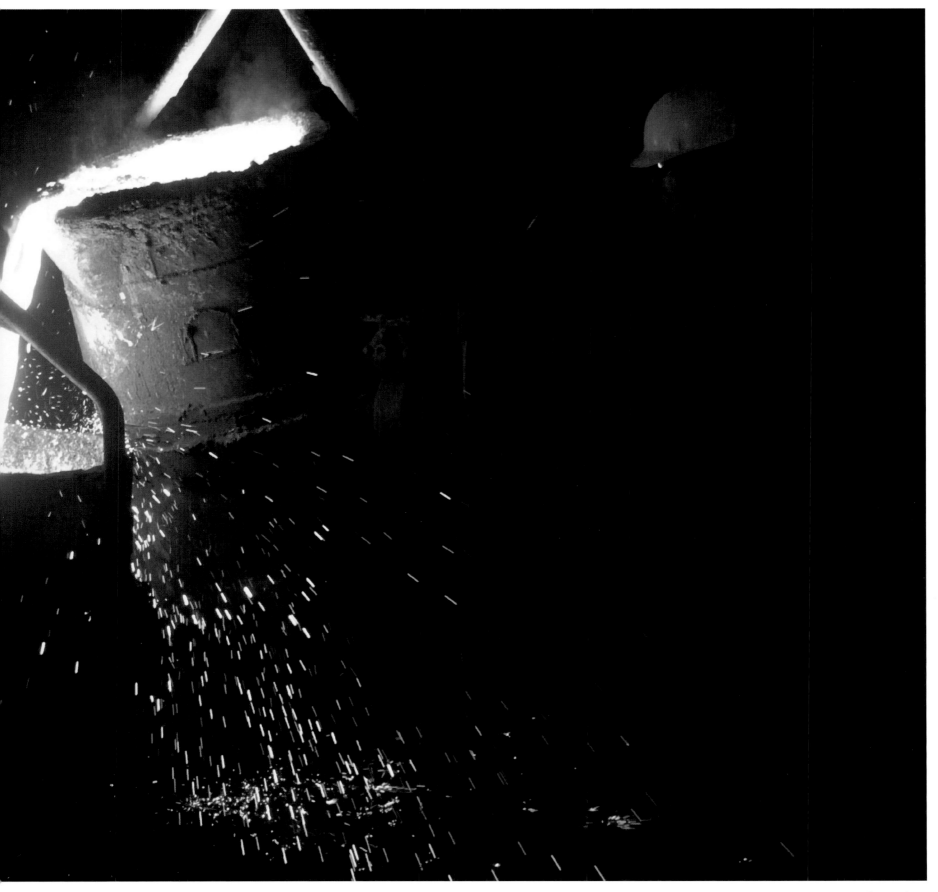

CHATTANOOGA

During the summer, the temperature reaches 115 degrees n the foundry's melting department. That's not the worst of it, according to Ron Clark, who pours up to 60 tons of molten iron a day into molds. A few years ago, a mold broke and hot iron spilled into his boot, severely burning his foot. A couple of skin grafts later, he was fine.

MEMPHIS

The Memphis terminal of Swift Transportation is one in a network of 36 terminals throughout the U.S. and Mexico. Founded in 1965, the trucking company employs more than 16,000 drivers who operate 17,000 trucks. They haul dozens of products, including paper goods, nonperishable foods, and building materials.

Photos by Lance Murphey

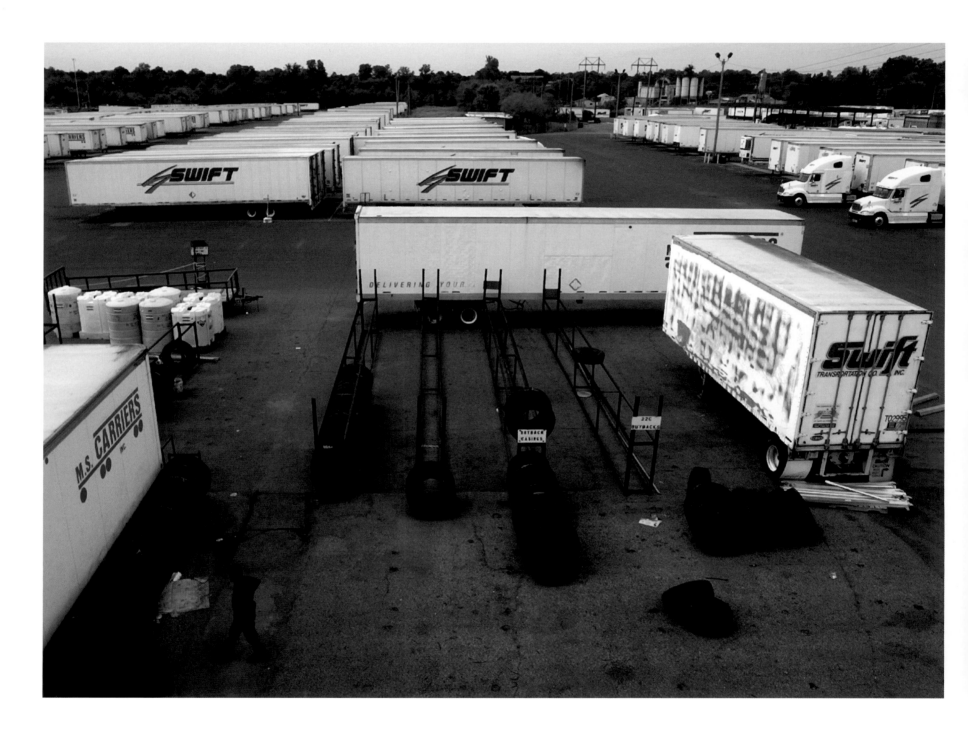

MEMPHIS

Truck driver John Gump lets his toy poodle Prince stretch his legs while getting the oil changed on his tractor trailer at the terminal. Soon they'll be heading west to Denver to deliver Ford auto parts. With creature comforts in the cab including a bunk bed, refrigerator, and microwave, the 175 hours fly by.

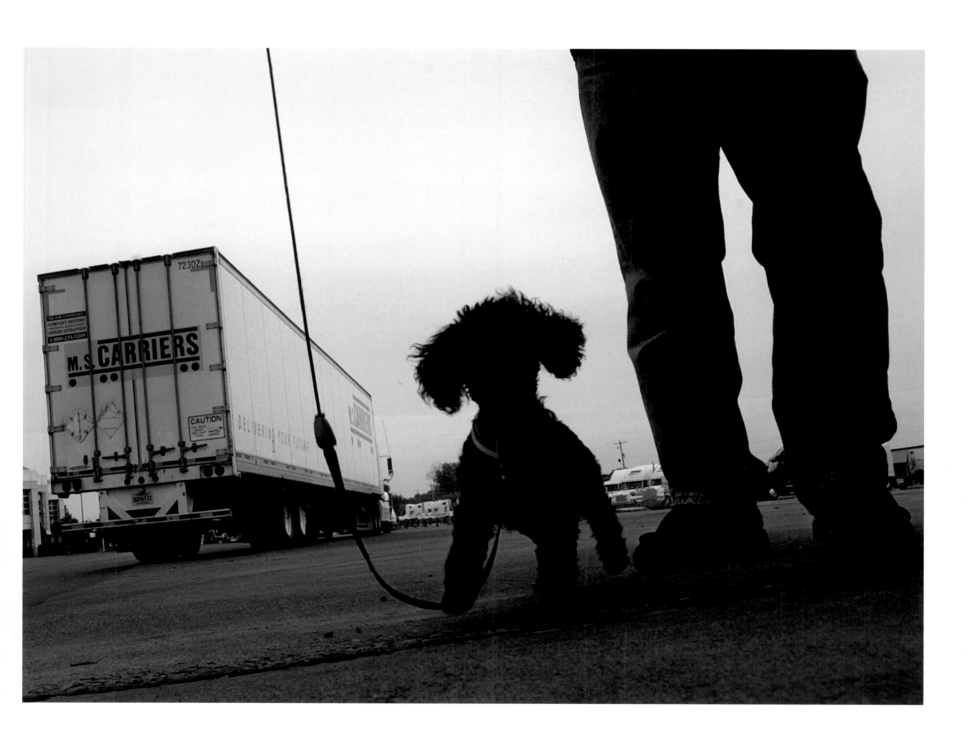

NASHVILLE
Tennessee Governor Phil Bredesen (right) motions for Reverend James Thomas of Jefferson Baptist Church to join him for lunch at Swett's Cafeteria. The two have been allies ever since Bredesen ran for mayor of Nashville in 1991 and came by the church for an endorsement. "He is a good man and a good governor," says Reverend Thomas. "If he promises something, he will do it."
Photo by Nancy Lee Andrews

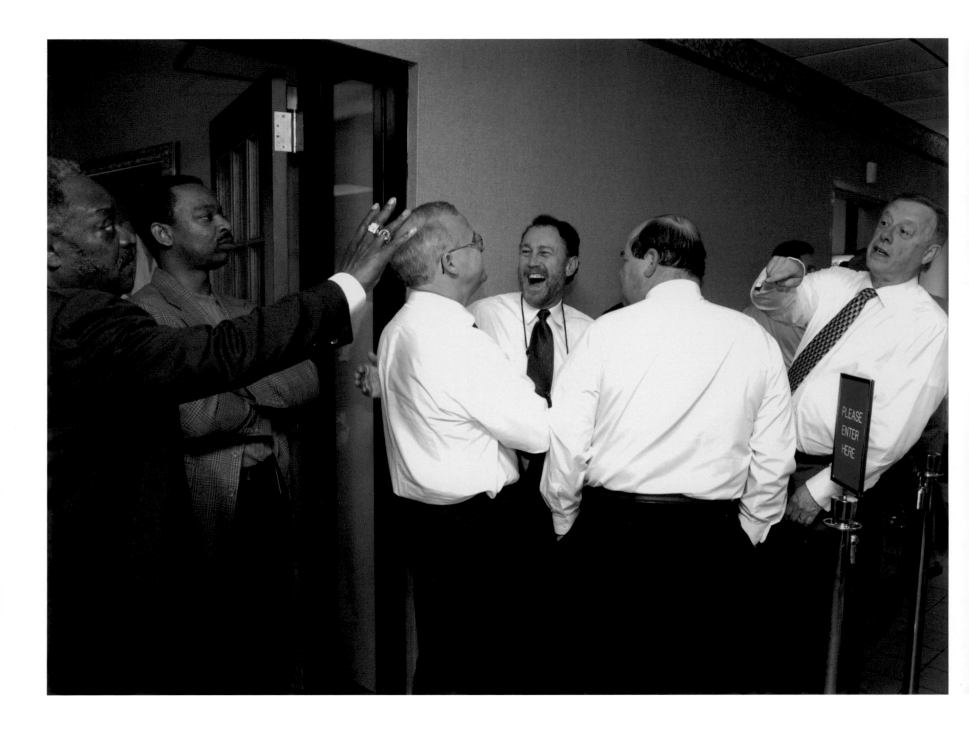

NASHVILLE

George Geist is the third generation to work in the turn-of-the-century blacksmith shop his granddad originally built for horseshoeing and wagon repairing. When George and wife Ann took over the business in 1955, Geist's dad had been fixing push mowers. Now the focus is power mowers—with a little art forging on the side. "We're real busy," says George.
Photo by Rusty Russell

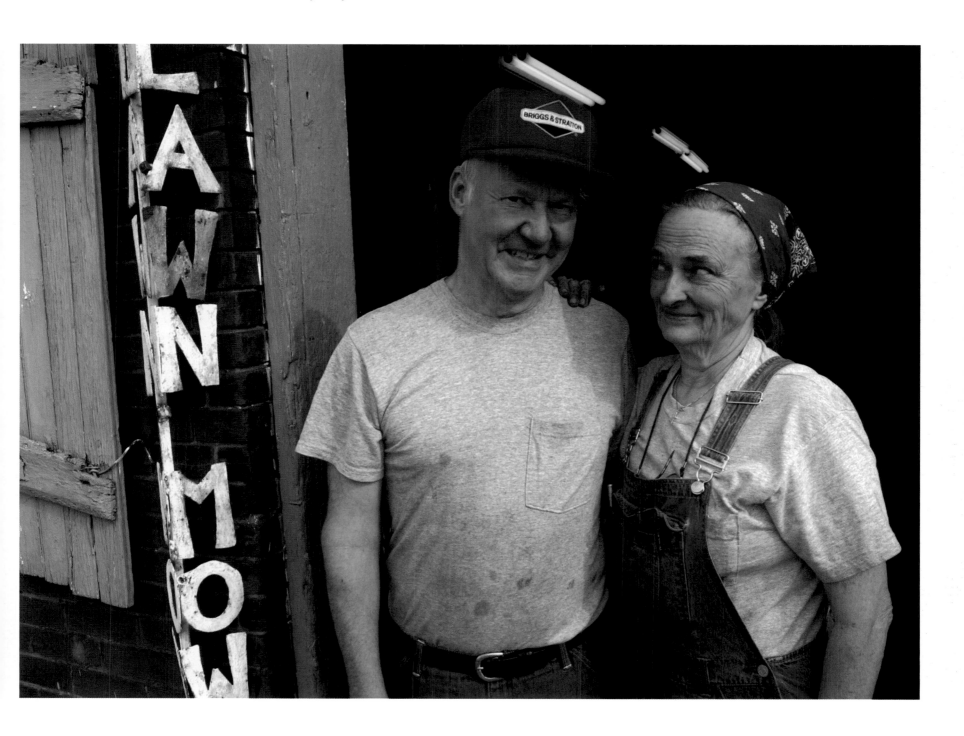

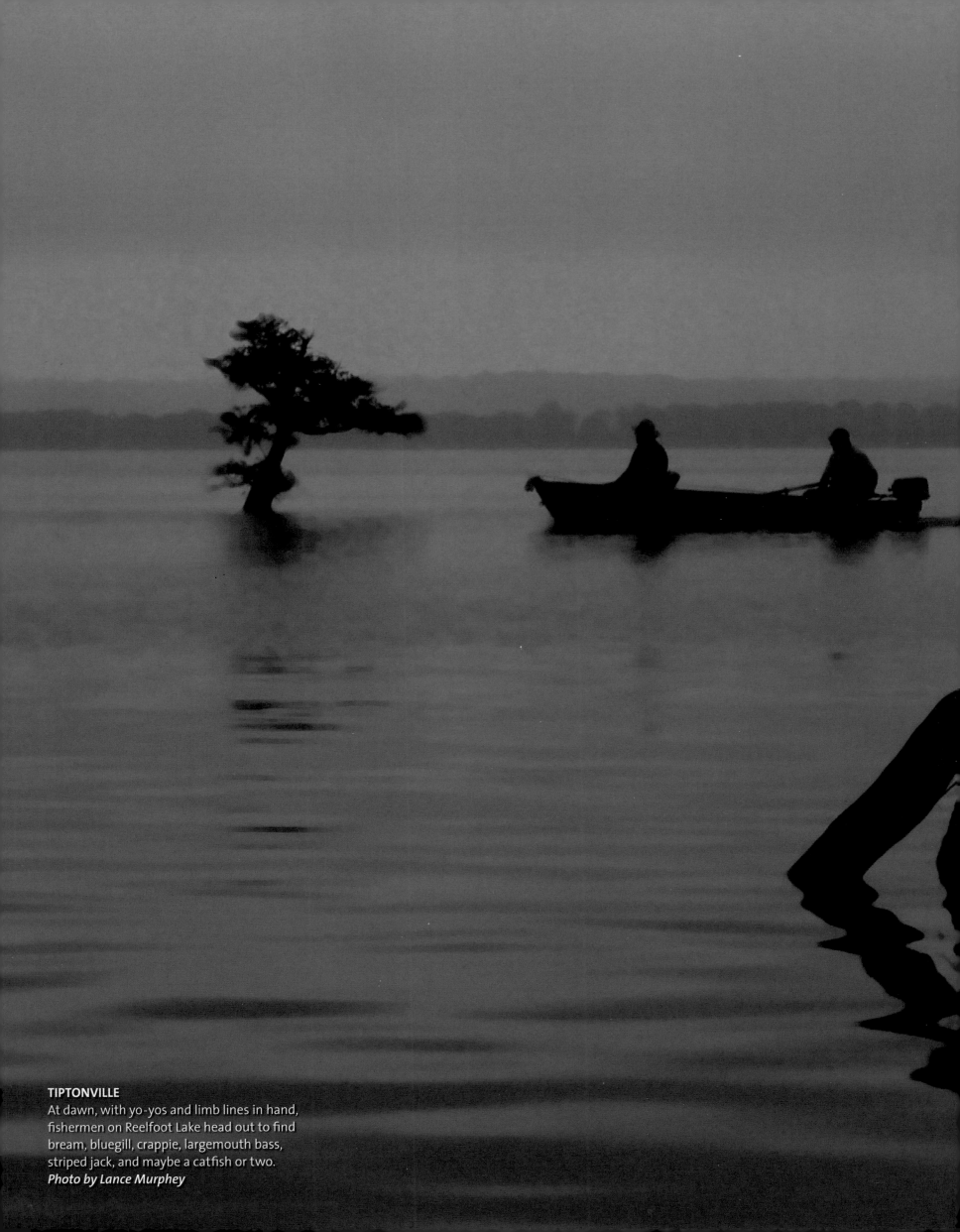

TIPTONVILLE
At dawn, with yo-yos and limb lines in hand, fishermen on Reelfoot Lake head out to find bream, bluegill, crappie, largemouth bass, striped jack, and maybe a catfish or two.
Photo by Lance Murphey

Tennessee At Play

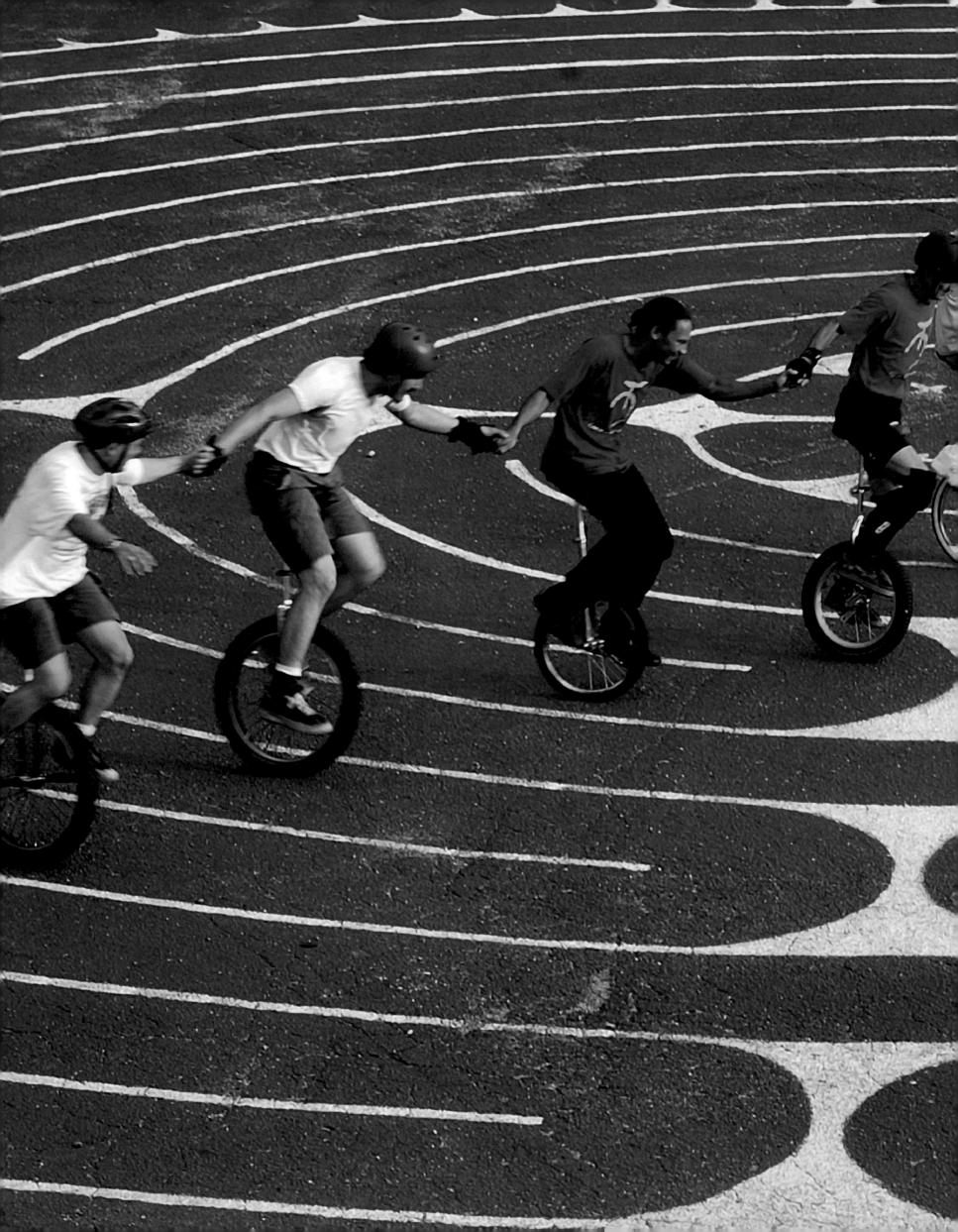

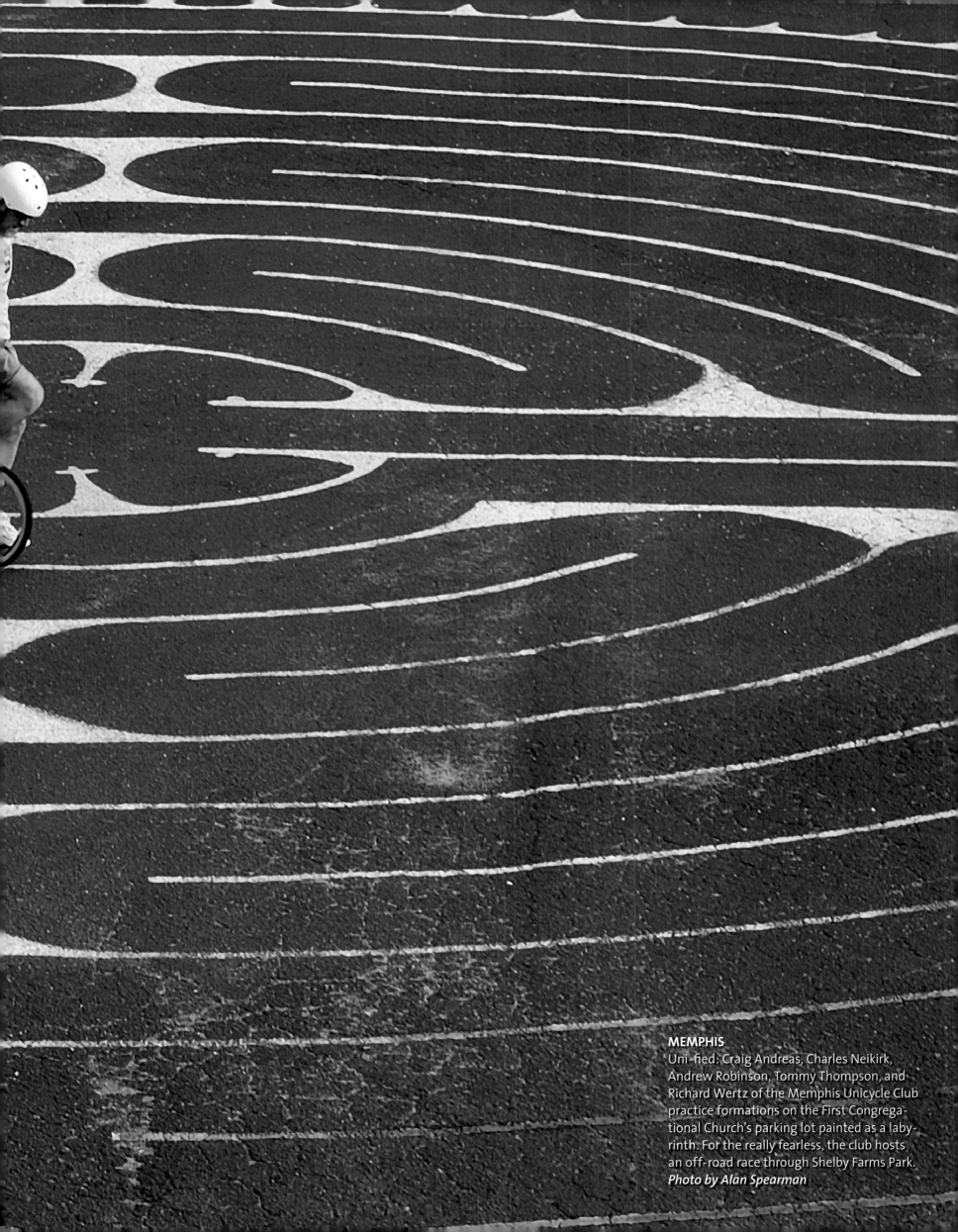

MEMPHIS
Uni-fied: Craig Andreas, Charles Neikirk, Andrew Robinson, Tommy Thompson, and Richard Wertz of the Memphis Unicycle Club practice formations on the First Congregational Church's parking lot painted as a labyrinth. For the really fearless, the club hosts an off-road race through Shelby Farms Park.
Photo by Alan Spearman

CHATTANOOGA

Abigail Tulis awaits her entrance during the Tennessee Ballet's performance of "Ballet Goes Country" at the University of Tennessee's Roland Hayes Concert Hall. Executive Director Barry Van Cura chose a country music program to attract a younger audience. "Everyone benefits from ballet," he says.

Photo by Billy Weeks

MEMPHIS

At Midtown Yoga in Memphis, instructor Arline Jernigan (center) and students Lonnice Brittenum Bonner, Grace Gentry Harwood, and James Smith twist into astavakrasana, or eight-angle pose, during a vinyasa yoga class.

Photo by Alan Spearman

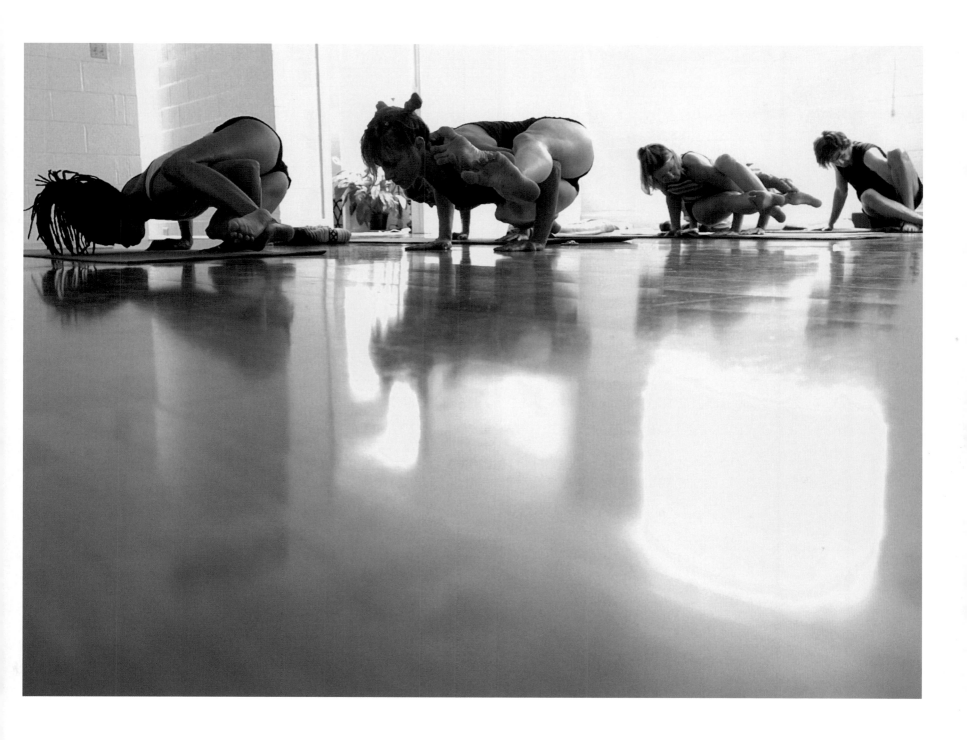

GREAT SMOKY MOUNTAINS NATIONAL PARK
Once a year, Betsy Caldwell, 17, and her mom
Barbara do a mother-daughter bonding hike on
the Schoolhouse Gap Trial, a six-and-a-half mile
round-trip jaunt. Betsy just graduated from high
school and leaves home in the fall to attend East
Tennessee State University.
Photo by Patrick Murphy-Racey, pmrphoto.com

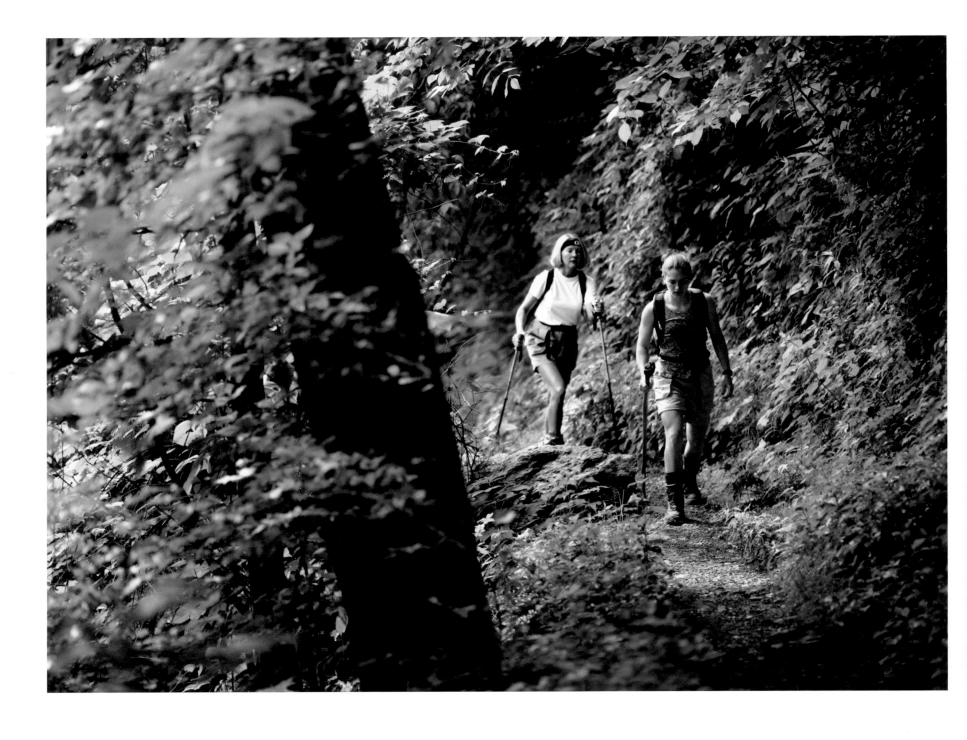

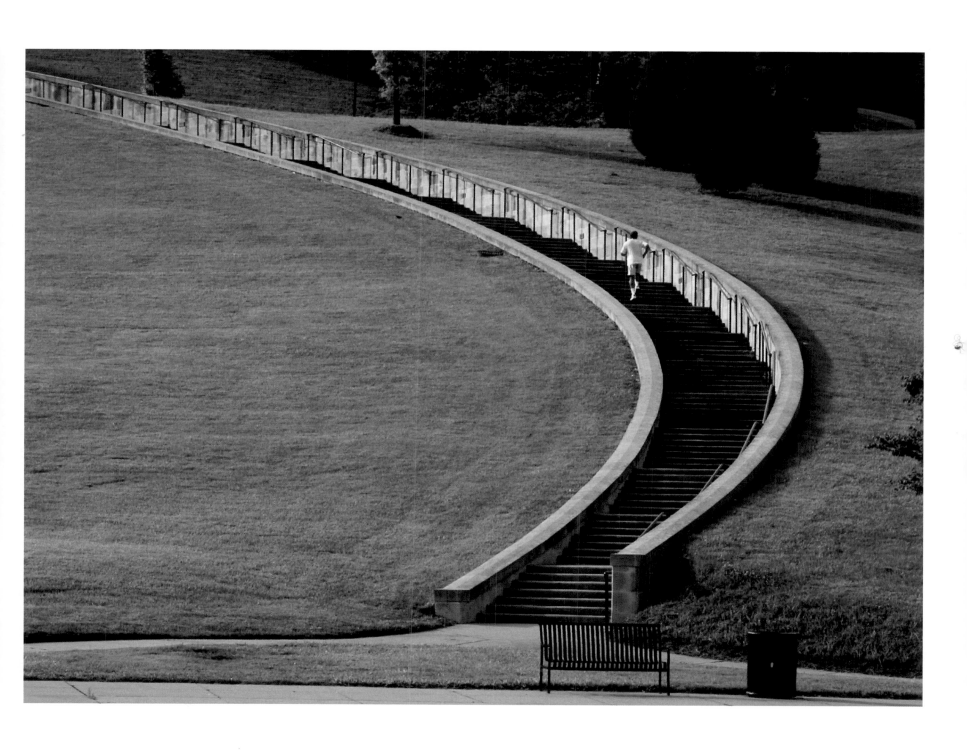

NASHVILLE

The serpentine stairway climbs to the Belvedere overlook in front of the state capitol building. Across the street from the 19-acre Bicentennial Mall State Park, it's a favorite with joggers who want to ratchet up their cardio workout.

Photo by Dean Dixon

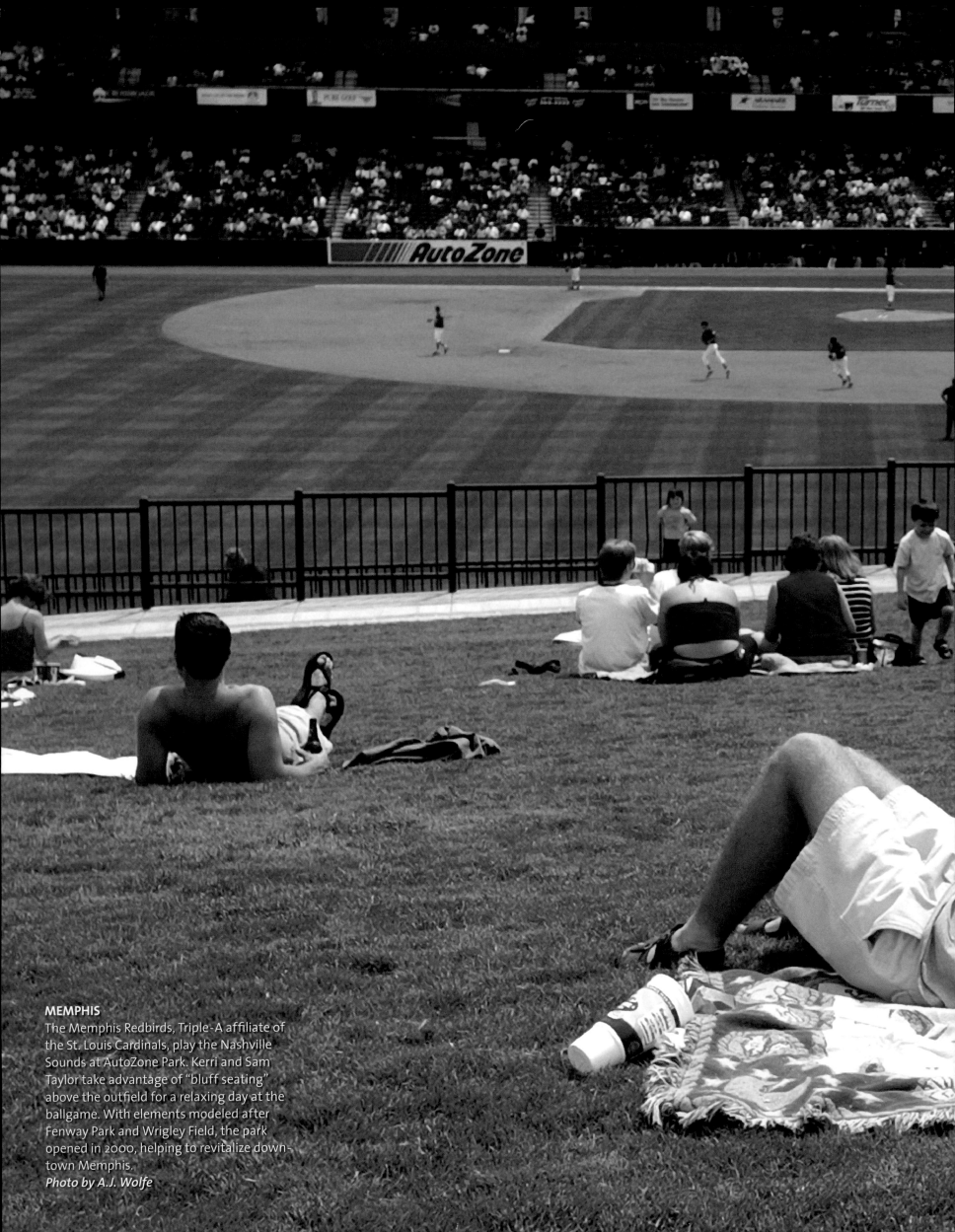

MEMPHIS

The Memphis Redbirds, Triple-A affiliate of the St. Louis Cardinals, play the Nashville Sounds at AutoZone Park. Kerri and Sam Taylor take advantage of "bluff seating" above the outfield for a relaxing day at the ballgame. With elements modeled after Fenway Park and Wrigley Field, the park opened in 2000, helping to revitalize downtown Memphis.

Photo by A.J. Wolfe

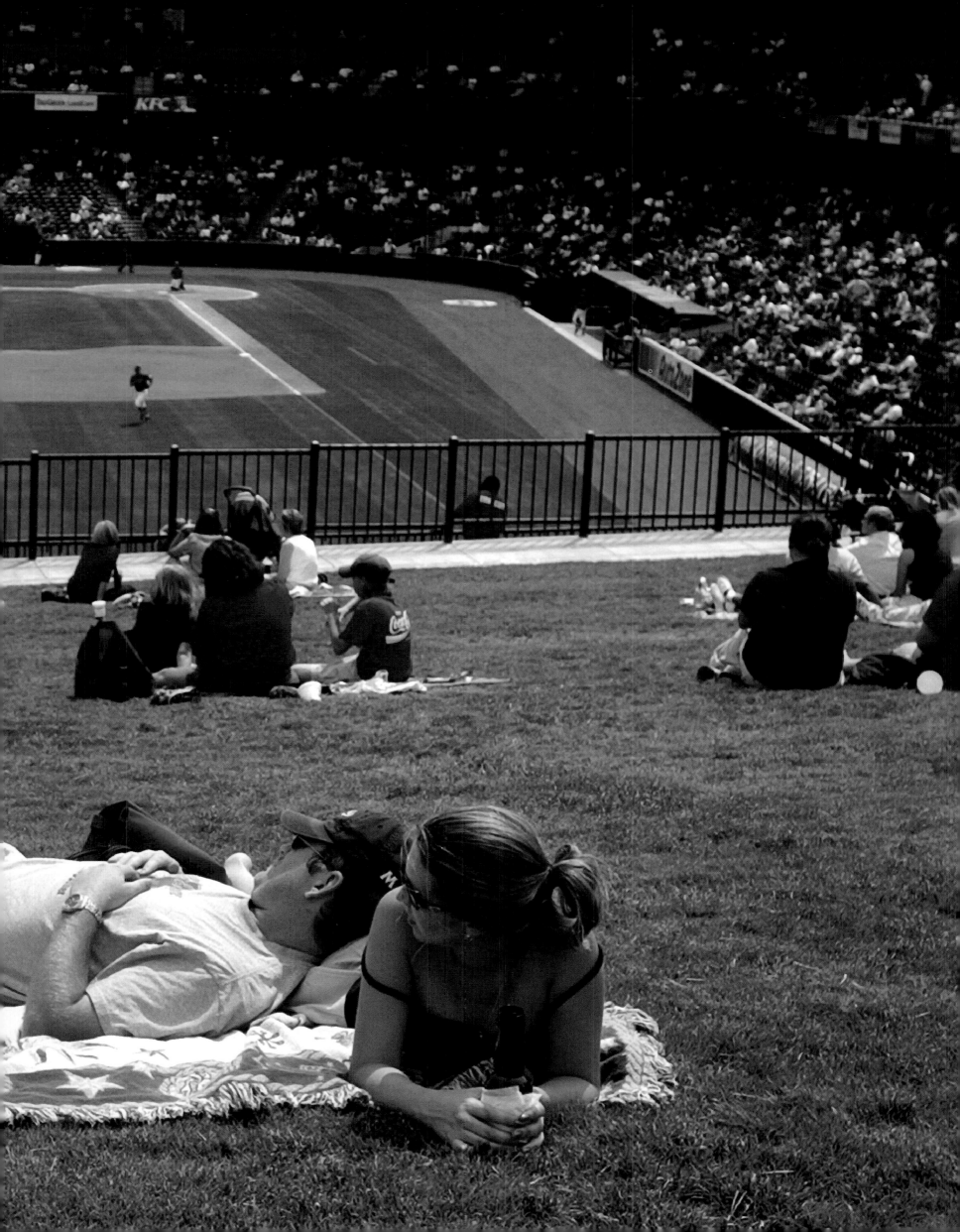

KNOXVILLE

Scott Altizer pumps iron in the University of Tennessee's Neyland-Thompson Sports Center. As the high school recruiting coach for the university's football team, Altizer has to convince talented players to join Big Orange. The team's home is the 120,000-square-foot center, with its 70-yard All-Pro indoor practice field.
Photos by Patrick Murphy-Racey, pmrphoto.com

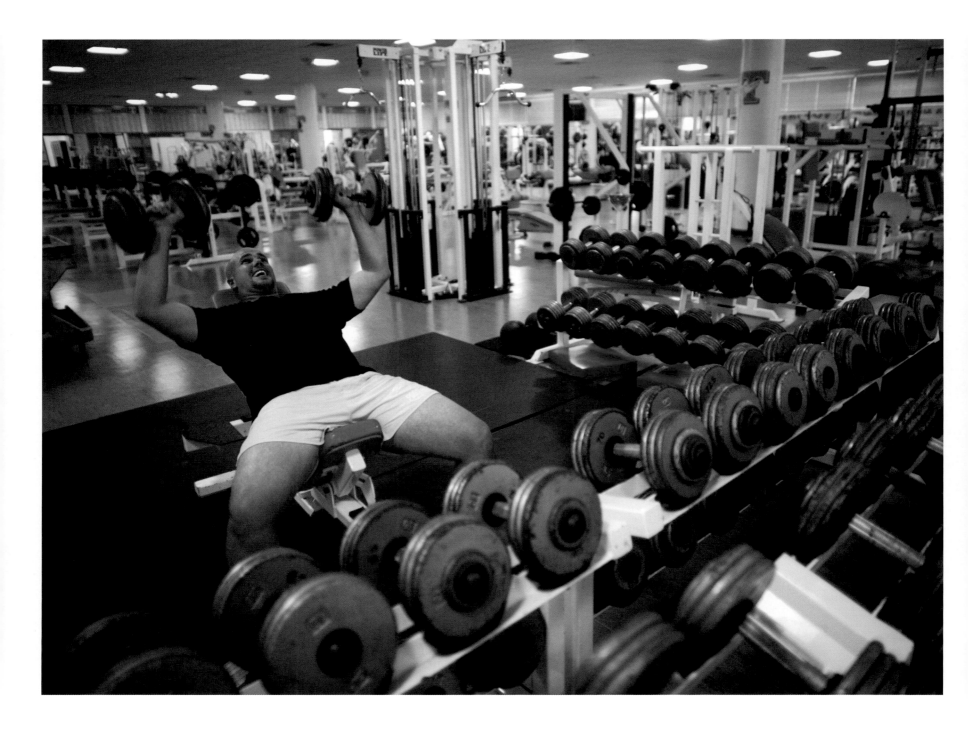

KNOXVILLE

Since 1992, when he took over as University of Tennessee's football coach, Philip Fulmer has compiled a stellar, 84–17 record. The ratio makes him the nation's top college football coach in terms of a winning percentage (.832). Fulmer is also among the top five all-time suppliers of college players to the NFL.

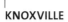

KNOXVILLE
Christian Robertson of the Midnight Demons scores during an under-eights game in an American Youth Soccer Organization league. Before kids can play on a team, their parents must sign a good-sportsmanship contract called "Kid Zone." They agree to refrain from profanity, smoking, negative comments, and coaching from the sidelines during games.
Photos by Patrick Murphy-Racey, pmrphoto.com

KNOXVILLE

Coach Laura Walters leads her undefeated Midnight Demons in a pregame cheer. The team was rescued by Walters last year when she took over after their coach quit. "I took a coaching course to learn the game," she says. "I love doing it."

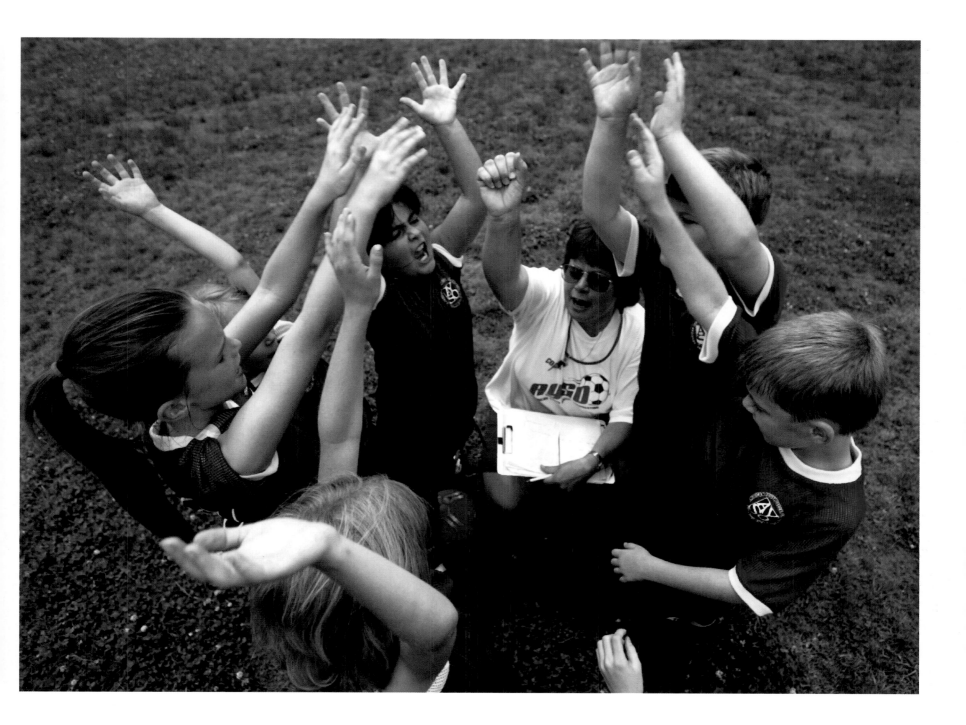

NASHVILLE
Heavy mid-May rains caused the J. Percy Priest Reservoir to flood the adjacent park. Regulars aren't too happy about all the water, though these two buddies make the best of it.
Photo by Rusty Russell

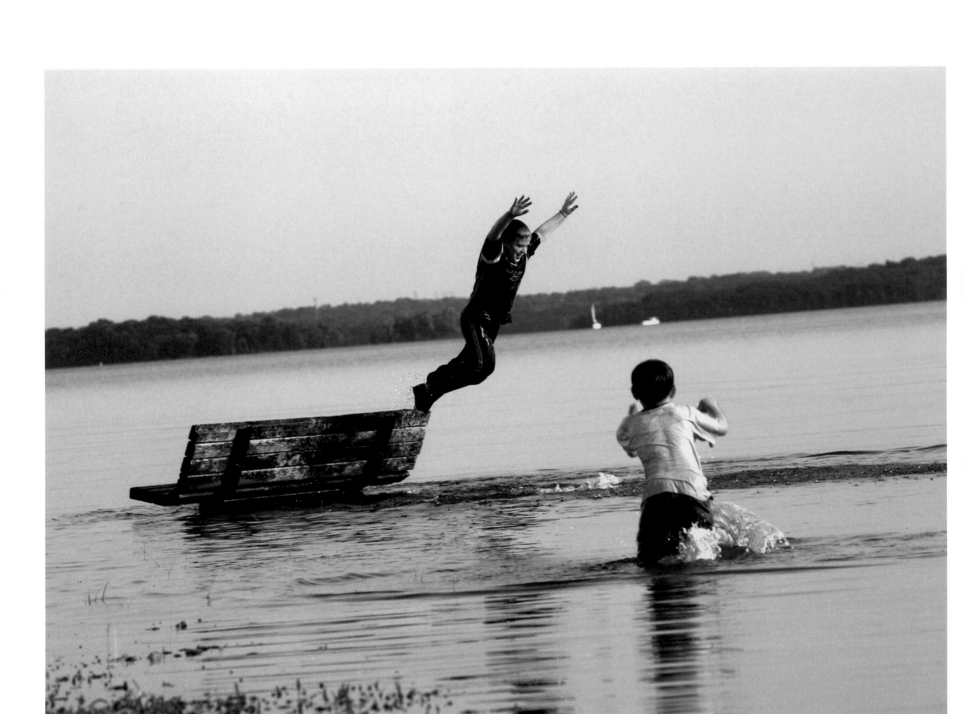

FRANKLIN

Mutton bustin': At the annual Franklin Rotary Rodeo, wee wranglers take a turn around the arena. Founded in 1949 as a fundraiser, the three-day event includes barrel racing, steer wrestling, bull riding, and calf roping.
Photo by Charlotte Neidel

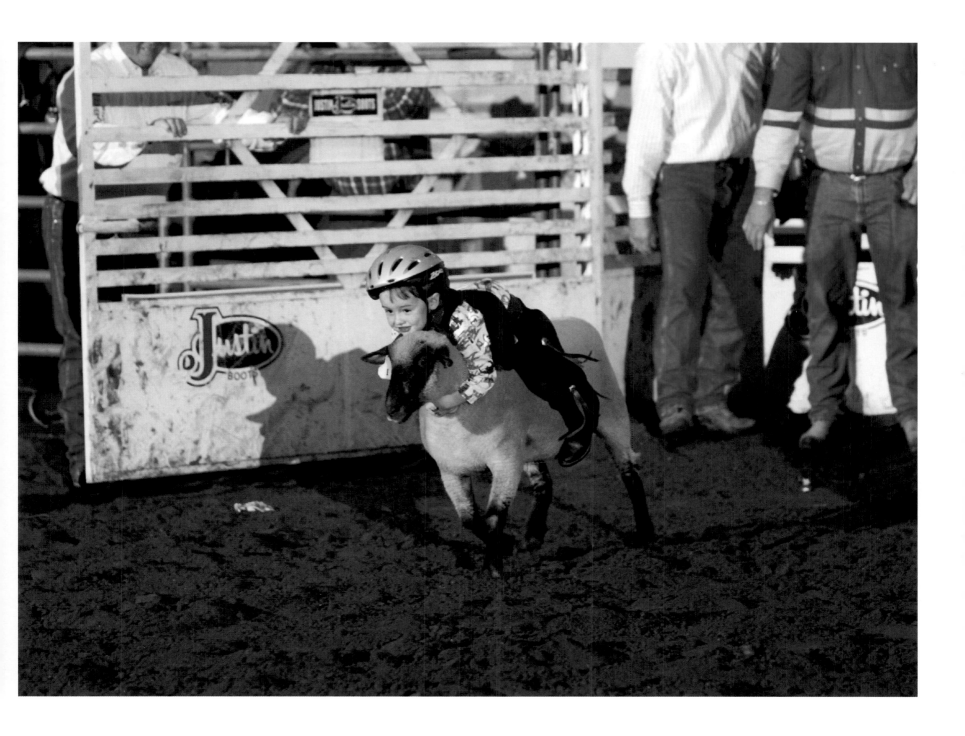

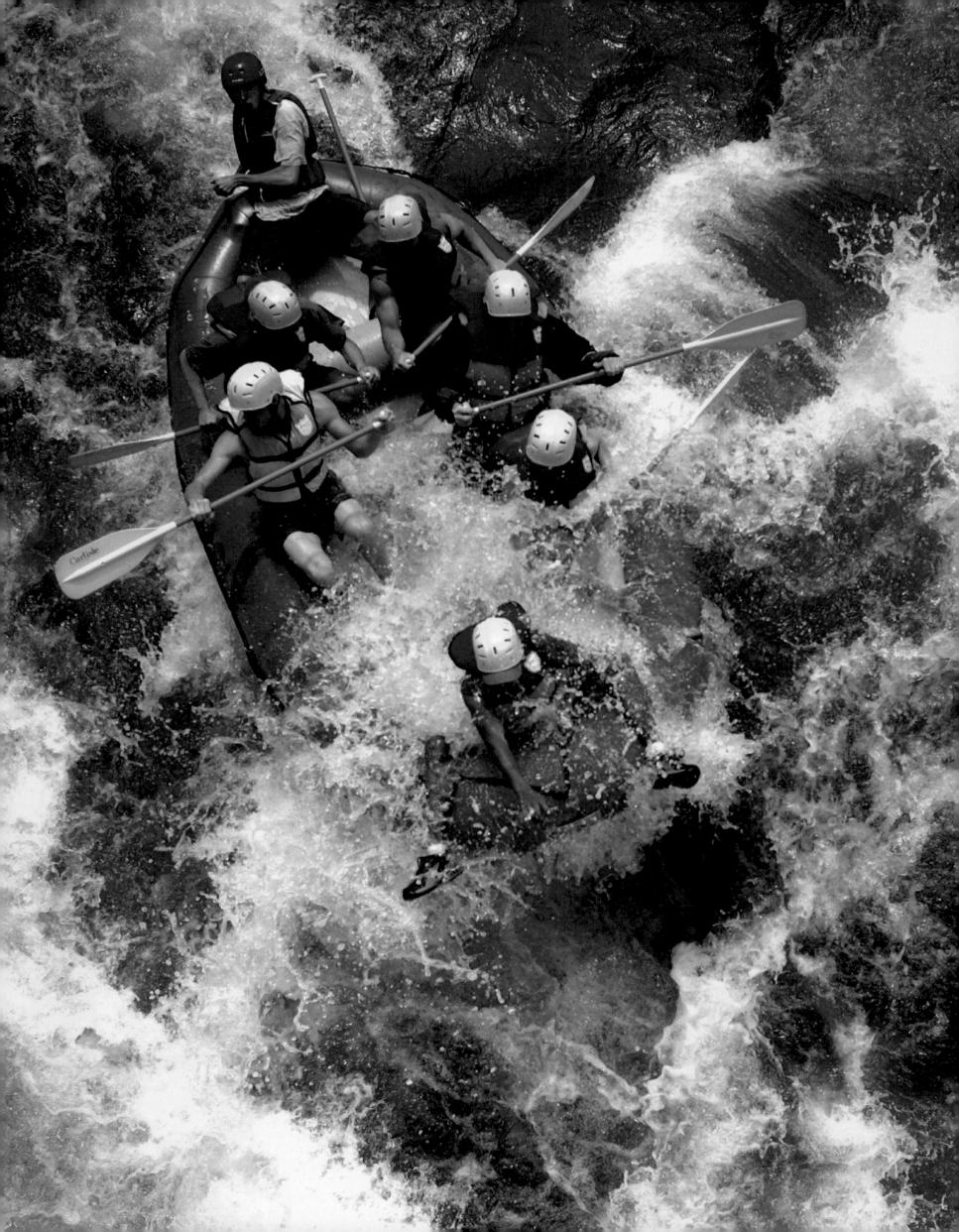

CHEROKEE NATIONAL FOREST

Swollen with spring runoff, the popular Middle Ocoee River is the white-water rafter's El Dorado. It plunges 269 feet in five miles and offers the longest stretch of class III–IV rapids in the country. The extremely challenging Upper Ocoee section of the river was the site of the 1996 Olympic Canoe-Kayak slalom course.

Photos by Billy Weeks

CHATTANOOGA

Chattanooga Locomotion tailback Amanda Horner breaks away from a Nashville Dream tackler during a National Woman's Football Association contest. Horner, a landscaper, plays women's pro-football for the love of the game—she and all her teammates have day jobs. "Of all the sports I have played, this one has the best atmosphere," she says. "We all get along."

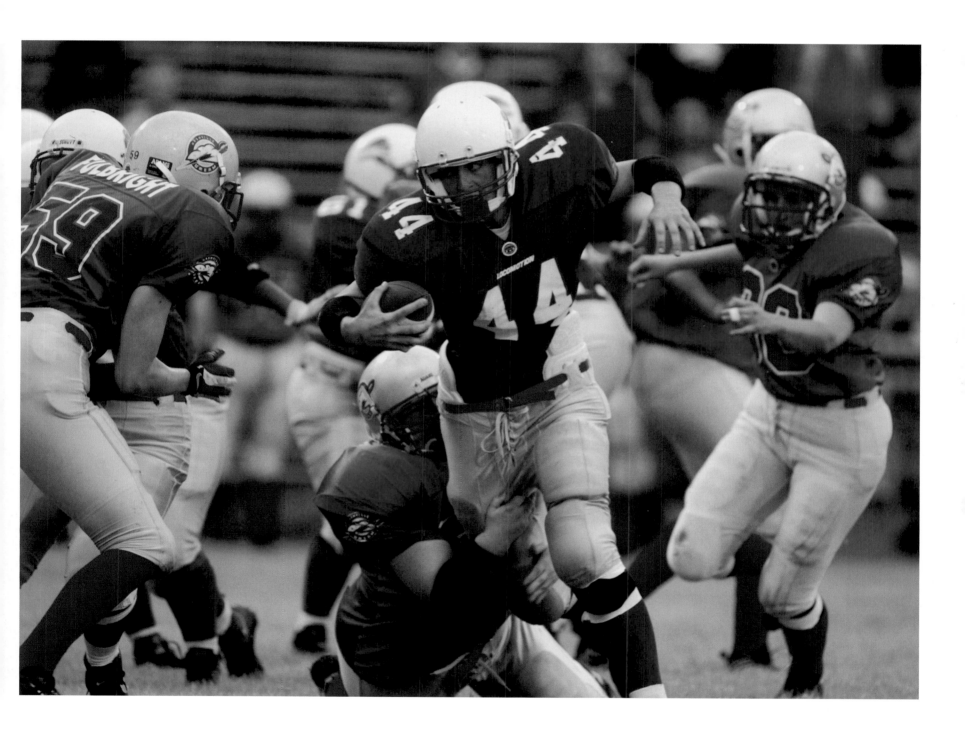

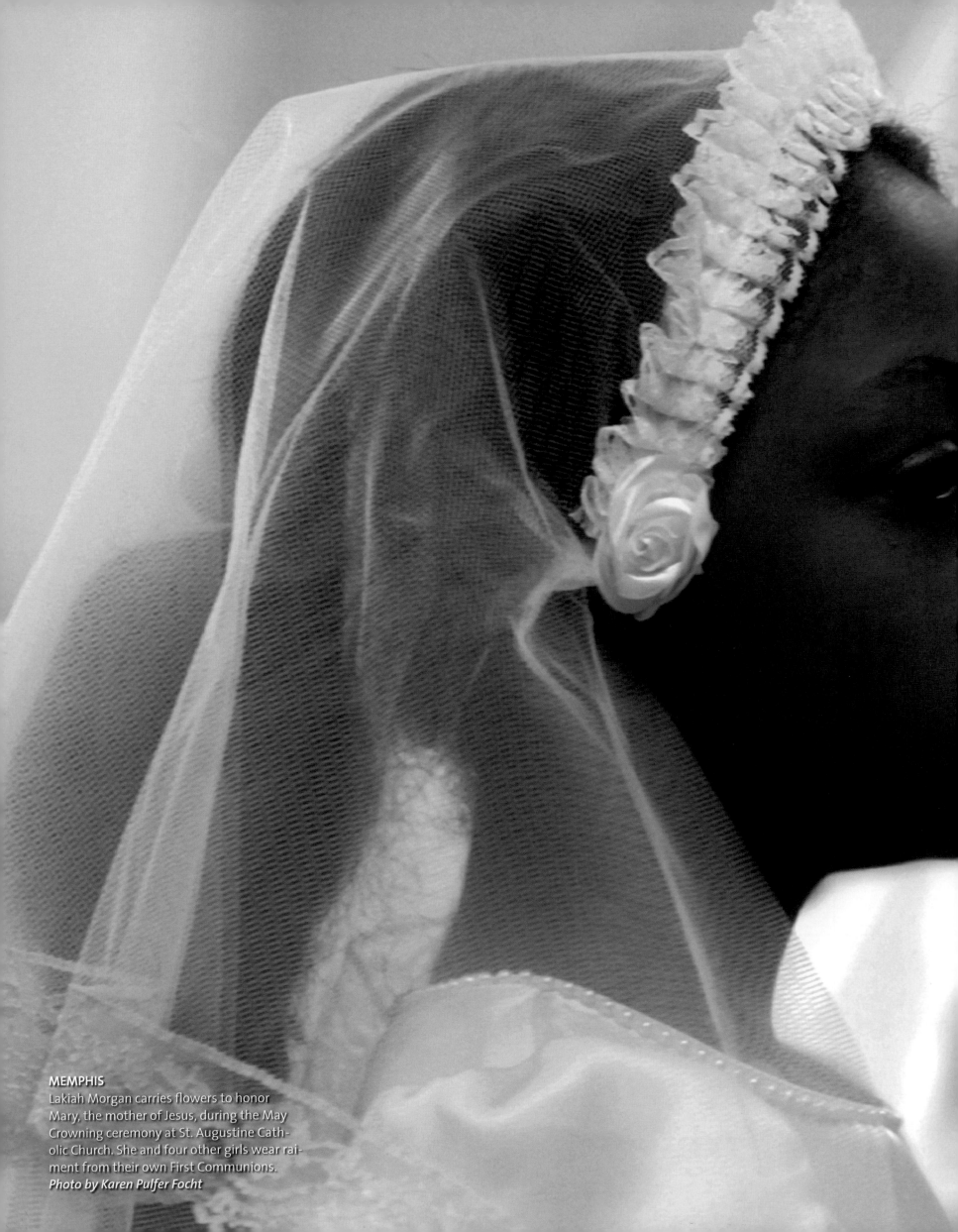

MEMPHIS
Lakiah Morgan carries flowers to honor Mary, the mother of Jesus, during the May Crowning ceremony at St. Augustine Catholic Church. She and four other girls wear raiment from their own First Communions.
Photo by Karen Pulfer Focht

Reason To Believe

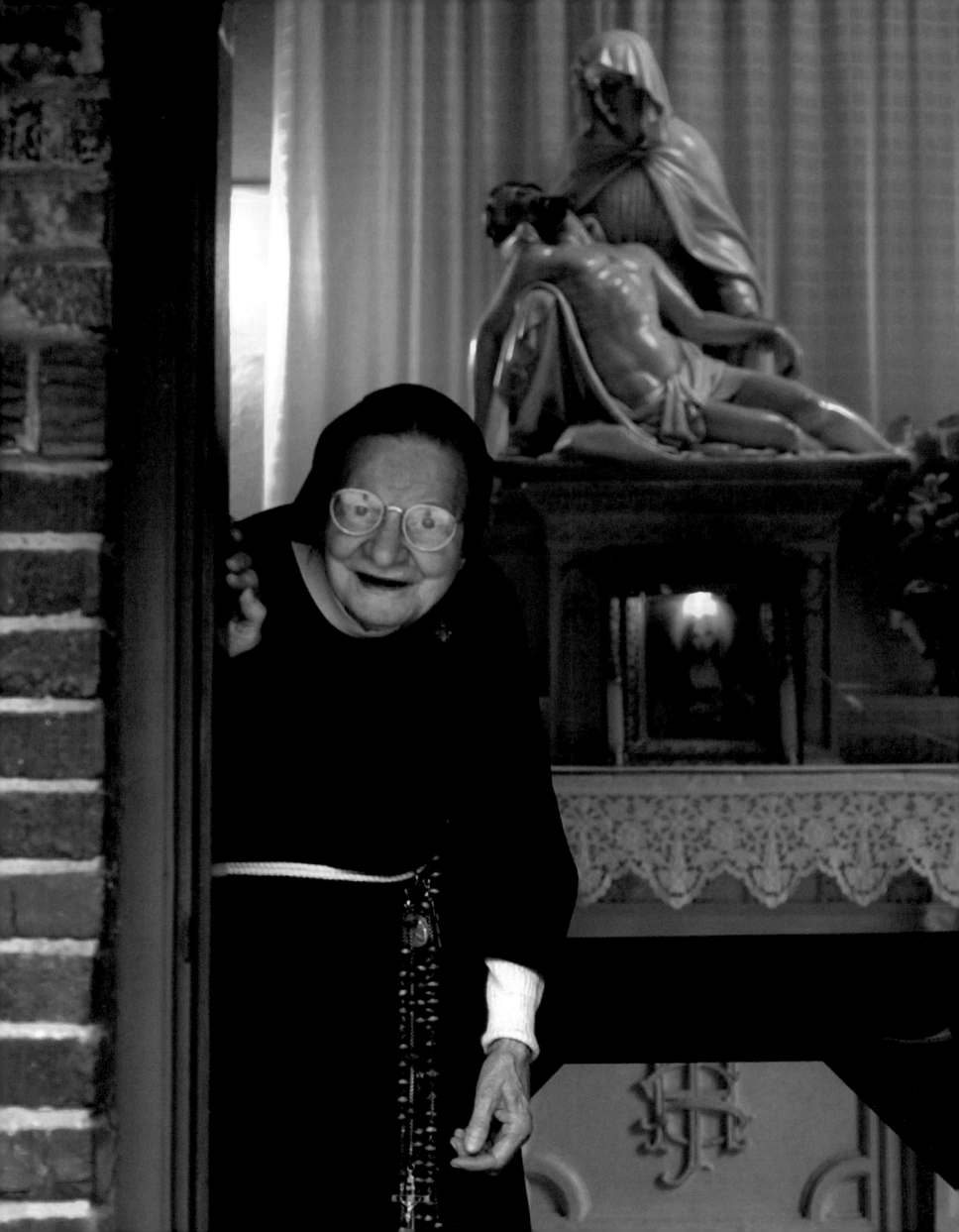

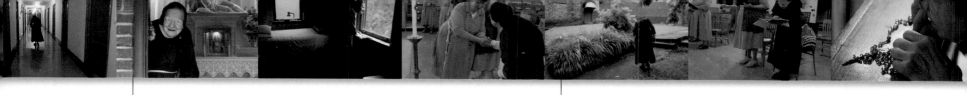

MEMPHIS

At the age of 10, Sister Mary Regina felt called to be a nun. Trained in the Franciscan order in Pennsylvania, she came to the Poor Clares monastery in 1964. She tends the Marian Shrine to the Sorrowful Mother. "It's my price and joy," she says.

Photos by Karen Pulfer Focht

MEMPHIS

Sister Mary Regina prefers to spend her days in silence. She prays up to seven hours a day. Her pilgrimage to the Chapel of Our Lady of Sorrows is part of her prayer ritual.

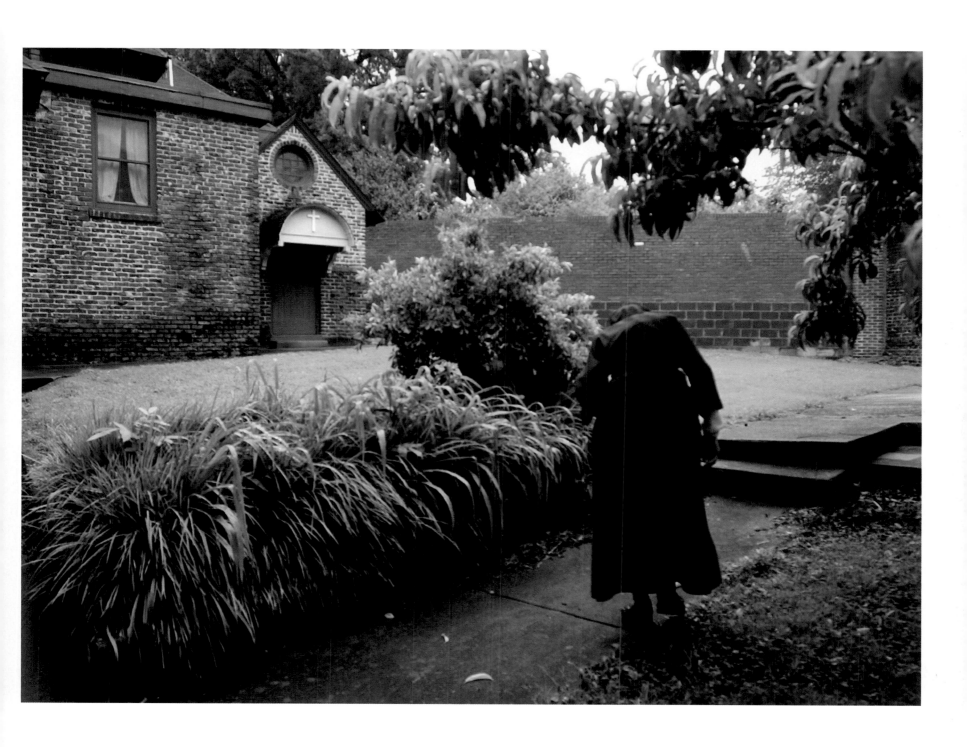

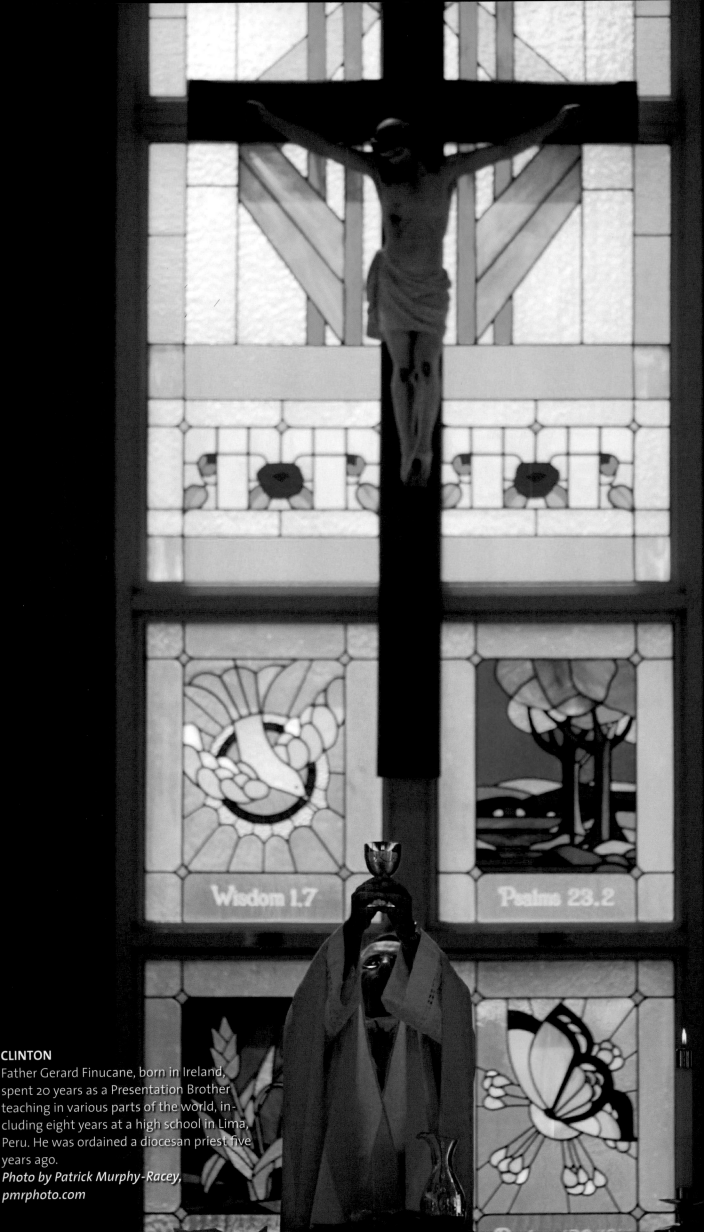

Wisdom 1.7

Psalms 23.2

CLINTON
Father Gerard Finucane, born in Ireland, spent 20 years as a Presentation Brother teaching in various parts of the world, including eight years at a high school in Lima, Peru. He was ordained a diocesan priest five years ago.
Photo by Patrick Murphy-Racey,
pmrphoto.com

456

JACKSON

On May 4, a tornado tore through downtown, mangling Mother Liberty Christian Methodist Episcopal Church on Highland Avenue. Organized by freed slaves after the Civil War, the church has been rebuilt twice after fires.

Photo by Lance Murphey

JACKSON

Sara Slack and sisters Francis and Claire Chandler remove debris from St. Luke's Episcopal Church after a May 4 tornado left the nave in shambles. Volunteers were able to save the altar, the reredos, and most of the stained-glass windows.
Photos by Lance Murphey

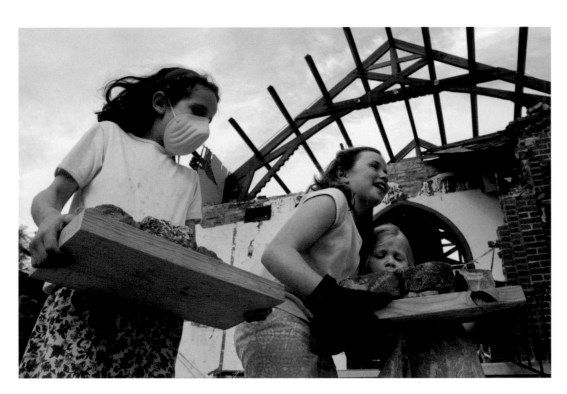

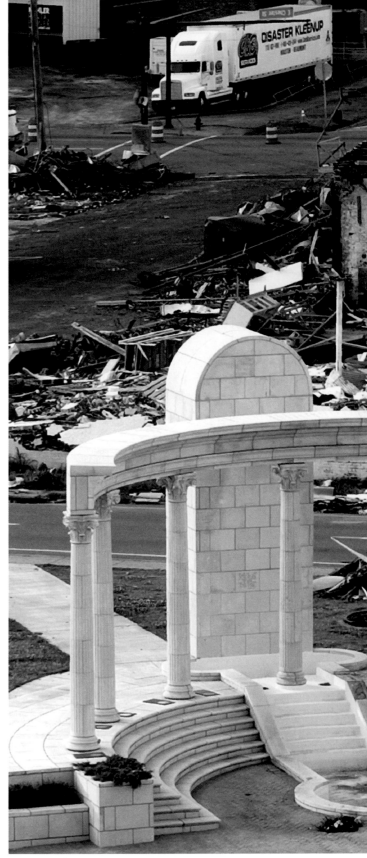

JACKSON

A memorial commemorating the six victims of a
1999 tornado remains standing after a tornado
on May 2 nearly decimated downtown Jackson,
killing 11 people in the area.

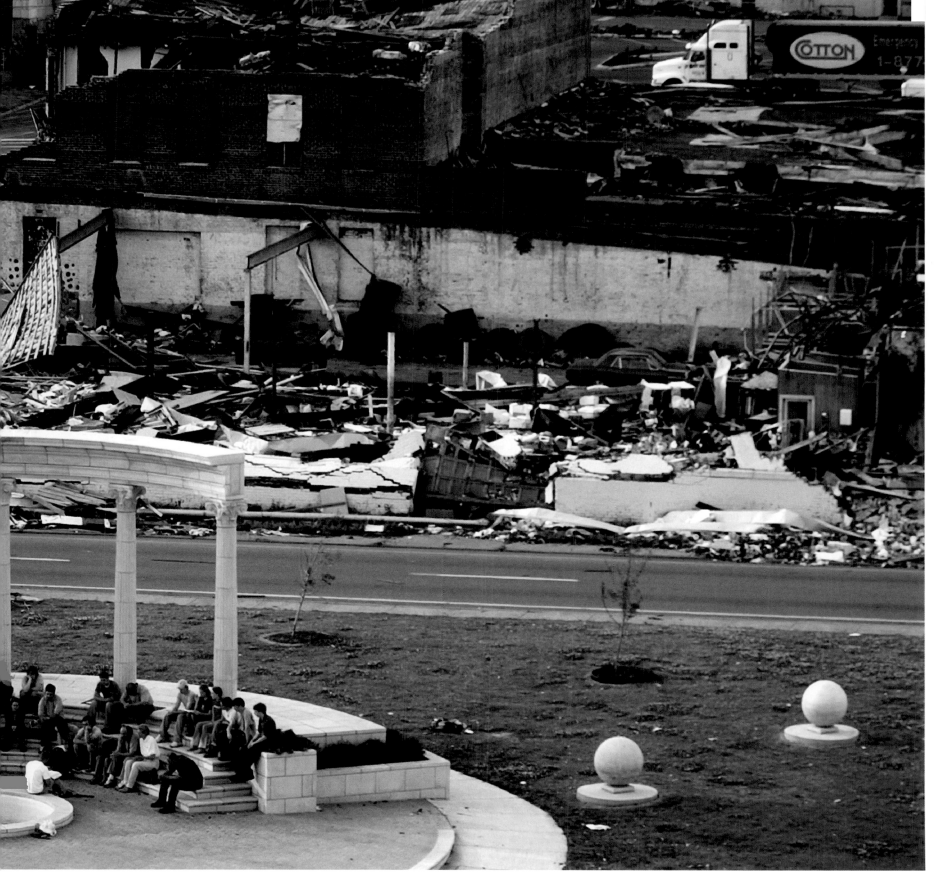

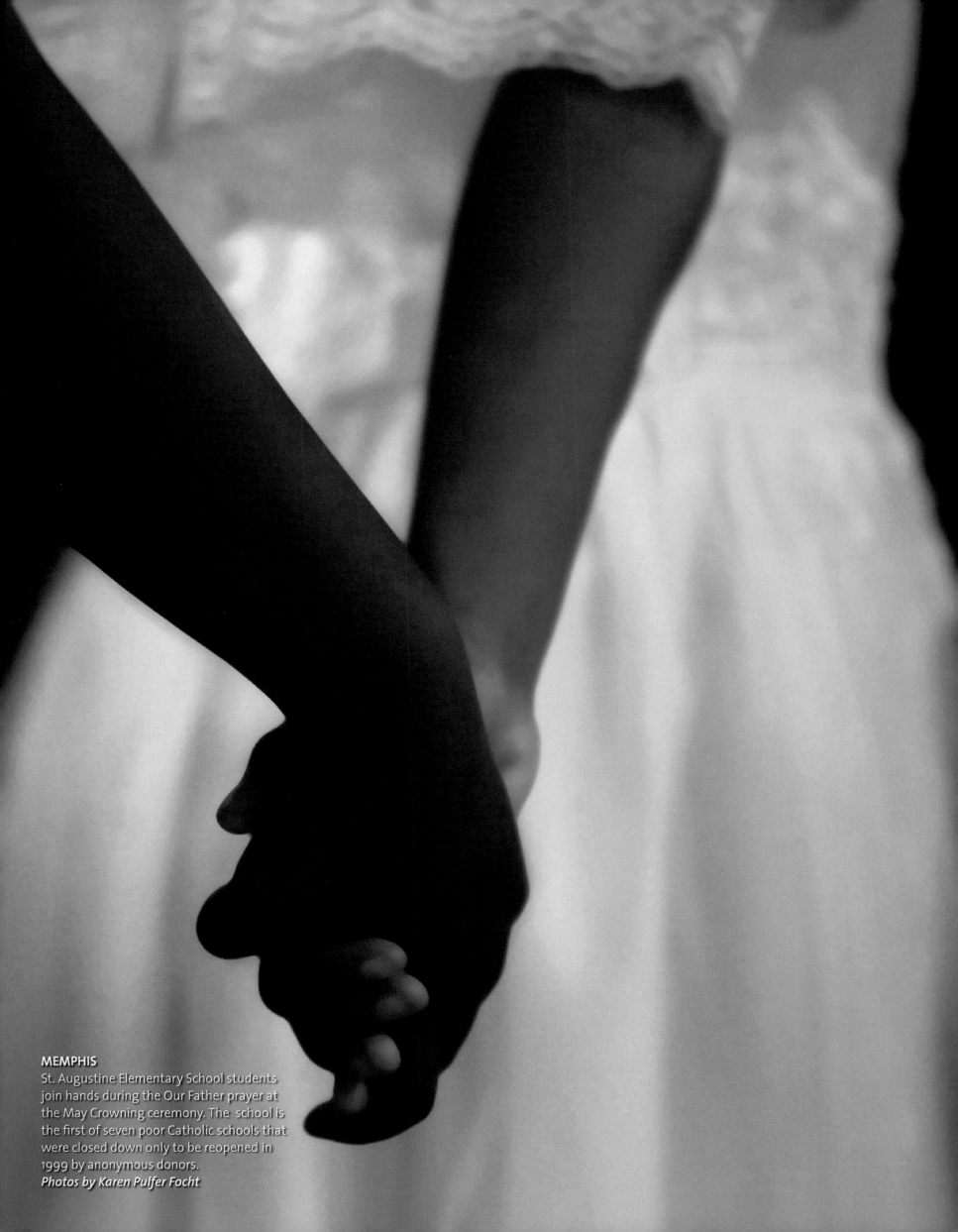

MEMPHIS
St. Augustine Elementary School students join hands during the Our Father prayer at the May Crowning ceremony. The school is the first of seven poor Catholic schools that were closed down only to be reopened in 1999 by anonymous donors.
Photos by Karen Pulfer Focht

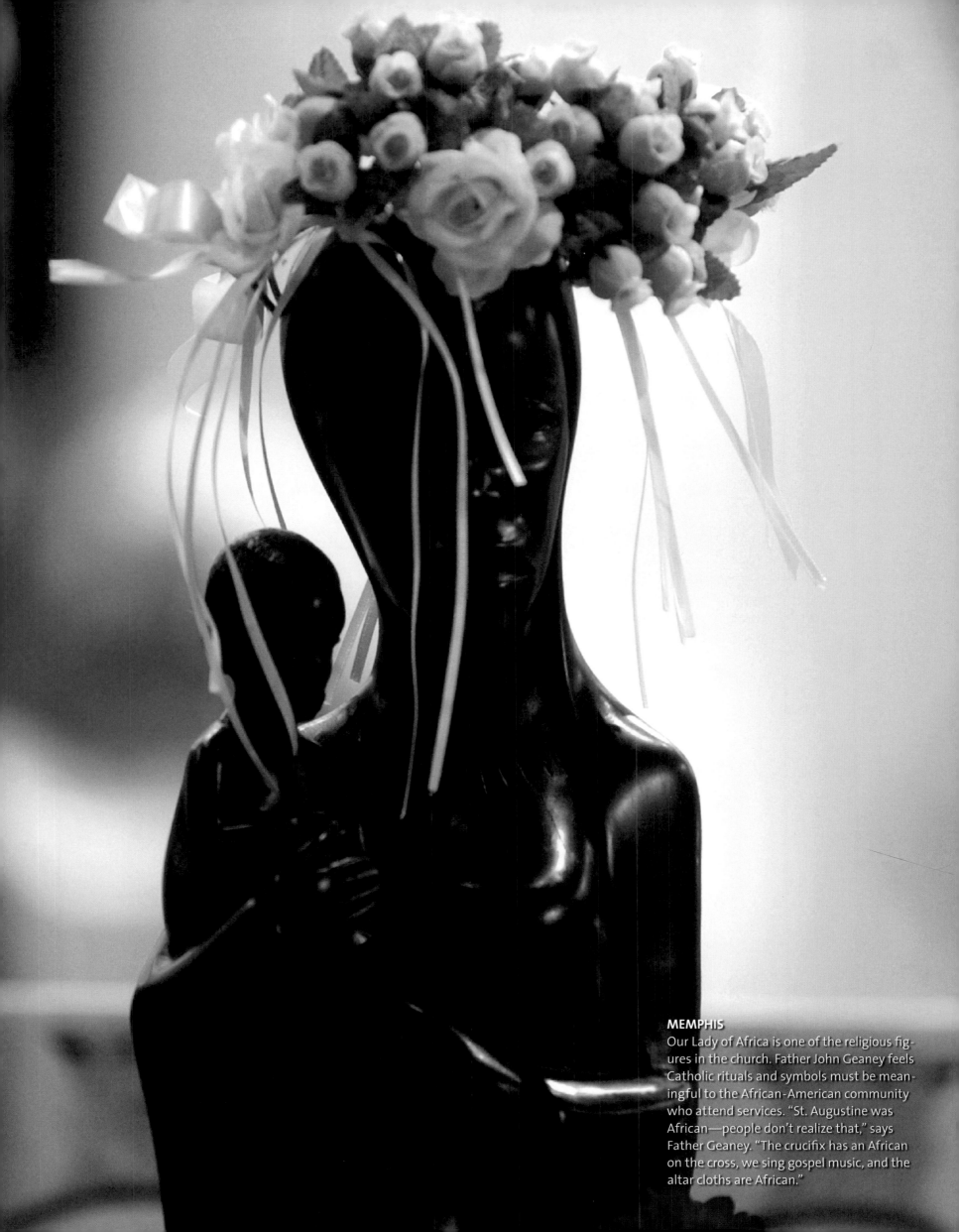

MEMPHIS
Our Lady of Africa is one of the religious figures in the church. Father John Geaney feels Catholic rituals and symbols must be meaningful to the African-American community who attend services. "St. Augustine was African—people don't realize that," says Father Geaney. "The crucifix has an African on the cross, we sing gospel music, and the altar cloths are African."

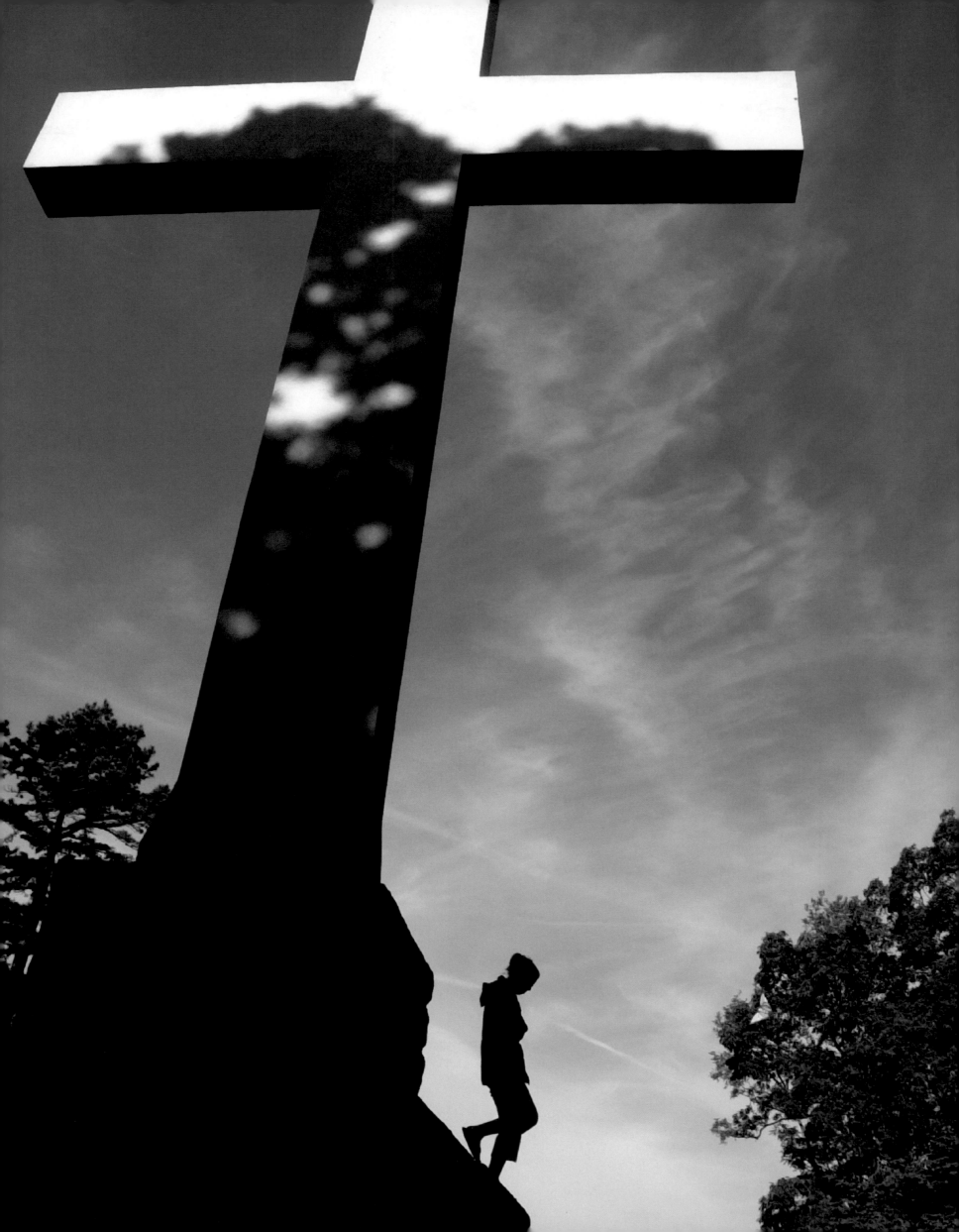

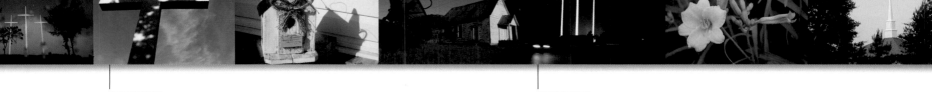

SEWANEE

The Memorial Cross, erected in 1922 on the University of the South campus, honors Sewanee residents who died in major U.S. conflicts starting with World War I.

Photo by Janet Worne, Lexington Herald-Leader

CORDOVA

Twenty-three miles east of Memphis, the crosses of Bellevue Baptist Church light up the night. The church celebrates its centennial this year. Despite its long history, the ministerial leadership has only changed hands twice.

Photo by Bruce Meisterman

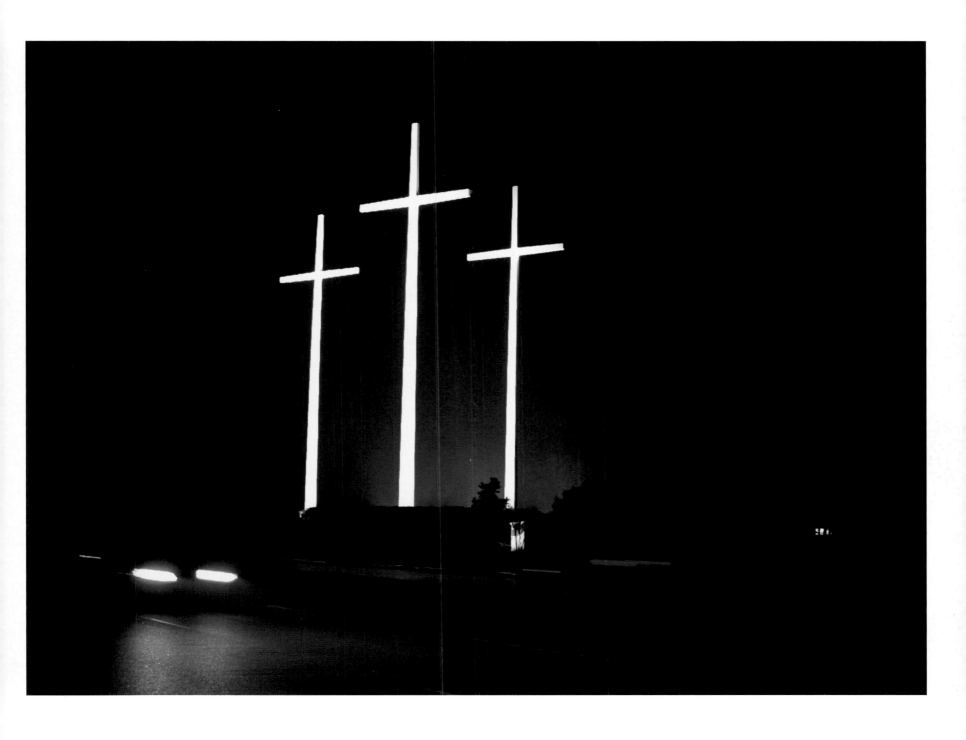

CLINTON

At St. Therese Catholic Church, Father Gerard Finucane doesn't believe in "crying rooms." In fact, if a parent gets up to leave mass with a noisy child, he says, "Sit down. Let them be children." This works out well for Kathi Palco. Her 2-year-old son Garrett is among the more vocal young parishioners. He often yells "Amen" whenever he feels like it.

Photos by Patrick Murphy-Racey, pmrphoto.com

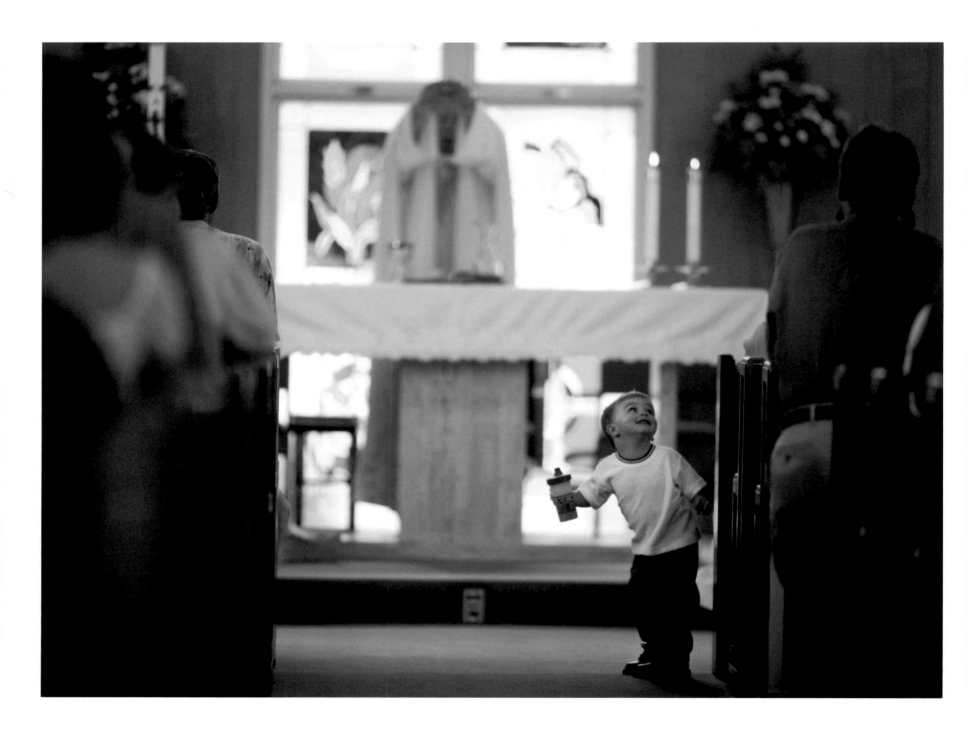

CLINTON

Sometimes, 11 a.m. comes a little too early. Father Gerard encourages everyone in his parish of 140 families to serve mass, not just the altar boys. As a result, there are many Sundays when a mom, dad, and son or daughter assist Father Gerard on the altar.

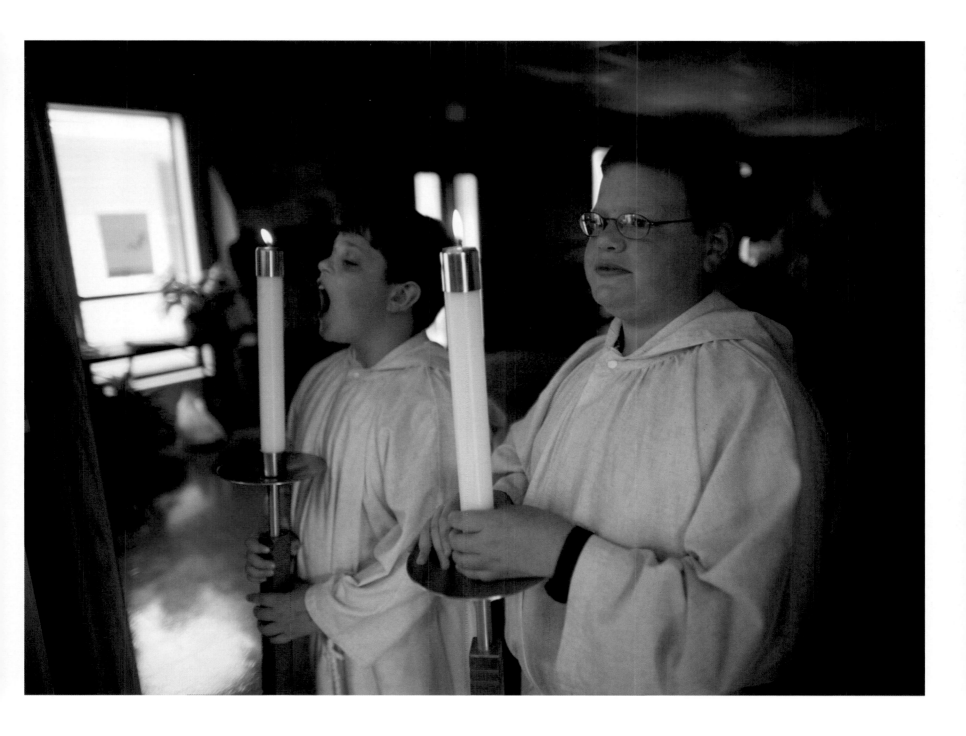

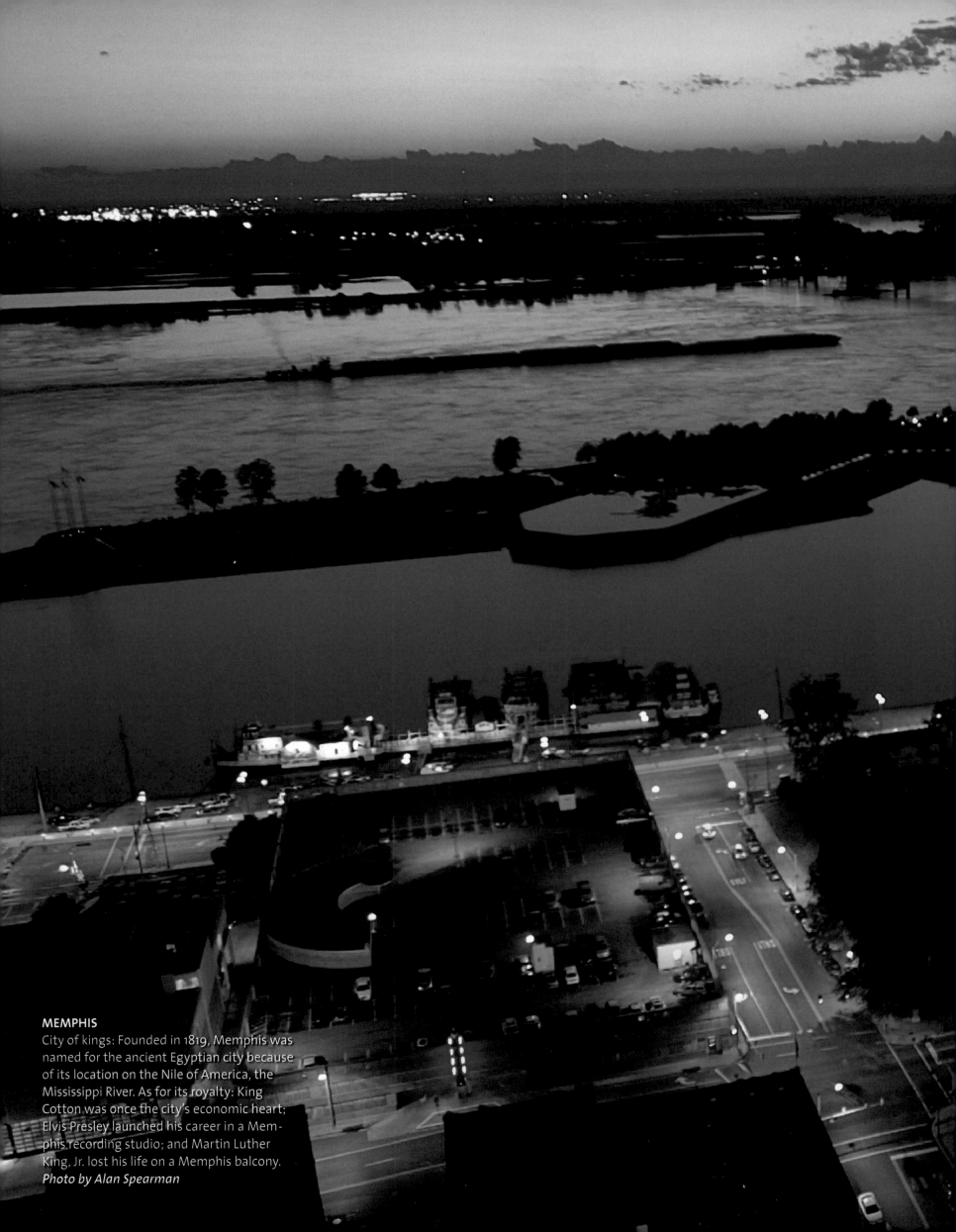

MEMPHIS

City of kings: Founded in 1819, Memphis was named for the ancient Egyptian city because of its location on the Nile of America, the Mississippi River. As for its royalty: King Cotton was once the city's economic heart; Elvis Presley launched his career in a Memphis recording studio; and Martin Luther King, Jr. lost his life on a Memphis balcony.
Photo by Alan Spearman

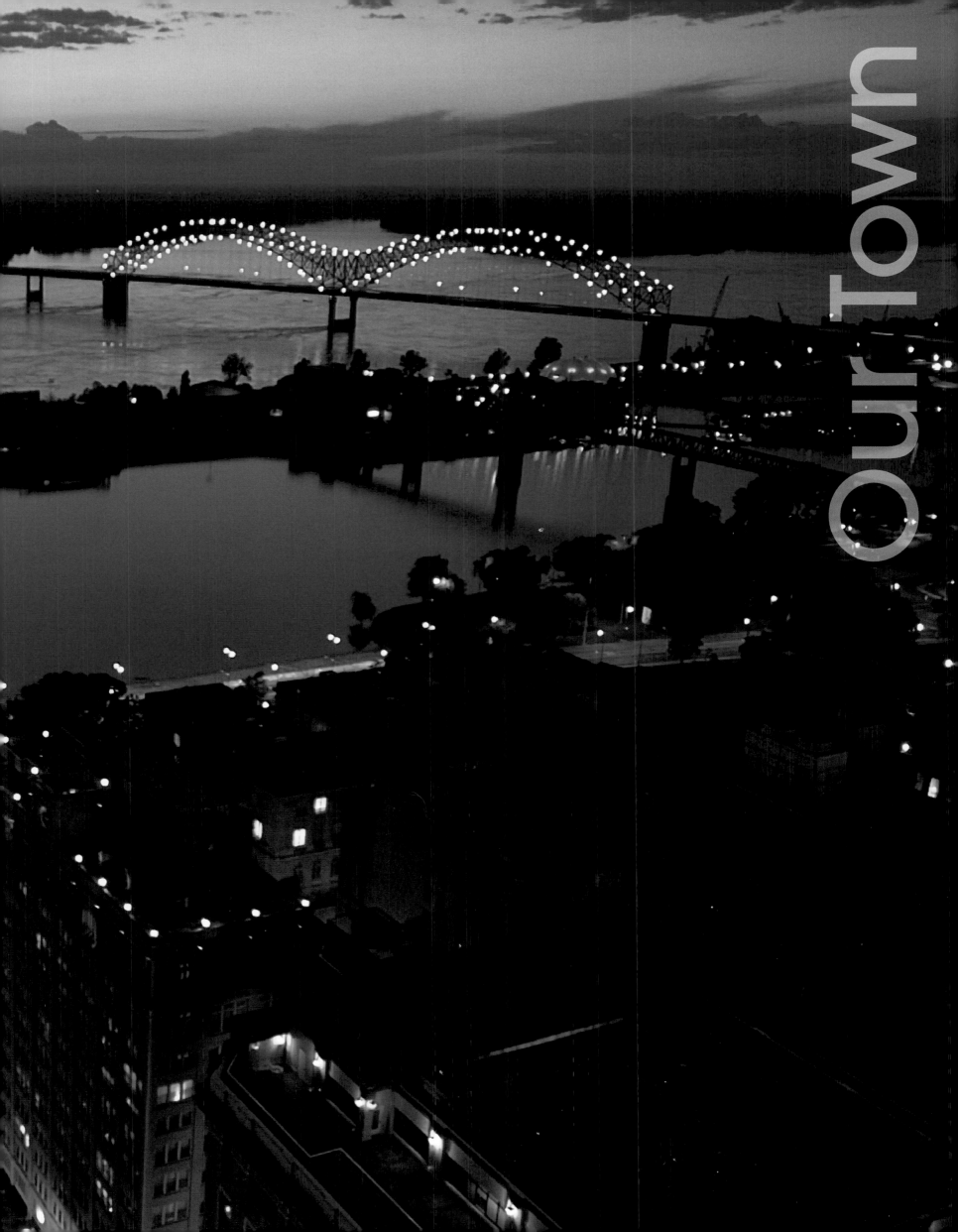

OurTown

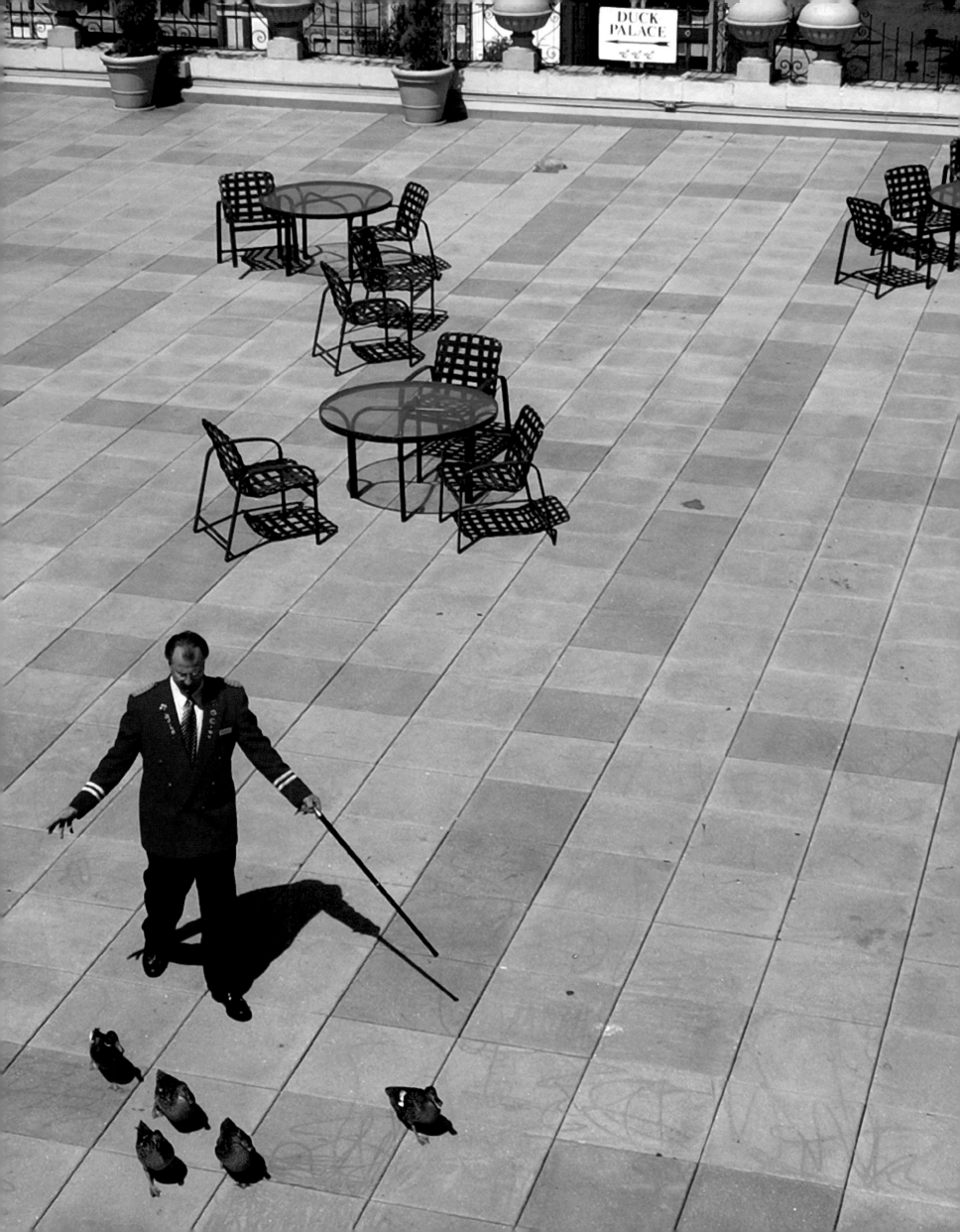

MEMPHIS

More than 250 applied, but Daniel J. Fox walked away with the title of Peabody Duckmaster after a nationwide job search. Fox ushers five hens and one drake mallard out of the Royal Duck Palace located on the Peabody Hotel's roof. More than 50 years ago, the original Duckmaster Edward Pembroke, a circus animal trainer turned bellhop, began the tradition by teaching the hotel's ducks to march.

Photos by Lance Murphey

MEMPHIS

The March of the Peabody Ducks takes place every day. At 11 a.m., five ducks exit their reserved elevator, waddling down the red carpet to Sousa's "King Cotton March." The destination? The Peabody Hotel lobby's Duck Fountain. The day is spent paddling and preening. At 5 p.m., back down the carpet and into their elevator to take their ease in the Palace.

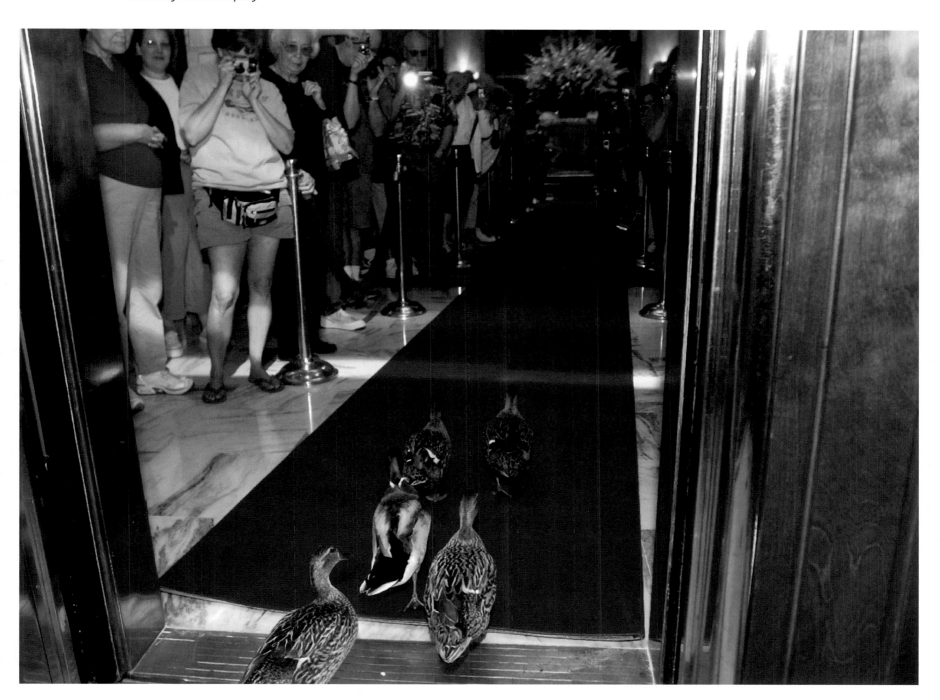

CHATTANOOGA
Portrait photographer Jay Mills was about to
scold his daughter Hannah for climbing on the
parked vintage cars. Then he noticed how good
she looked on the running board of a red Model A
in her new French dress.
Photo by John Rawlston

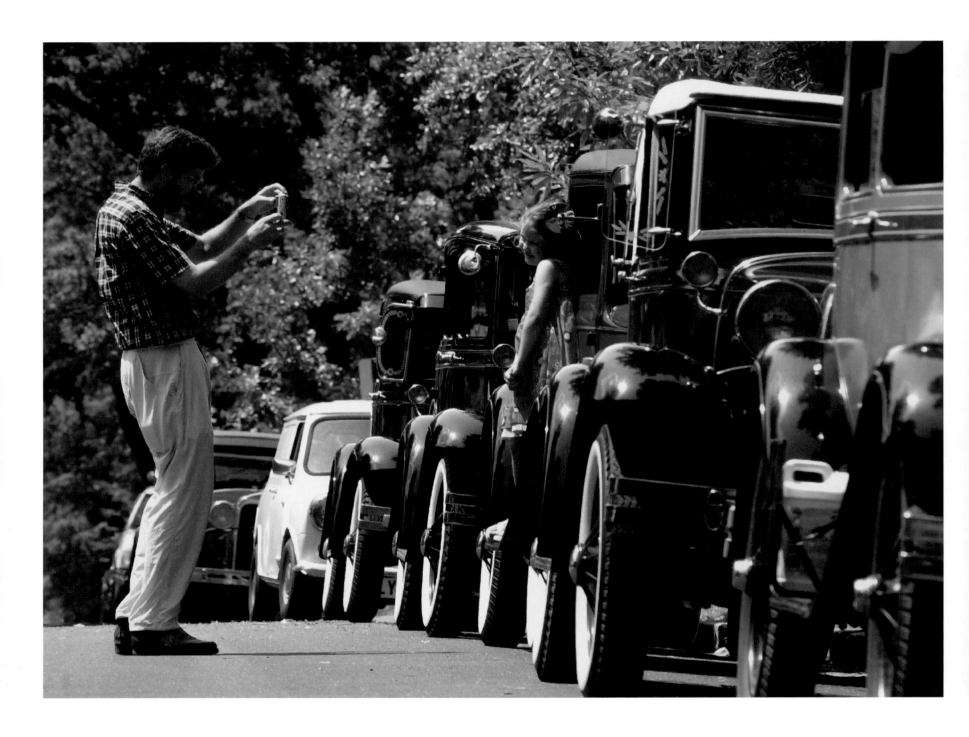

PIGEON FORGE

Keep on truckin': The 25th annual Ford F-100 Super Nationals and Family Reunion is the largest one-brand truck show in America. Begun by Jan and Pat Ford (Henry's fourth cousin), the event draws thousands of F-100 aficionados, who show off their restored and new trucks, and take excursions to places like Dollywood and the Great Smoky Mountains National Park.
Photo by Jim Eastin

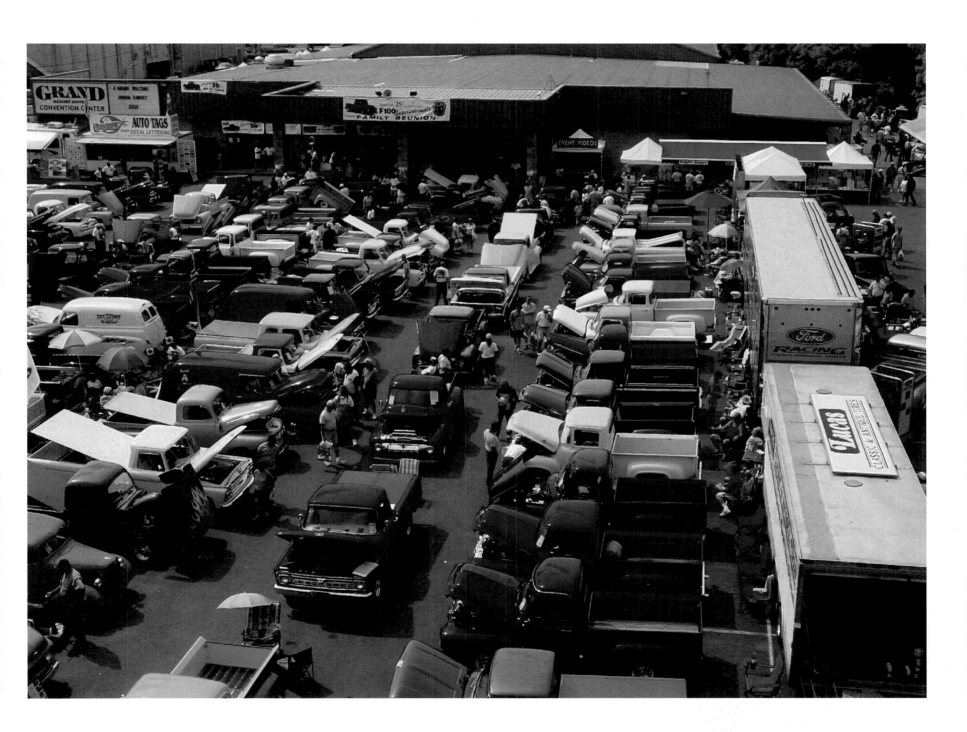

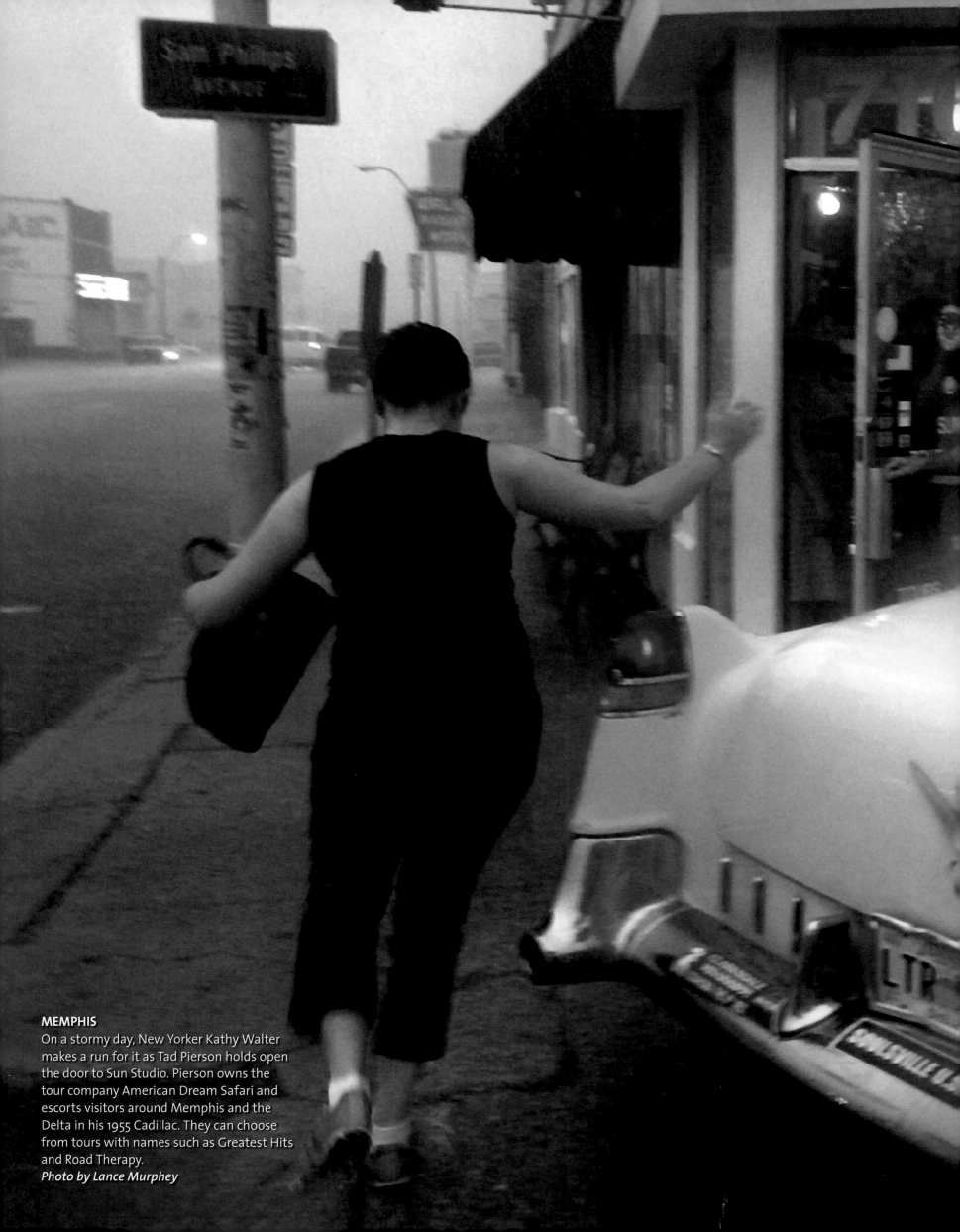

MEMPHIS
On a stormy day, New Yorker Kathy Walter makes a run for it as Tad Pierson holds open the door to Sun Studio. Pierson owns the tour company American Dream Safari and escorts visitors around Memphis and the Delta in his 1955 Cadillac. They can choose from tours with names such as Greatest Hits and Road Therapy.
Photo by Lance Murphey

NASHVILLE

The cost to hitch a ride on the big pink NashTrash tour bus is $25. Its 90-minute circuit hits the "lowlights" of country music sites around town: Ryman Auditorium, the original home of the Grand Ole Opry; Printers Alley; the dive bars; and even the county jail.

Photos by Dean Dixon

NASHVILLE

Happy tourists on the Jugg Sisters' NashTrash jitney: This Welsh bunch from Great Britain sampled country-western dancing at the Wildhorse Saloon and toured the infamous Men's District in Printer's Alley, where, even during Prohibition, patrons could find whatever they wanted. The NashTrash tour is strictly BYOB.

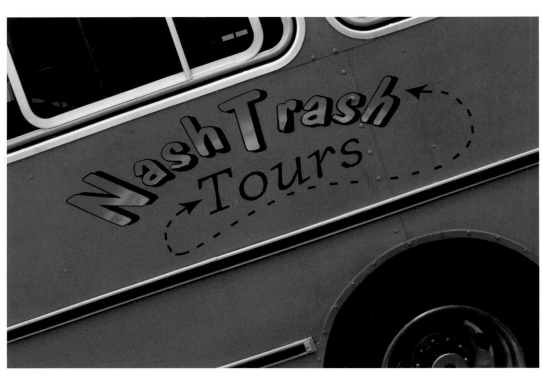

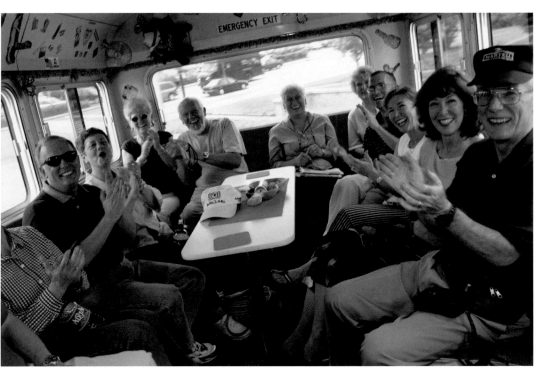

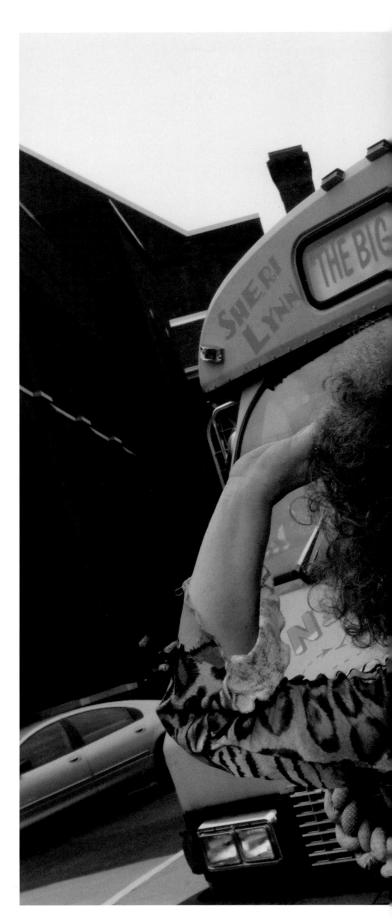

NASHVILLE
Singing tour guides, Brenda Kay and Sheri Lynn Jugg operate NashTrash Tours. They dish country music stars, give makeup tips on how to look trashier, and hand out their favorite recipes—including one for "knock-ya-nekkid" margaritas.

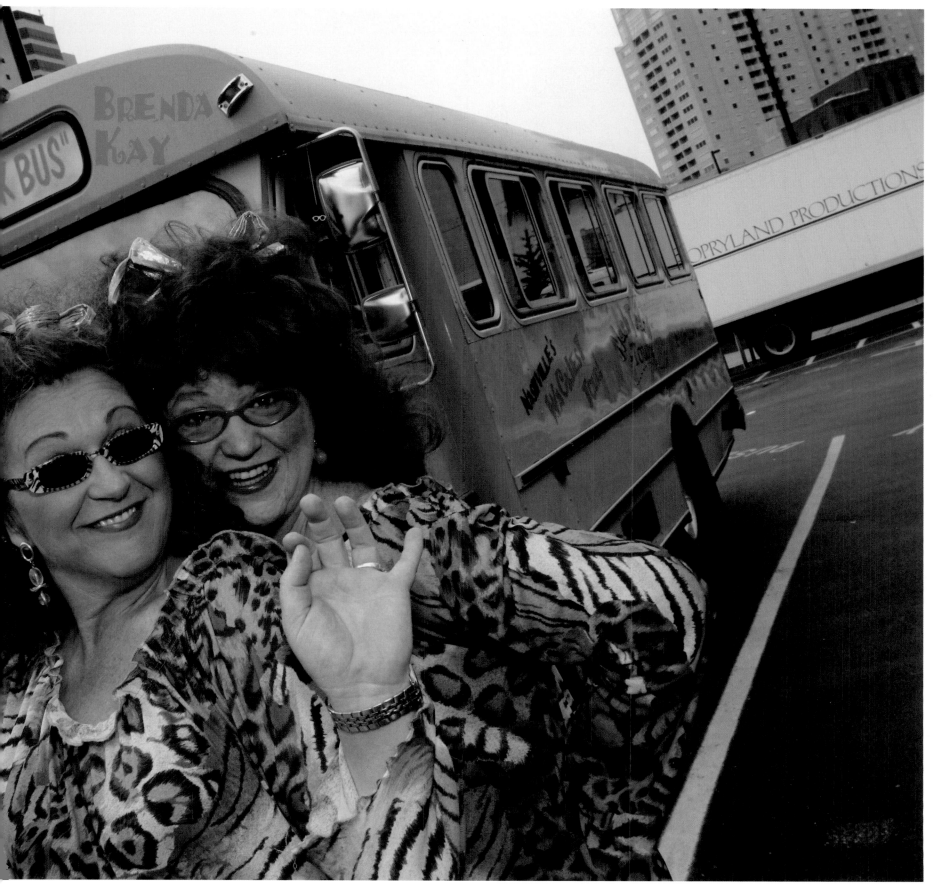

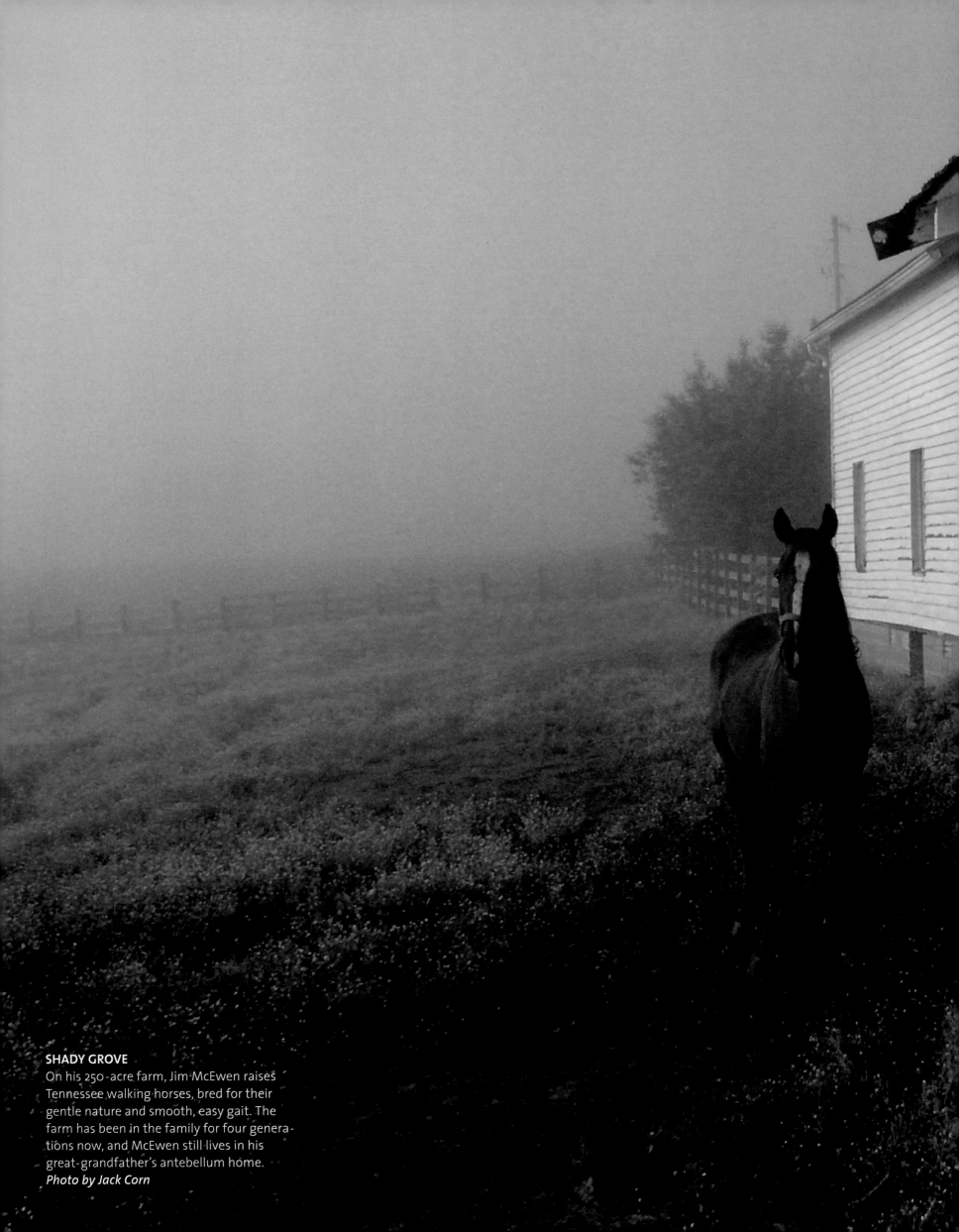

SHADY GROVE
On his 250-acre farm, Jim McEwen raises
Tennessee walking horses, bred for their
gentle nature and smooth, easy gait. The
farm has been in the family for four genera-
tions now, and McEwen still lives in his
great-grandfather's antebellum home.
Photo by Jack Corn

BENTON

Coasting on thermal currents, John McClary and Sarah Kelly soar above southeastern Tennessee farmlands in one of the Chilhowee Gliderport's L-23 Super Blaniks. McClary has been soloing since he was 14 years old and recently set a state record by gliding for 132.4 miles.
Photo by Chad McClure

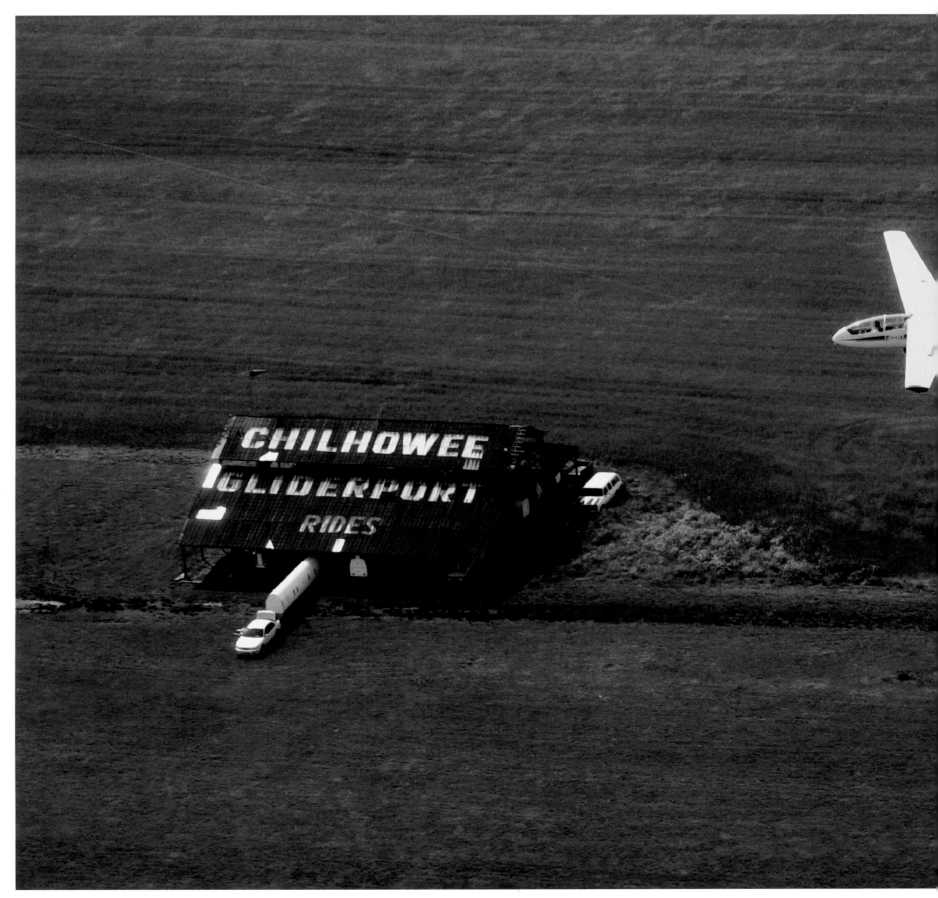

GREAT SMOKY MOUNTAINS NATIONAL PARK
Just outside Gatlinburg, the Roaring Fork stream offers the solace of deep woods. Turnouts along a six-mile loop road afford a quiet picnic spot by the water or access to trailheads that lead to Rainbow Falls and the Trillium Gap.
Photo by Gary Heatherly

SHADY GROVE
A direct descendent of an early settler in the area, Bill McEwen put a permanent conservation easement on his 170-acre farm so the land can never be developed.
Photo by Jack Corn

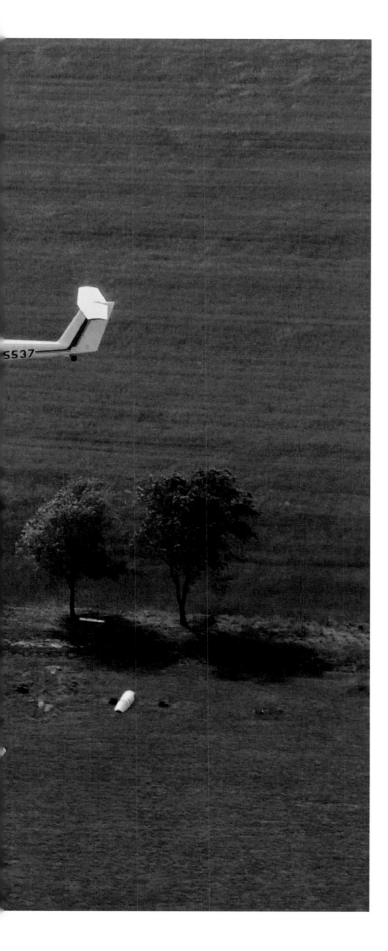

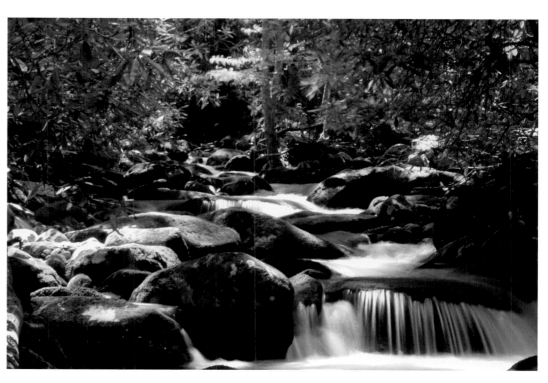

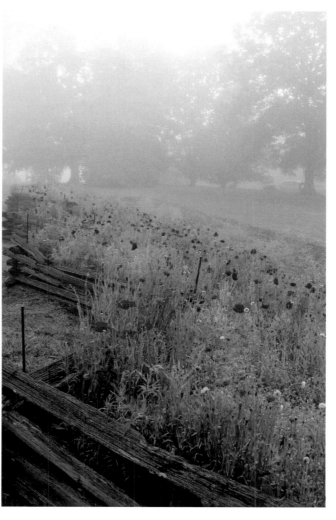

MEMPHIS
After her East High School graduation, Cherelle
Walls jubilates. The class salutatorian has just
learned that she and the valedictorian finished
with the same grade point average. The future
shines for Cherelle, who is heading off to MIT in
the fall with scholarships and awards in tow.
Photo by Lance Murphey

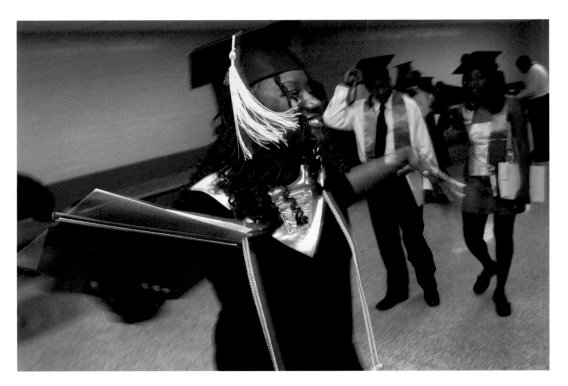

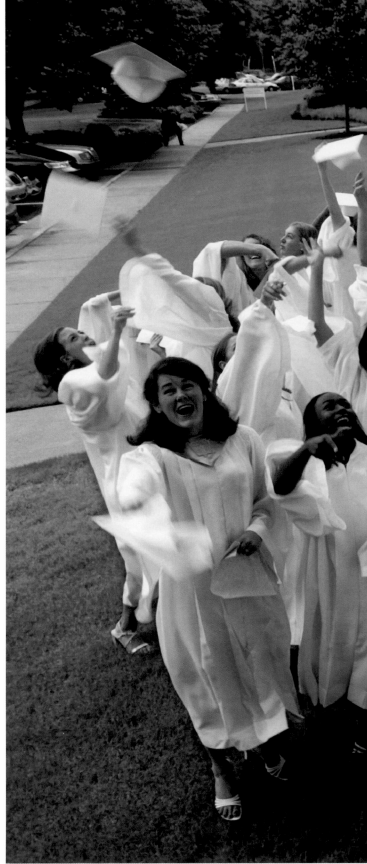

MEMPHIS

The 2003 graduating class of St. Mary's Episcopal School accumulated a whopping $3.6 million in merit scholarships to help the girls live up to their potential. The class of 64 young women was the largest in the school's 156-year history.
Photo by Lisa Waddell Buser

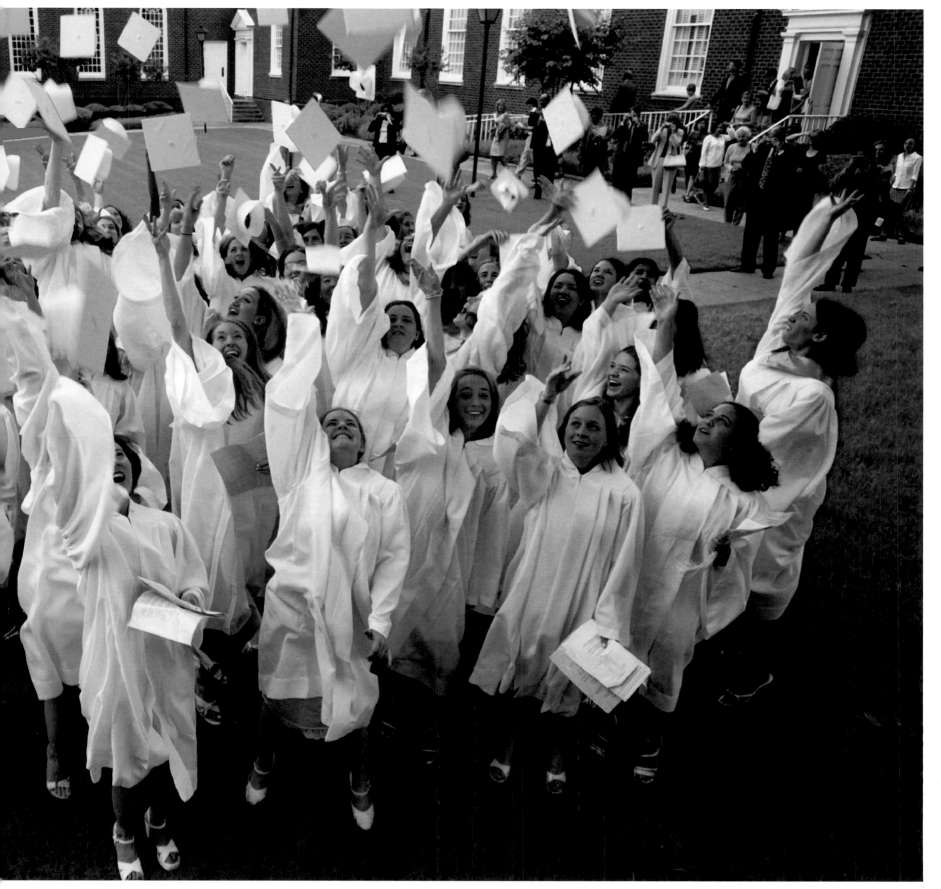

NASHVILLE
Next to the Gardner Memorial Chapel drive-up viewing window, funeral director Andrew L. Gardner, Jr. explains, "The window is for those who are sick or handicapped or not dressed properly for a funeral," he says. The idea came from his father, who died in 2002. Inside the building, there's a more traditional chapel.
Photos by John Partipilo, The Tennessean

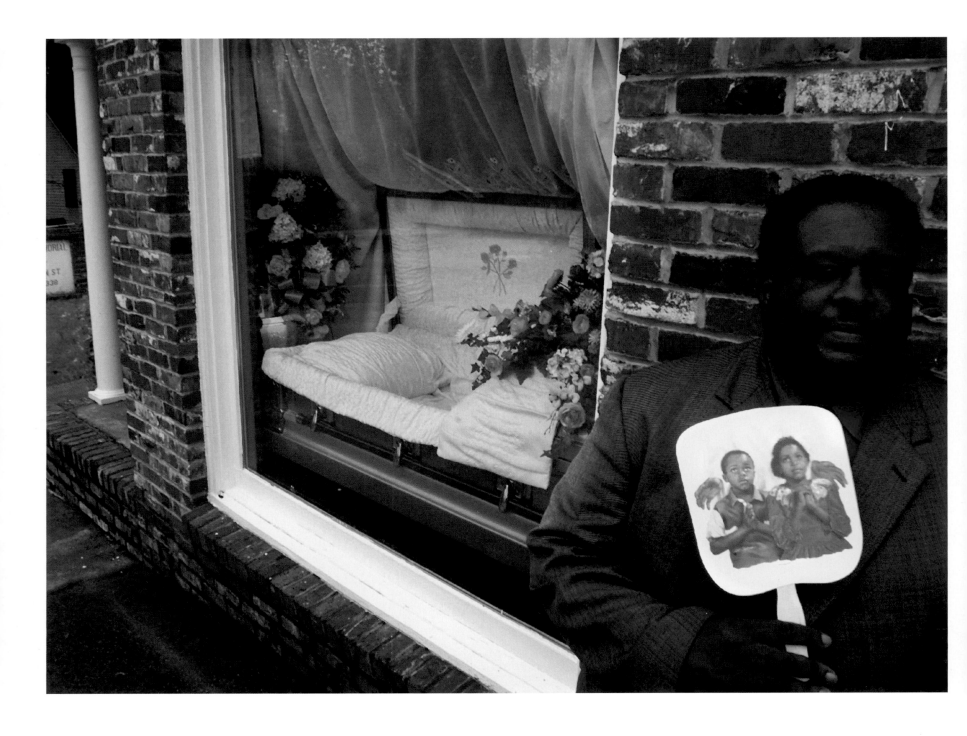

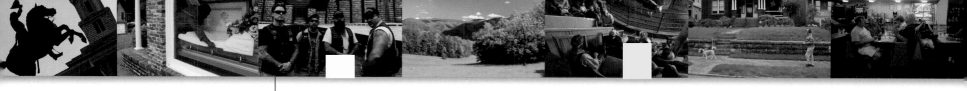

NASHVILLE

Rock, Keebler, Ignatz, and Sledgehammer are members of the New Jersey, Florida, and Tennessee chapters of the Teamsters motorcycle club. They've rumbled into Nashville to down a few beers and listen to live country music on Broadway.

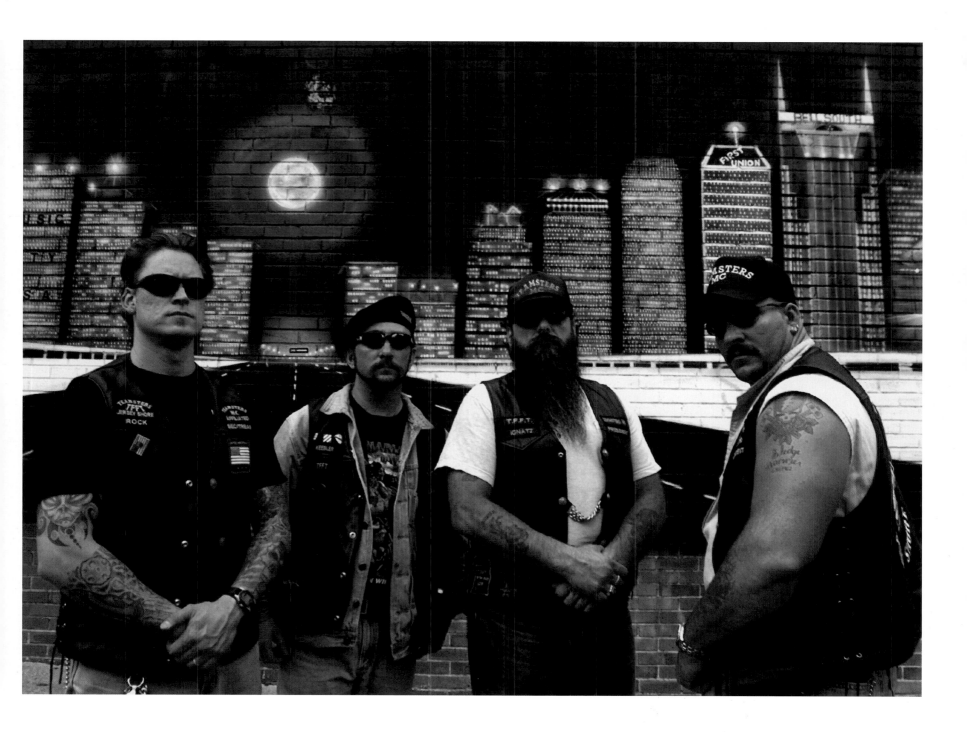

MEMPHIS
Where's Kermie? Robert Loesch of Bartlett is just one of several contestants vying for the title of Ms. Piggie at the Memphis in May World Championship Barbecue Cooking Contest.
Photos by Lance Murphey

MEMPHIS

Sow Luau team members cut loose after their on-stage performance in the Ms. Piggie competition. The weekend's contenders compete in categories such as sauces, costumes, and t-shirt design during the annual event known as the "Superbowl of Swine." As for the Ms. Piggie pageant, Sow Luau hogged second place.

MEMPHIS

Sam Barbieri of Flushing, New York, and Scott Abbott of Shawnee, Kansas, talk pig. The annual barbecue cooking contest attracts 90,000 visitors from around the world. Some come with the hopes of winning part of the $61,050 prize money; others come to see the crazy costumes or the plethora of grills.

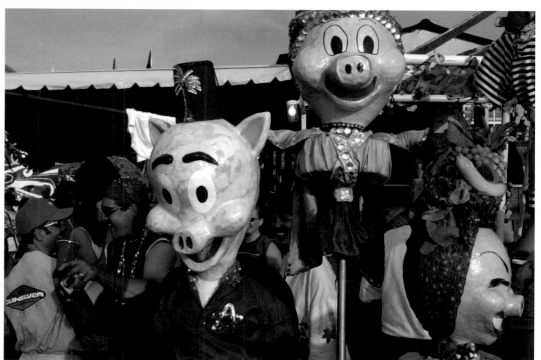

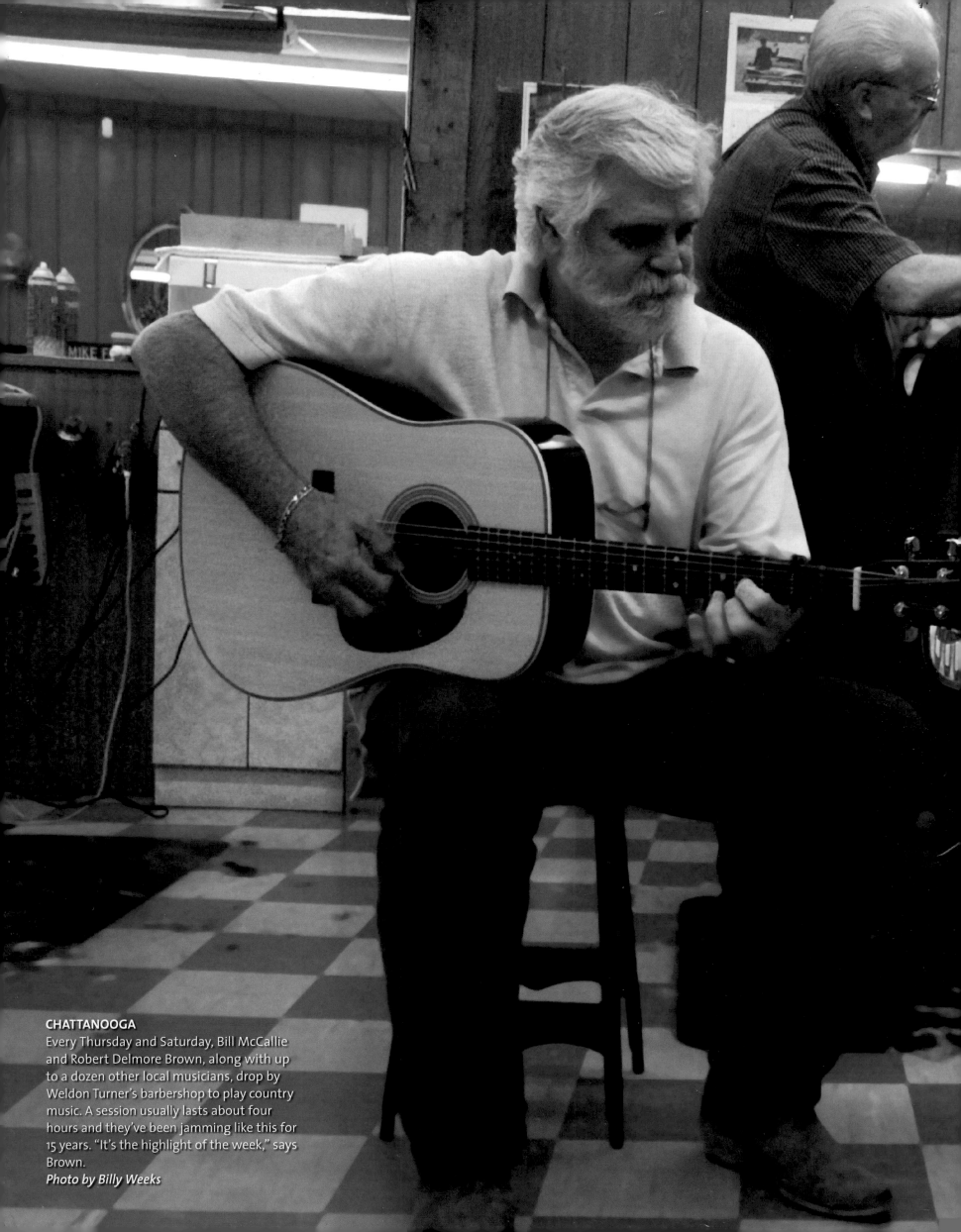

CHATTANOOGA
Every Thursday and Saturday, Bill McCallie and Robert Delmore Brown, along with up to a dozen other local musicians, drop by Weldon Turner's barbershop to play country music. A session usually lasts about four hours and they've been jamming like this for 15 years. "It's the highlight of the week," says Brown.
Photo by Billy Weeks

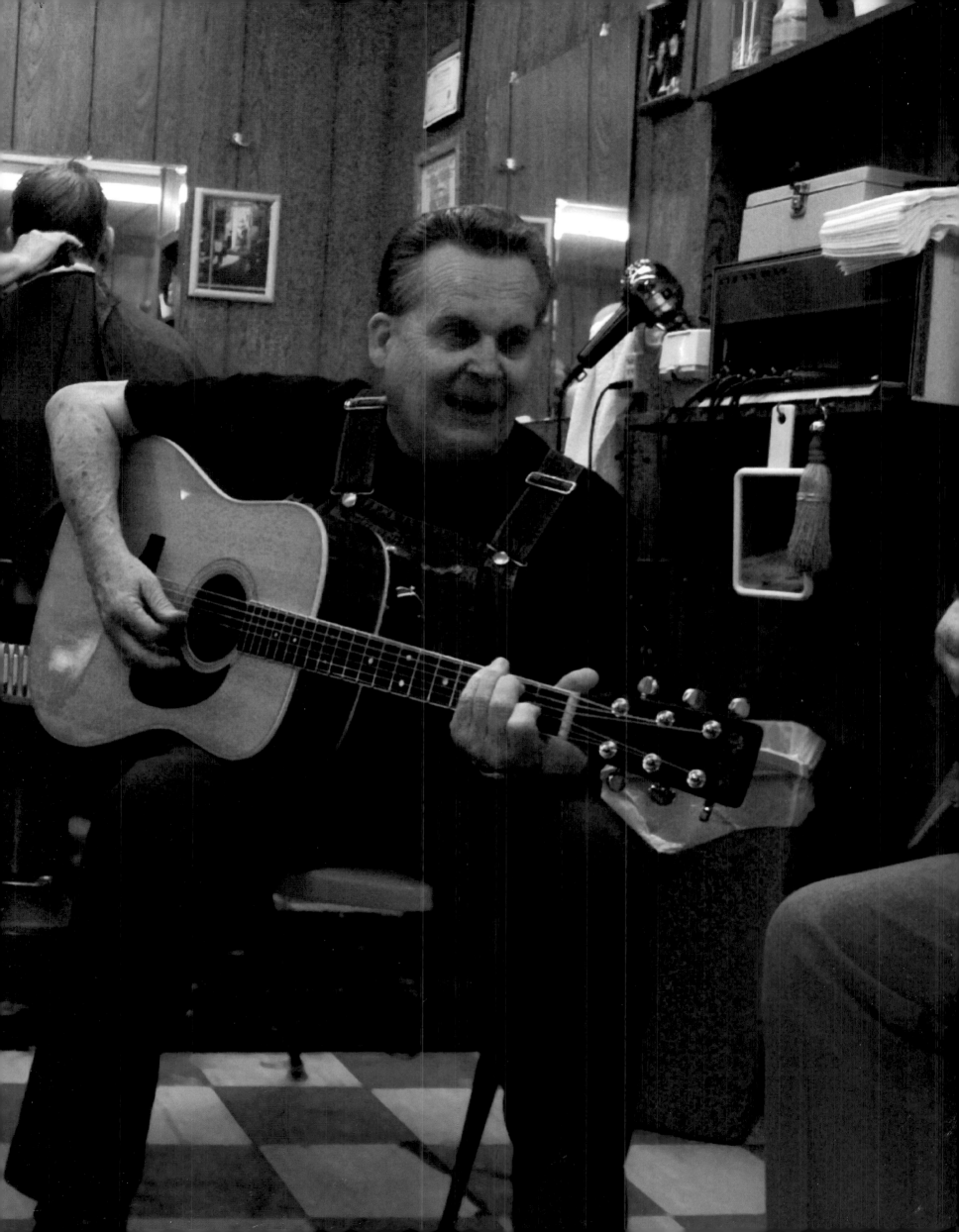

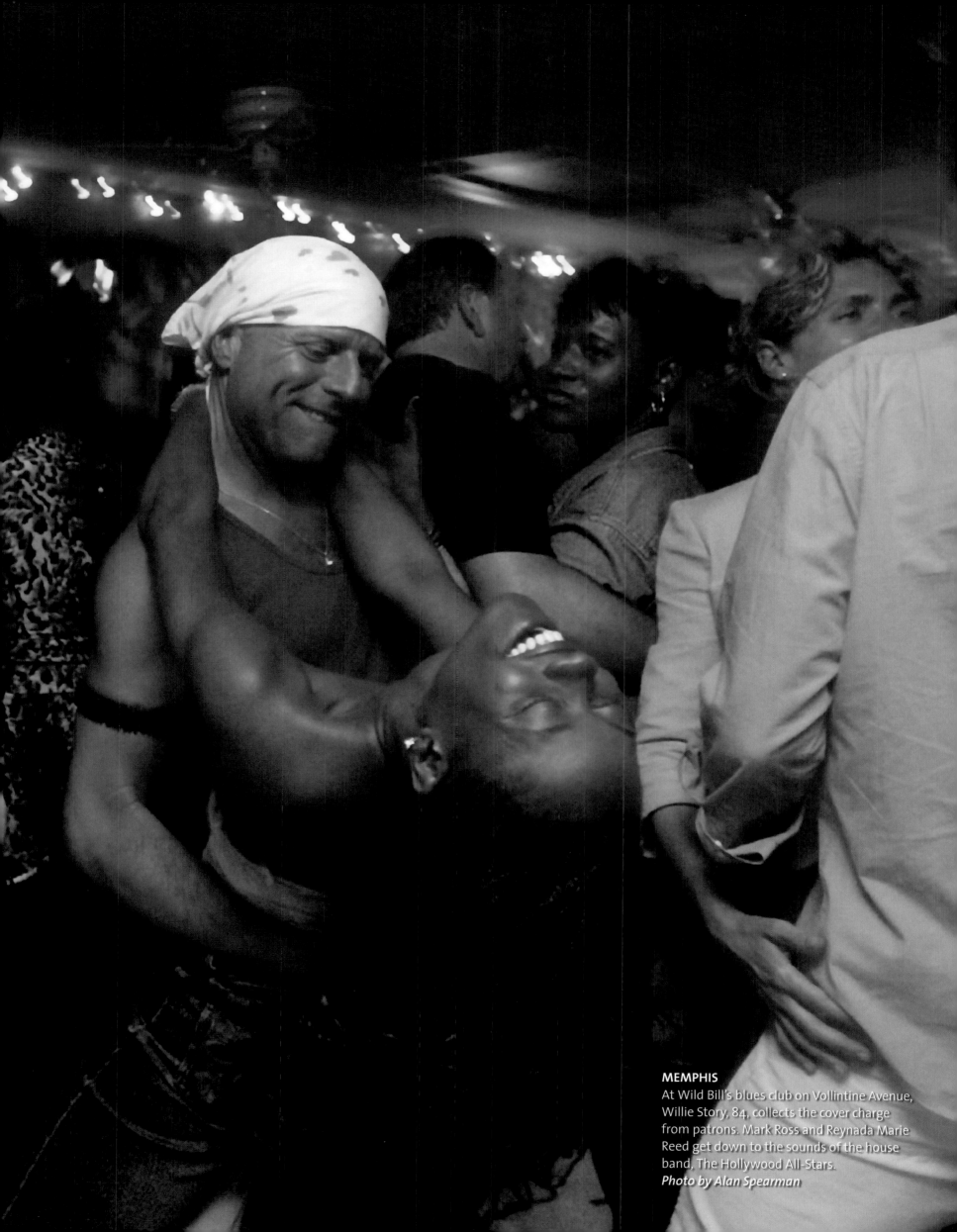

MEMPHIS

At Wild Bill's blues club on Vollintine Avenue, Willie Story, 84, collects the cover charge from patrons. Mark Ross and Reynada Marie Reed get down to the sounds of the house band, The Hollywood All-Stars.
Photo by Alan Spearman

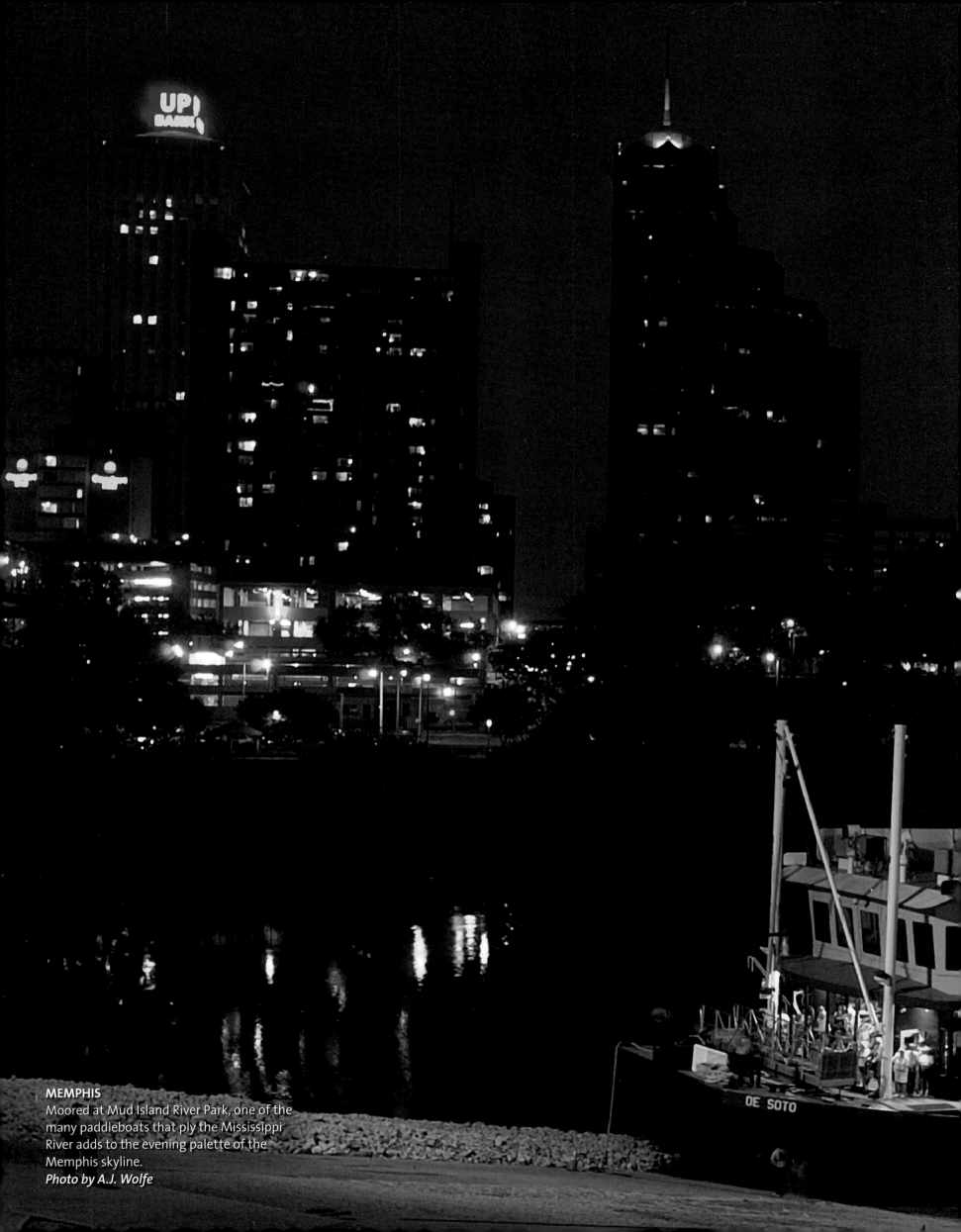

MEMPHIS
Moored at Mud Island River Park, one of the
many paddleboats that ply the Mississippi
River adds to the evening palette of the
Memphis skyline.
Photo by A.J. Wolfe

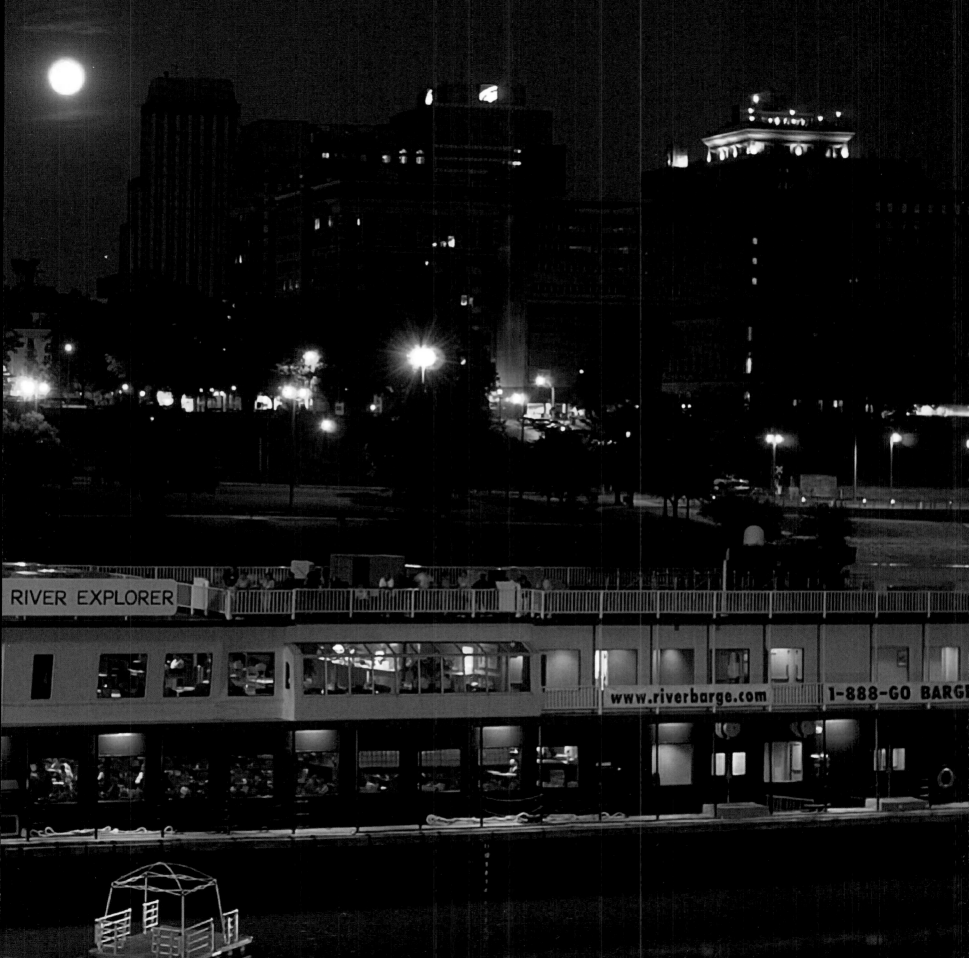

How It Worked

The week of May 12-18, 2003, more than 25,000 professional and amateur photographers spread out across the nation to shoot over a million digital photographs with the goal of capturing the essence of daily life in America.

The professional photographers were equipped with Adobe Photoshop and Adobe Album software, Olympus C-5050 digital cameras, and Lexar Media's high-speed compact flash cards.

The 1,000 professional contract photographers plus another 5,000 stringers and students sent their images via FTP (file transfer protocol) directly to the *America 24/7* website. Meanwhile, thousands of amateur photographers uploaded their images to Snapfish's servers.

At *America 24/7*'s Mission Control headquarters, located at CNET in San Francisco, dozens of picture editors from the nation's most prestigious publications culled the images down to 25,000 of the very best, using Photo Mechanic by Camera Bits. These photos were transferred into Webware's ActiveMedia Digital Asset Management (DAM) system, which served as a central image library and enabled the designers to track, search, distribute, and reformat the images for the creation of the 51 books, foreign language editions, web and magazine syndication, posters, and exhibitions.

Once in the DAM, images were optimized (and in some cases resampled to increase image resolution) using Adobe Photoshop. Adobe InDesign and Adobe InCopy were used to design and produce the 51 books, which were edited and reviewed in multiple locations around the world in the form of Adobe Acrobat PDFs. Epson Stylus printers were used for photo proofing and to produce large-format images for exhibitions. The companies providing support for the *America 24/7* project offer many of the essential components for anyone building a digital darkroom. We encourage you to read more on the following pages about their respective roles in making *America 24/7* possible.

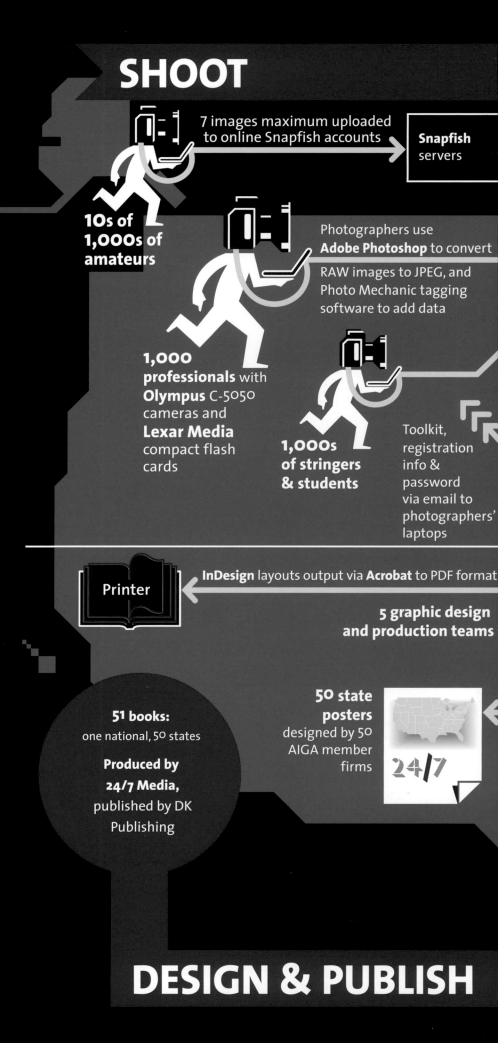

SHOOT

7 images maximum uploaded to online Snapfish accounts

Snapfish servers

10s of 1,000s of amateurs

Photographers use **Adobe Photoshop** to convert RAW images to JPEG, and Photo Mechanic tagging software to add data

1,000 professionals with **Olympus** C-5050 cameras and **Lexar Media** compact flash cards

1,000s of stringers & students

Toolkit, registration info & password via email to photographers' laptops

Printer

InDesign layouts output via **Acrobat** to PDF format

5 graphic design and production teams

51 books: one national, 50 states

Produced by 24/7 Media, published by DK Publishing

50 state posters designed by 50 AIGA member firms

24/7

DESIGN & PUBLISH

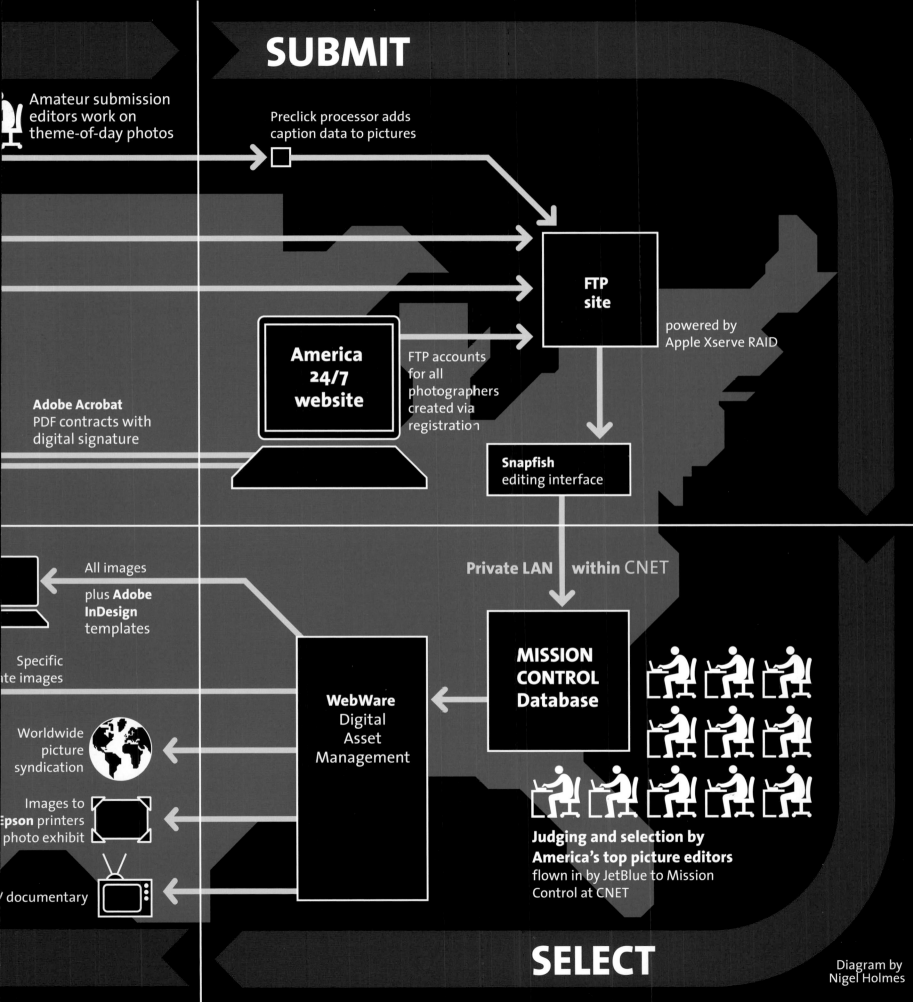

About Our Sponsors

America 24/7 gave digital photographers of all levels the opportunity to share their visions of what it means to live in the United States. This project was made possible by a digital photography revolution that is dramatically changing and improving picture-taking for professionals and amateurs alike. And an Adobe product, Photoshop®, has been at the center of this sea change.

Adobe's products reflect our customers' passion for the creative process, be it the photographer, graphic designer, layout artist, or printer. Adobe is the Publishing and Imaging Software Partner for *America 24/7* and products such as Adobe InDesign®, Photoshop, Acrobat®, and Illustrator® were used to produce this stunning book in a matter of weeks. We hope that our software has helped do justice to the mythic images, contributed by well-known photographers and the inspired hobbyist.

Adobe is proud to be a lead sponsor of *America 24/7*, a project that celebrates the vibrancy of the American spirit: the same spirit that helped found Adobe and inspires our employees and customers to deliver the very best.

Bruce Chizen
President and CEO
Adobe Systems Incorporated

Olympus, a global technology leader in designing precision healthcare solutions and innovative consumer electronics, is proud to be the official digital camera sponsor of *America 24/7*. The opportunity to introduce Americans from coast to coast to the thrill, excitement, and possibility of digital photography makes the vision behind this book a perfect fit for Olympus, a leader in digital cameras since 1996.

For most people, the essence of digital photography is best grasped through firsthand experience with the technology, which is precisely what *America 24/7* is about. We understand that direct experience is the pathway to inspiration, and welcome opportunities like this sponsorship to bring the power of the digital experience into the lives of people everywhere. To Olympus, *America 24/7* offers a platform to help realize a core mission: to deliver and make accessible the power of the digital experience to millions of American photographers, amateurs, and professionals alike.

The 1,000 professional photographers contracted to shoot on the America 24/7 project were all equipped with Olympus C-5050 digital cameras. Like all Olympus products, the C-5050 is offered by a company well known for designing, manufacturing, and servicing products used by professionals to perform their work, every day. Olympus is a customer-centric company committed to working one-to-one with a diverse group of professionals. From biomedical researchers who use our clinical microscopes, to doctors who perform life-saving procedures with our endoscopes, to professional photographers who use cameras in their daily work, Olympus is a trusted brand.

The digital imaging technology involved with *America 24/7* has enabled the soul of America to be visually conveyed, not just by professional observers, but by the American public who participated in this project—the very people who collectively breath life into this country's existence each day.

We are proud to be enabling so many photographers to capture the pictures on these pages that tell the story of who we are as a nation. From sea to shining sea, digital imagery allows us to connect to one another in ways we never dreamed possible.

At Olympus, our ideas have proliferated as rapidly as technology has evolved. We have channeled these visions into breakthrough products and solutions to meet the demands of our changing world-products like microscopes, endoscopes, and digital voice recorders, supported by the highly regarded training, educational, and consulting services we offer our customers.

Today, 83 years after we introduced our first microscope, we remain as young, as curious, and as committed as ever.

Lexar Media has grown from the digital photography revolution, which is why we are proud to have supplied the digital memory cards used in the America 24/7 project. Lexar Media's high-performance memory cards utilize our unique and patented controller coupled with high-speed flash memory from Samsung, the world's largest flash memory supplier. This powerful combination brings out the ultimate performance of any digital camera.

Photographers who demand the most from their equipment choose our products for their advanced features like write speeds up to 40X, Write Acceleration technology for enabled cameras, and Image Rescue, which recovers previously deleted or lost images. Leading camera manufacturers bundle Lexar Media digital memory cards with their cameras because they value its performance and reliability.

Lexar Media is at the forefront of digital photography as it transforms picture-taking worldwide, and we will continue to be a leader with new and innovative solutions for professionals and amateurs alike.

Snapfish, which developed the technology behind the *America 24/7* amateur photo event, is a leading online photo service, with more than 5 million members and 100 million photos posted online. Snapfish enables both film and digital camera owners to share, print, and store their most important photo memories, at prices that cannot be equaled. Digital camera users upload photos into a password-protected online album for free. Users can also order film-quality prints on professional photographic paper for as low as 25¢. Film camera users get a full set of prints, plus online sharing and storage, for just $2.99 per roll.

Founded in 1995, eBay created a powerful platform for the sale of goods and services by a passionate community of individuals and businesses. On any given day, there are millions of items across thousands of categories for sale on eBay. eBay enables trade on a local, national and international basis with customized sites in markets around the world.

Through an array of services, such as its payment solution provider PayPal, eBay is enabling global e-commerce for an ever-growing online community.

JetBlue Airways is proud to be *America 24/7's* preferred carrier, flying photographers, photo editors, and organizers across the United States.

Winner of Condé Nast Traveler's Readers' Choice Awards for Best Domestic Airline 2002, JetBlue provides friendly service and low fares for travelers in 22 cities in nine states across America.

On behalf of JetBlue's 5,000 crew members, we're excited to be involved in this remarkable project, and for the opportunity to serve American travelers each and every day, coast to coast, 24/7.

DIGITAL POND

Digital Pond has been a leading creator of large graphic displays for museums, corporations, trade shows, retail environments and fine art since 1992.

We were proud to bring together our creative, print and display capabilities to produce signage and displays for mission control, critical retouching for numerous key images for the book, and art galleries for the New York Public Library and Bryant Park.

The Pond's team and SplashPic® Online service enabled us to nimbly design, produce and install over 200 large graphic panels in two NYC locations within the truly "24/7" production schedule of less than ten days.

WebWare Corporation is pleased to be a major sponsor of the America 24/7 project. We take pride in being part of a groundbreaking adventure that is stretching the boundaries—and the imagination—in digital photography, digital asset management, publishing, news, and global events.

Our ActiveMedia Enterprise™ digital asset management software is the "nerve center" of *America 24/7*, the central repository for managing, sharing, and collaborating on the project's photographs. From photo editors and book publishers to 24/7's media relations and marketing personnel, ActiveMedia provides the application support that links all facets of the project team to the content worldwide.

WebWare helps Global 2000 firms securely manage, reuse, and distribute media assets locally or globally. Its suite of ActiveMedia software products provide powerful media services platforms for integrating rich media into content management systems marketing and communication portals; web publishing systems; and e-commerce portals.

Google

Google's mission is to organize the world's information and make it universally accessible and useful.

With our focus on plucking just the right answer from an ocean of data, we were naturally drawn to the America 24/7 project. The book you hold is a compendium of images of American life distilled from thousands of photographs and infinite possibilities. Are you looking for emotion? Narrative? Shadows? Light? It's all here, thanks to a multitude of photographers and writers creating links between you, the reader, and a sea of wonderful stories. We celebrate the connections that constitute the human experience and are pleased to help engender them. And we're pleased to have been a small part of this project, which captures the results of that interaction so vividly, so dynamically, and so dramatically.

Special thanks to additional contributors: FileMaker, Apple, Camera Bits, LaCie, Now Software, Preclick, Outpost Digital, Xerox, Microsoft, WoodWing Software, net-linx Publishing Solutions, and Radical Media. The Savoy Hotel, San Francisco; The Pan Pacific, San Francisco; Four Seasons Hotel, San Francisco; and The Queen Anne Hotel. Photography editing facilities were generously hosted by CNET Networks, Inc.

Participating Photographers

Tennessee Coordinator: Dennis Copeland*, Director of Photography, *The Commercial Appeal*

Morris Abernathy
Nancy Lee Andrews
Lisa Waddell Buser
Gina Collins
Jack Corn
Steve Dewease
Dean Dixon
Jim Eastin
Karen Pulfer Focht
Gary Heatherly
Margie Hodge
Mark Humphrey
Dave Hymel
John E. May
Ray Maynard
Chad McClure
Bruce Meisterman

Lance Murphey
Patrick Murphy-Racey, pmrphoto.com
Charlotte Neidel
Rickey Newell
John Partipilo, *The Tennessean*
John Rawlston
John Russell, Maximum Exposure
Rusty Russell
Alan Spearman
David Tallon
Richard Vance
Jim Weber
Billy Weeks
A.J. Wolfe
Janet Worne, *Lexington Herald-Leader*

*Pulitzer Prize winner

Thumbnail Picture Credits

Credits for thumbnail photographs are listed by the page number and are in order from left to right.

20 Mark Humphrey
April Porter
Mark Humphrey
April Porter
April Porter
Karen Pulfer Focht
Patrick Murphy-Racey, pmrphoto.com

21 Mark Humphrey
Mark Humphrey
Mark Humphrey
Mark Humphrey
Mark Humphrey
Mark Humphrey
Mark Humphrey

25 Alan Spearman
Karen Pulfer Focht
Alan Spearman
Karen Pulfer Focht
Karen Pulfer Focht
C. Paige Burchel
Patrick Murphy-Racey, pmrphoto.com

28 John E. May
John E. May
Bruce Meisterman
April Porter
John E. May
L. B. Greene
L. B. Greene

29 Lisa Waddell Buser
Mark Humphrey
Michael Broyles, Broyles Renderings, Inc.
John E. May
Mark Humphrey
John E. May
L. B. Greene

32 April Porter
John E. May
John Partipilo, *The Tennessean*
Gary Heatherly

John Partipilo, *The Tennessean*
Gary Heatherly
Jack Corn

33 John Partipilo, *The Tennessean*
John Partipilo, *The Tennessean*
John Partipilo, *The Tennessean*
John Partipilo, *The Tennessean*
John Partipilo, *The Tennessean*
Michael Broyles, Broyles Renderings, Inc.
John Partipilo, *The Tennessean*

35 Mark Humphrey
Alan Spearman
Lisa Waddell Buser
Jim Eastin
Mark Humphrey
Alan Spearman
Mark Humphrey

36 John Russell, Maximum Exposure
John Russell, Maximum Exposure
John Russell, Maximum Exposure
Jack Corn
John Russell, Maximum Exposure
Jack Corn
John Russell, Maximum Exposure

37 John Russell, Maximum Exposure
John Russell, Maximum Exposure
Jack Corn
John Russell, Maximum Exposure
Jack Corn
Jack Corn
Jack Corn

38 Gary Heatherly
A.J. Wolfe
Gary Heatherly
A.J. Wolfe
Cherri Zaske
Gary Heatherly
Jack Corn

39 Gary Heatherly
A.J. Wolfe
Gary Heatherly
Gary Heatherly
Gary Heatherly
Gary Heatherly
A.J. Wolfe

40 Jack Corn
Jack Corn
Jack Corn
Jack Corn
Jack Corn
Jack Corn
Jack Corn

42 Billy Weeks
Jack Corn
Karen Pulfer Focht
April Porter
A.J. Wolfe
Gary Heatherly
Bruce Meisterman

43 Jack Corn
Dean Dixon
John E. May
Karen Pulfer Focht
Jack Corn
John E. May
Karen Pulfer Focht

51 Lance Murphey
Karen Pulfer Focht
John Rawlston
Gary Heatherly
Bruce Meisterman
Michael Broyles, Broyles Renderings, Inc.
Bruce Meisterman

52 Rusty Russell
Jack Corn
Rusty Russell
Rusty Russell
Rusty Russell
Rusty Russell
Rusty Russell

53 Rusty Russell
Rusty Russell
Rusty Russell
Jack Corn
Rusty Russell
Rusty Russell
Rusty Russell

55 Dean Dixon
Dean Dixon
Dean Dixon
Dean Dixon
Dean Dixon
Dean Dixon
Dean Dixon

56 April Porter
Karen Pulfer Focht
April Porter
Dean Dixon
Karen Pulfer Focht
Dean Dixon
Jim Weber

57 Nancy Lee Andrews
April Porter
John E. May
Karen Pulfer Focht

Patrick Murphy-Racey, pmrphoto.com
Gary Heatherly
Karen Pulfer Focht

58 April Porter
Lance Murphey
Lance Murphey
Dean Dixon
Jack Corn
Alan Spearman
A.J. Wolfe

59 A.J. Wolfe
April Porter
A.J. Wolfe
Gary Heatherly
A.J. Wolfe
Billy Weeks
Lance Murphey

60 Chad McClure
Lance Murphey
Billy Weeks
Lance Murphey
April Porter
Bruce Meisterman
Gary Heatherly

61 Patrick Murphy-Racey, pmrphoto.com
Billy Weeks
Lance Murphey
Lance Murphey
Patrick Murphy-Racey, pmrphoto.com
Alan Spearman
Lance Murphey

64 Jim Weber
Alan Spearman
Jim Weber
Jim Weber
Jim Weber
Jim Weber
Jim Weber

65 Alan Spearman
Jim Weber
Jim Weber
Jim Weber
Jim Weber
Jim Weber
Jim Weber

66 Rusty Russell
Rickey Newell
Lance Murphey
Rusty Russell
Bruce Meisterman
Rusty Russell
Rusty Russell

67 Rusty Russell
Rusty Russell
Lance Murphey
Rusty Russell
Rusty Russell
Rusty Russell
Rusty Russell

68 Billy Weeks
Gary Heatherly
Morris Abernathy
Gary Heatherly
Jim Eastin
Morris Abernathy
Alan Spearman

69 Morris Abernathy
Morris Abernathy
Morris Abernathy

Morris Abernathy
Morris Abernathy
Jack Corn
Patrick Murphy-Racey, pmrphoto.com

70 John Partipilo, *The Tennessean*
Alan Spearman
Alan Spearman
A.J. Wolfe
Alan Spearman
Alan Spearman
John Partipilo, *The Tennessean*

71 A.J. Wolfe
John Partipilo, *The Tennessean*
John Rawlston
Alan Spearman
John Rawlston
John Partipilo, *The Tennessean*
A.J. Wolfe

73 April Porter
Karen Pulfer Focht
Karen Pulfer Focht
April Porter
Alan Spearman
Karen Pulfer Focht
Alan Spearman

74 Billy Weeks
Billy Weeks
Bruce Meisterman
Billy Weeks
Dean Dixon
Billy Weeks
Dean Dixon

75 Alan Spearman
Jim Eastin
Mike McEwen
Billy Weeks
Michael Broyles, Broyles Renderings, Inc.
Rusty Russell
Patrick Murphy-Racey, pmrphoto.com

76 April Porter
April Porter
Lance Murphey
Gary Heatherly
Jack Corn
Patrick Murphy-Racey, pmrphoto.com
Lance Murphey

77 Lance Murphey
Jack Corn
John Rawlston
Lance Murphey
Patrick Murphy-Racey, pmrphoto.com
Lance Murphey
Patrick Murphy-Racey, pmrphoto.com

78 Dean Dixon
Jim Weber
Nancy Lee Andrews
Karen Pulfer Focht
Jack Corn
Jim Eastin
Alan Spearman

79 Alan Spearman
Karen Pulfer Focht
Rusty Russell
Nancy Lee Andrews
Rusty Russell
Nancy Lee Andrews
Rusty Russell

85 Alan Spearman
Billy Weeks
Alan Spearman
Lisa Waddell Buser
Alan Spearman
Bruce Meisterman
Lisa Waddell Buser

86 Rusty Russell
Chad McClure
Patrick Murphy-Racey, pmrphoto.com
Chad McClure
John Rawlston
Patrick Murphy-Racey, pmrphoto.com
April Porter

87 Rusty Russell
Rusty Russell
Karen Pulfer Focht
Dean Dixon
Rusty Russell
Rusty Russell
Rusty Russell

90 April Porter
Gary Heatherly
Patrick Murphy-Racey, pmrphoto.com
Gary Heatherly
Dean Dixon
Jack Corn
Bruce Meisterman

91 Alan Spearman
John Rawlston
Patrick Murphy-Racey, pmrphoto.com
Patrick Murphy-Racey, pmrphoto.com
Patrick Murphy-Racey, pmrphoto.com
Alan Spearman
Patrick Murphy-Racey, pmrphoto.com

92 A.J. Wolfe
A.J. Wolfe
Alan Spearman
Patrick Murphy-Racey, pmrphoto.com
A.J. Wolfe
A.J. Wolfe
A.J. Wolfe

93 A.J. Wolfe
Patrick Murphy-Racey, pmrphoto.com
A.J. Wolfe
Alan Spearman
Patrick Murphy-Racey, pmrphoto.com
A.J. Wolfe
Alan Spearman

94 Charlotte Neidel
John Rawlston
Rusty Russell
Charlotte Neidel
Charlotte Neidel
John Rawlston
John Rawlston

95 Charlotte Neidel
Charlotte Neidel
John Rawlston
Charlotte Neidel
John Rawlston
Rusty Russell
April Porter

97 Billy Weeks
Billy Weeks
Karen Pulfer Focht
Alan Spearman
Billy Weeks
Karen Pulfer Focht
Billy Weeks

101 Karen Pulfer Focht
Karen Pulfer Focht
Karen Pulfer Focht
Karen Pulfer Focht
Karen Pulfer Focht
Karen Pulfer Focht
Karen Pulfer Focht

104 April Porter
Lance Murphey
Dean Dixon
April Porter
Lance Murphey
Karen Pulfer Focht
Lance Murphey

105 April Porter
Lance Murphey
Michael Broyles, Broyles Renderings, Inc.
Lance Murphey
Michael Broyles, Broyles Renderings, Inc.
Lance Murphey
Michael Broyles, Broyles Renderings, Inc.

109 A.J. Wolfe
Janet Worne, *Lexington Herald-Leader*
Michael Broyles, Broyles Renderings, Inc.
Billy Weeks
Bruce Meisterman
Michael Broyles, Broyles Renderings, Inc.
Michael Broyles, Broyles Renderings, Inc.

110 Mark Humphrey
Karen Pulfer Focht
Patrick Murphy-Racey, pmrphoto.com
Mark Humphrey
Karen Pulfer Focht
Mark Humphrey
Jack Corn

111 Michael Broyles, Broyles Renderings, Inc.
Patrick Murphy-Racey, pmrphoto.com
Patrick Murphy-Racey, pmrphoto.com
Patrick Murphy-Racey, pmrphoto.com
A.J. Wolfe
Patrick Murphy-Racey, pmrphoto.com
Karen Pulfer Focht

115 Jack Corn
Lance Murphey
John Rawlston
Lance Murphey
Lance Murphey
Lance Murphey
Lance Murphey

116 Jim Eastin
Dean Dixon
John Rawlston
April Porter
Alan Spearman
Jack Corn
Dean Dixon

117 Alan Spearman
Patrick Murphy-Racey, pmrphoto.com
Lance Murphey
Jim Eastin
Jim Eastin
Patrick Murphy-Racey, pmrphoto.com
Jim Eastin

120 April Porter
Dean Dixon
Gary Heatherly
Dean Dixon
Dean Dixon
Gary Heatherly
Dean Dixon

121 Gary Heatherly
Dean Dixon
Chad McClure
Dean Dixon
Michael Broyles, Broyles Renderings, Inc.
Patrick Murphy-Racey, pmrphoto.com
Dean Dixon

124 Gary Heatherly
Chad McClure
Gary Heatherly
Jack Corn
Jack Corn
Jack Corn
Jack Corn

125 Jack Corn
Gary Heatherly
Jack Corn
Jack Corn
Jack Corn
Patrick Murphy-Racey, pmrphoto.com
Jack Corn

126 Bruce Meisterman
Lance Murphey
John Rawlston
Dean Dixon
Lance Murphey
Janet Worne, *Lexington Herald-Leader*
Chad McClure

127 Bruce Meisterman
Gary Heatherly
Bruce Meisterman
Lisa Waddell Buser
Lance Murphey
Bruce Meisterman
Lance Murphey

128 Jack Corn
Dean Dixon
John Partipilo, *The Tennessean*
Dean Dixon
April Porter
Lance Murphey
Jack Corn

129 Dean Dixon
John Partipilo, *The Tennessean*
John Partipilo, *The Tennessean*
Gary Heatherly
Lance Murphey
John Rawlston
Patrick Murphy-Racey, pmrphoto.com

130 Dean Dixon
Lance Murphey
Dean Dixon
Karen Pulfer Focht
John Rawlston
Lance Murphey
Lance Murphey

131 Lance Murphey
Lance Murphey
Alan Spearman
Lance Murphey
Lance Murphey
Dean Dixon
John Partipilo, *The Tennessean*

Staff

The *America 24/7* series was imagined years ago by our friend Oscar Dystel, a publishing legend whose vision and enthusiasm have been a source of great inspiration.

We also wish to express our gratitude to our truly visionary publisher, DK.

Rick Smolan, Project Director
David Elliot Cohen, Project Director

Administrative
Katya Able, Operations Director
Gina Privitere, Communications Director
Chuck Gathard, Technology Director
Kim Shannon, Photographer Relations Director
Erin O'Connor, Photographer Relations Intern
Leslie Hunter, Partnership Director
Annie Polk, Publicity Manager
John McAlester, Website Manager
Alex Notides, Office Manager
C. Thomas Hardin, State Photography Coordinator

Design
Brad Zucroff, Creative Director
Karen Mullarkey, Photography Director
Judy Zimola, Production Manager
David Simoni, Production Designer
Mary Dias, Production Designer
Heidi Madison, Associate Picture Editor
Don McCartney, Production Designer
Diane Dempsey Murray, Production Designer
Jan Rogers, Associate Picture Editor
Bill Shore, Production Designer and Image Artist
Larry Nighswander, Senior Picture Editor
Bill Marr, Sarah Leen, Senior Picture Editors
Peter Truskier, Workflow Consultant
Jim Birkenseer, Workflow Consultant

Editorial
Maggie Canon, Managing Editor
Curt Sanburn, Senior Editor
Teresa L. Trego, Production Editor
Lea Aschkenas, Writer
Olivia Boler, Writer
Korey Capozza, Writer
Beverly Hanly, Writer
Bridgett Novak, Writer
Alison Owings, Writer
Fred Raker, Writer
Joe Wolff, Writer
Elise O'Keefe, Copy Chief
Daisy Hernández, Copy Editor
Jennifer Wolfe, Copy Editor

Infographic Design
Nigel Holmes

Literary Agent
Carol Mann, The Carol Mann Agency

Legal Counsel
Barry Reder, Coblentz, Patch, Duffy & Bass, LLP
Phil Feldman, Coblentz, Patch, Duffy & Bass, LLP
Gabe Perle, Ohlandt, Greeley, Ruggiero & Perle, LLP
Jon Hart, Dow, Lohnes & Albertson, PLLC
Mike Hays, Dow, Lohnes & Albertson, PLLC
Stephen Pollen, Warshaw Burstein, Cohen, Schlesinger & Kuh, LLP
Rick Pappas

Accounting and Finance
Rita Dulebohn, Accountant
Robert Powers, Calegari, Morris & Co. Accountants
Eugene Blumberg, Blumberg & Associates
Arthur Langhaus, KLS Professional Advisors Group, Inc.

Picture Editors
J. David Ake, Associated Press
Caren Alpert, formerly *Health* magazine
Simon Barnett, *Newsweek*
Caroline Couig, *San Jose Mercury News*
Mike Davis, formerly *National Geographic*
Michel duCille, *Washington Post*
Deborah Dragon, *Rolling Stone*
Victor Fisher, formerly Associated Press
Frank Folwell, *USA Today*
MaryAnne Golon, *Time*
Liz Grady, formerly *National Geographic*
Randall Greenwell, *San Francisco Chronicle*
C. Thomas Hardin, formerly *Louisville Courier-Journal*
Kathleen Hennessy, *San Francisco Chronicle*
Scot Jahn, *U.S. News & World Report*
Steve Jessmore, *Flint Journal*
John Kaplan, University of Florida
Kim Komenich, *San Francisco Chronicle*
Eliane Laffont, *Hachette Filipacchi Media*
Jean-Pierre Laffont, *Hachette Filipacchi Media*
Andrew Locke, MSNBC
Jose Lopez, *The New York Times*
Maria Mann, formerly AFP
Bill Marr, formerly *National Geographic*
Michele McNally, *Fortune*
James Merithew, *San Francisco Chronicle*
Eric Meskauskas, *New York Daily News*
Maddy Miller, *People* magazine
Michelle Molloy, *Newsweek*
Dolores Morrison, *New York Daily News*
Karen Mullarkey, formerly *Newsweek, Rolling Stone, Sports Illustrated*
Larry Nighswander, Ohio University School of Visual Communication
Jim Preston, *Baltimore Sun*
Sarah Rozen, formerly *Entertainment Weekly*
Mike Smith, *The New York Times*
Neal Ulevich, formerly Associated Press

Website and Digital Systems
Jeff Burchell, Applications Engineer

Television Documentary
Sandy Smolan, Producer/Director
Rick King, Producer/Director
Bill Medsker, Producer

Video News Release
Mike Cerre, Producer/Director

Digital Pond
Peter Hogg
Kris Knight
Roger Graham
Philip Bond
Frank De Pace
Lisa Li

Senior Advisors
Jennifer Erwitt, Strategic Advisor
Tom Walker, Creative Advisor
Megan Smith, Technology Advisor
Jon Kamen, Media and Partnership Advisor
Mark Greenberg, Partnership Advisor
Patti Richards, Publicity Advisor
Cotton Coulson, Mission Control Advisor

Executive Advisors
Sonia Land
George Craig
Carole Bidnick

Advisors
Chris Anderson
Samir Arora
Russell Brown
Craig Cline
Gayle Cline
Harlan Felt
George Fisher
Phillip Moffitt
Clement Mok
Laureen Seeger
Richard Saul Wurman

DK Publishing
Bill Barry
Joanna Bull
Therese Burke
Sarah Coltman
Christopher Davis
Todd Fries
Dick Heffernan
Jay Henry
Stuart Jackman
Stephanie Jackson
Chuck Lang
Sharon Lucas
Cathy Melnicki
Nicola Munro
Eunice Paterson
Andrew Welham

Colourscan
Jimmy Tsao
Eddie Chia
Richard Law
Josephine Yam
Paul Koh
Chee Cheng Yeong
Dan Kang

Chief Morale Officer
Goose, the dog